A gift in honor of

David J. Virden

From

Mr. & Mrs. Wm. P. Virden

BOWMAN LIBRARY

IMPRESSIONISM
in Perspective

THE ARTISTS IN PERSPECTIVE SERIES

H. W. Janson, general editor

The ARTISTS IN PERSPECTIVE *series presents individual illustrated volumes of interpretive essays on the most significant painters, sculptors, architects, and genres of world art.*

Each volume provides an understanding of art and artists through both esthetic and cultural evaluations.

BARBARA EHRLICH WHITE has taught art history since 1959 and currently teaches at Tufts University. She has published and lectured widely on Renoir, on Impressionism, and on women's studies in art history. She was associate producer of an Emmy-winning documentary film on Renoir.

IMPRESSIONISM
in Perspective

Edited by

BARBARA EHRLICH WHITE

A SPECTRUM BOOK

Prentice-Hall, Inc., Englewood Cliffs, New Jersey

Library of Congress Cataloging in Publication Data
Main entry under title:

IMPRESSIONISM IN PERSPECTIVE.

 (Artists in perspective series) (A Spectrum Book)
 Bibliography: p.
 1. Impressionism (Art)—France—Addresses, essays, lectures. 2. Painting, Modern—19th cen-
tury—France—Addresses, essays, lectures. 3. Renoir, Auguste, 1841—1919—Addresses, essays, lec-
tures. 4. Pissarro, Camille, 1830–1903—Addresses, essays, lectures. 5. Monet, Claude, 1840–
1926—Addresses, essays, lectures. I. White, Barbara Ehrlich.
ND547.5.I4I448 759.4 77–21780
ISBN–0–13–452037–8
ISBN–0–13–452029–7 pbk.

© 1978 BY PRENTICE-HALL, INC.
ENGLEWOOD CLIFFS, N.J. 07632

A SPECTRUM BOOK

Printed in the United States of America

10 9 8 7 6 5 4 3 2 1

PRENTICE-HALL INTERNATIONAL, INC. *(London)*
PRENTICE-HALL OF AUSTRALIA PTY., LTD. *(Sydney)*
PRENTICE-HALL OF CANADA, LTD. *(Toronto)*
PRENTICE-HALL OF INDIA PRIVATE, LIMITED *(New Delhi)*
PRENTICE-HALL OF JAPAN, INC. *(Tokyo)*
PRENTICE-HALL OF SOUTHEAST ASIA PTE., LTD. *(Singapore)*
WHITEHALL BOOKS, LIMITED *(Wellington, New Zealand)*

To my husband, Leon,
and to my sons, Joel and David

CONTENTS

PART FOUR / Social Support, Recognition, and Sales

PART FIVE / Style, Technique, Influences, Present Status

ACKNOWLEDGMENTS

The two people whom I would first like to thank are Meyer Schapiro and John Rewald. Meyer Schapiro, University Professor Emeritus at Columbia University, has, during the past half-century, distinguished himself as a brilliant lecturer, inspired teacher, and prolific writer. As my masters' and doctoral advisor, he provided a model of excellence that has been my constant inspiration. Albert Elsen of Stanford University who also studied under Schapiro wrote: "More than any other single scholar, Schapiro showed you what art history could be. He was the compleat art historian: connoisseur and critic, but also with his credentials as an archaeologist. Many of his closest friends were in other fields—philosophy, psychology, and physics. Many of us have the feeling that he draws his greatest inspiration from them and it is an inspiration to us not to isolate ourselves from other disciplines." [1] Schapiro's lectures, seminars, and writings on Impressionism were my basic source for interpretation and analysis.

John Rewald's writings were my primary resource for information and bibliography. Rewald has written *the* basic book on the subject—*The History of Impressionism*. First published in 1946 and in its fourth, revised edition in 1973, this book is the benchmark for the study of Impressionism. As the book jacket to the most recent edition aptly states: "Mr. Rewald presents the simultaneous developments of the various painters, their relationships, their feuds, and their common struggle, as an integrated whole. There are detailed accounts of the various historic group exhibitions and complete characterizations of the Impressionist painters as individuals and as artists, based on innumerable documents—many little known and many previously unpublished. These documents, extensively quoted, include letters by the artists themselves, contemporary criticism, and eyewitness reports about the painters, their habits, and their sur-

[1] From Piri Halasz, "Homage to Meyer Schapiro: 'The Compleat Art Historian,'" *ARTNews*, Summer 1973, p. 59.

roundings." Without a doubt, Rewald's *History of Impressionism* provides the most diverse and complete perspective on this movement.

Rewald's extensive bibliography of over one thousand titles is a tour de force. First, in chronological order, he lists 273 books and articles on the Impressionist movement. Following this, for each of the twelve key Impressionist painters, he presents a detailed bibliography. As an example, for Monet, Rewald lists (in separate categories, each in chronological order): Monet's oeuvre (works) catalogues; sources for the artist's own writings; witness accounts; biographies; studies of style; and sources of reproductions. For Monet alone, this bibliography provides 105 titles. Beyond this basic text, Rewald has written innumerable books, articles, and catalogues, on individual Impressionists and on the movement as a whole.

Another resource that I would like to acknowledge is Linda Nochlin's *Impressionism and Post-Impressionism, 1874–1904,* a Prentice-Hall Sources and Documents book. This excellent anthology was of great help in my preparation of Parts One and Two of this volume.

I would like to thank Lucretia Slaughter Gruber for her painstaking translation of five important long selections. I would like to thank Charles Durand-Ruel for secondary permission from his various publications. While all of the primary permissions are mentioned in the credits, I again want to thank the various publishers and authors for allowing their articles to appear in this anthology.

On a personal level, I wish to thank Norma Broude for general discussions about the Artists in Perspective series books. People who were kind to me during the time that I worked on this book include: Davida Comba, Horst Janson, and Blanche MacKenzie. I wish to thank those students in my Impressionism seminar in Spring 1977 for their perceptive comments. And I would also like to thank Michael Hunter and Maria Carella of Prentice-Hall for their help in the preparation of this book.

Finally, I want to thank my husband, Leon, for his enthusiastic support of all projects I take on. I also want to warmly thank my sons: Joel spent hours helping me to count lines, cut, paste, and mount; David helped by pasting. Without their good-natured assistance, the process of completing the book would not have been as enjoyable as it was.

INTRODUCTION

Barbara Ehrlich White

This book presents perspectives on a group movement, Impression-
ism, with special attention to its three key figures—Monet, Renoir, and
Pissarro—as opposed to other anthologies in this series, which give per-
spectives on only one artist. The pre-Impressionists, Degas and Manet,
are not included though some of their work is indeed Impressionist, nor
are the post-Impressionists, Cézanne, Seurat, Van Gogh, and Gauguin,
although each of them had an early Impressionist phase.

I have included nearly fifty selections written during the past century.
My goal is to present diversified perspectives by artists, poets, writers,
journalists, sociologists, cultural historians, and art historians; by those
who were favorable and others who were hostile; by some who saw
Impressionism as unimportant and others who believed it to be the first
modern style. Each viewpoint adds a new dimension to our understand-
ing of the complex artistic movement called Impressionism.

It was difficult to choose which selections to include in light of the
over one thousand titles listed in Rewald's 1973 bibliography. I decided
to include obscure and difficult-to-obtain pieces, selections never before
published in English, as well as some of the more basic sources. My aim
was to include both factual information and interesting analyses from
varied viewpoints. My hope is that the book will serve as a springboard
to reading and to museum-going. Furthermore, for those interested in
research, I hope that Impressionism will be recognized as an area with
many unexplored facets—and with new perspectives yet to be written.

The first three parts of the anthology are contemporary perspectives,
mostly short selections by artists and writers. The last two parts are more
recent; these are longer analyses by scholars in different disciplines.

Part One, The Impressionists' Perspectives, begins with Georges
Rivière's defense of Impressionism in 1877. (Here Rivière's style of

1

criticism is Impressionist in that his writing style is direct, effervescent, and spontaneous.) The weekly newspaper *L'Impressionnist, journal d'art* was sold every Thursday during the month that the third group exhibit of Impressionists' work took place in Paris. The founding charter (December 27, 1873) of the group (La Société anonyme des artistes, peintres, sculpteurs, graveurs, etc.) had foreseen "the publication, as soon as possible, of a periodical exclusively concerned with art."[1] Three-and-a-half years later, at the suggestion of Renoir, Rivière, an art critic and staunch defender of the Impressionists, founded a weekly journal for the express purpose of counteracting the hostility of the popular press—a hostility that had arisen in response to the two earlier exhibits. The exhibition of 1877 was to be the largest and most representative contemporary Impressionist exhibit, with eighteen painters and two hundred and thirty paintings represented.[2] In Rivière's periodical, written for the general public, he voiced the aims and goals of his artist friends; they may well have checked his texts, since he was writing as their spokesman.

Rivière's selection is followed in Part One by interviews, letters, advice, and recollections by Claude Monet, Auguste Renoir, and Camille Pissarro. While no artist tries to explain what Impressionism is, each voices his love of nature and his empirical attitude. Monet's statements are especially clear regarding his goal of capturing his personal vision of the changing character of the visible world. Renoir's proposal of 1884 called for the establishment of an association of artists and artisans who accepted irregularity as their aesthetic principle. Renoir stated here that nature is always irregular and that art should follow nature. While Renoir's proposed association was never formed, it is interesting to note that in 1884 (at a time when the Impressionist group was breaking up), Renoir held firm to his naturalism. In Pissarro's letters and conversations, this naturalism is reiterated. Like Monet and Renoir, Pissarro talks of his search to reproduce his visual sensations. In an almost religious manner, Monet, Renoir, and Pissarro declare themselves worshippers of nature in its ever-changing appearances.

In Part Two, contemporary French, American, and English writers, poets, and journalists voice differing views of Impressionism. In the late 1860s, Émile Zola praises the naturalism of Monet's paintings. Eight years later, the American, Henry James, has a less favorable reaction to the Impressionists, viewing them as curious, lacking in imagination, second-rate talents, and cynics. Seven years after James, Jules Laforgue, the French poet, writes a perceptive defense of Impressionist naturalism in

[1] John Rewald, *The History of Impressionism,* 4th ed. rev. (New York: The Museum of Modern Art, 1973), p. 394.
[2] Lionello Venturi, *Les Archives de l'Impressionnisme* (Paris, New York: Durand-Ruel, 1939), II, 259–61.

his review of a German exhibit. In 1886, Guy de Maupassant chronicles his observations of Monet painting a series of cliffs at different times of the day. In 1889, Oscar Wilde writes a witty piece on the influence of Impressionism on contemporary perceptions of the climate. In the two concluding articles in Part Two, Oscar Reutersvärd excerpts specific criticism by journalists of the 1870s, '80s, and '90s concerning the "violet-tomania" and the accentuated brush stroke of the Impressionists. These two characteristics troubled the critics, and by focusing on them, Reutersvärd is able to explain the stubborn incomprehensiveness of the majority of contemporary journalists.

In Part Three, twelve great artists from seven different countries, writing from 1884 to 1952, discuss their positive and negative feelings about Impressionism. Their opinions are drawn from published and unpublished articles, recollections, and letters.

Part Four includes three long articles that provide much information about cultural history, sociology, and prices of Impressionist works. First, Arnold Hauser presents an intellectual and cultural history of the Impressionist period. Next, Harrison and Cynthia White, in a unique sociological study, analyze the role of Durand-Ruel, the primary dealer of Impressionist works, as a speculator and a patron; the Whites also explain the finances and standard of living of the artists, and they demonstrate the power of the group exhibits. Then, in John Rewald's diagram, we trace the participation of fifty-eight artists in the eight Impressionist group shows of 1874 to 1886. Finally, François Duret-Robert's article of 1973 traces the meteorlike rise in the dollar value of Impressionist paintings during the past century.

Part Five includes six articles about style, technique, influences, and the present status of Impressionism. Lionello Venturi gives a general description of the movement. Richard Brown analyzes the technique of Pissarro. Aaron Scharf talks of the relationship between Impressionism and photography. Gerald Needham writes of the influence of Japanese art on Impressionism. Carol Osborne studies the relationship between the Paris Salon and Impressionism. Lastly, Kirk Varnedoe reconsiders the status of Impressionism in light of contemporary art, scholarship, and economic realities.

The Appendices consist of John Rewald's maps, showing where the Impressionists worked, and Jean Leymarie's chronology (1830–1927) of dates and events significant to Impressionism.

<p style="text-align:center">• • •</p>

Impressionism was the style practiced by Monet, Renoir, Pissarro, and others during the twenty or so years from about 1866 to 1886. Monet's work continues to show Impressionist style until his death in 1926. Renoir

and Pissarro move away from Impressionism in figure painting after the early 1880s, although their landscapes continue to be Impressionist until their deaths in 1919 and 1903, respectively.

Impressionism is both the ultimate development of an earlier 19th-century naturalism and the beginning of abstraction, which develops throughout the 20th century. It is both a collective movement and the work of numerous original individuals.

Impressionism was practiced by a group of artists born within a few years of each other. Foremost among them were Claude Monet, b. 1840; Camille Pissarro, b. 1830; (Pierre) Auguste Renoir, b. 1841; Alfred Sisley, b. 1839; Frédéric Bazille, b. 1841, and Berthe Morisot, b. 1841. These painters had similar artistic values in that they wished to render nature in an imaginative and joyful manner. Some of them (Monet, Renoir, Sisley, and Bazille) met in Charles Gleyre's studio in 1862; they worked together in the 1860s and '70s (see Figs. 1 and 2) in Paris and in the suburbs (see the second map in the Appendix); they talked together at the Parisian Café Guerbois on the rue des Batignolles; beginning in the 1870s,[3] they sought the help of the dealer Paul Durand-Ruel, and, starting in 1874, they exhibited together.[4] In the 1870s and '80s, a vicious battle was initiated by the popular press,[5] who claimed that the Impressionists were sloppy artists of no talent who exhibited their sketches as a revolutionary gesture to offend people of traditional taste. Ironically, the Impressionists desperately wanted to be appreciated and accepted by the very public and critics who derided them. Beginning in the mid-1860s, they were either rejected or poorly hung at the official Salons; by 1874 they felt it necessary to begin to establish their own group exhibits. In spite of these separate exhibits and their explanatory journal, *L'Impressionniste* (April 1877), the public and critics could not understand their style. It was not until the early 1890s, when the artists were middle-aged (in their forties and fifties), that Impressionism was accepted, the artists' intentions were better understood, and their paintings were sold at reasonable prices.

During the late 1860s and '70s, strong personal ties between the artists existed and the different Impressionists' work showed the most similarity. By the early 1880s, there was an increasing amount of internal tension among the members of the group. Indeed, in the eighth exhibit of 1886, most of the important Impressionists (Monet, Renoir, Sisley) refused to participate. The departure of the Impressionists from Paris began in the early 1880s. In 1882, Pissarro moved to Osny; two years later

[3] *Ibid.*, II, pp. 143–220 (see Durand-Ruel's memoires). *Ibid.*, I and II (see letters from the artists to Durand-Ruel).
[4] *Ibid.*, II, pp. 255–72 (catalogues of the eight Impressionist shows).
[5] *Ibid.*, II, pp. 273–340 (excerpts from Impressionist criticism from 1863 to 1880).

he moved to Eragny. In 1883, Monet moved to Giverny and also worked at Etretat. In 1885, Renoir moved to La Roche-Guyon and also lived in Essoyes. While the artists remained friends, they no longer worked together and rarely saw one another.

• • •

The term "Impressionist" originated in 1874 and was in general use from 1877. The term was derived from the title of a painting that Monet exhibited at the first group show of 1874. This painting, *Impression, Sunrise (Le Havre)* (1872) is now in a private Paris collection.[6] This is not the Musée Marmottan painting, as is often stated.[7] The first group exhibit opened on April 14, 1874. Ten days later, a mocking article by Louis Leroy appeared in the *Charivari* entitled: "Exhibition of the Impressionists." In this hostile review, which doubted the sincerity and talent of the painters,[8] Leroy wrote of Monet's painting *Impression, Sunrise (Le Havre)*: "*Impression*—I was certain of it. I was just telling myself that, since I was impressed, there had to be some impression in it . . . and what freedom, what ease of workmanship! Wallpaper in its embryonic state is more finished than that seascape."[9]

Four days later, Jules Catagnary wrote an article, "Exposition du boulevard des Capucines—Les impressionnistes," for *Le Siècle*, April 29, 1874. He wrote of the exhibit:

> The common concept which united them as a group and gives them a collective strength in the midst of our disaggregate epoch is the determination not to search for a smooth execution, but to be satisfied with a certain general aspect. Once the impression is captured, they declare their role terminated. . . . If one wants to characterize them with a single word that explains their efforts, one would have to create the new term of *Impressionists*. They are impressionists in the sense that they render not a landscape but the sensation produced by a landscape.[10]

In spite of the objection of some of the artists, the term was accepted. The first two issues of Rivière's journal of 1877 included articles called "L'exposition des impressionnistes," written by Rivière himself. Monet called himself an Impressionist in his 1880 interview with Taboreux.

• • •

To write about the Impressionist style is not easy, since there is such diversity between the individual artists' works, between images of

[6] Rewald, *Impressionism,* p. 316 (illustration).
[7] *Ibid.,* p. 339, *n.*23. Both paintings are the same size: 19½" x 25½".
[8] *Ibid.,* pp. 318–24.
[9] *Ibid.,* p. 323.
[10] *Ibid.,* p. 330.

different themes, and between paintings of different years. A comparison of paintings of the same motif done by pairs of artists working together, such as the two paintings in 1869 of *La Grenouillère*, by Renoir and by Monet (see Figs. 1 and 2), reveals the uniqueness of each painter's perception. Other pairs of paintings of the same motif by different artists can be used to illustrate the difference between Impressionism and photography.[11] In 1891, when Monet exhibited 15 different views of his haystacks, he was pursuing his goal of capturing an instantaneous impression of one theme at different seasons and different moments.[12] Monet was, in essence, showing that there is an unlimited number of perceptions, no one more valid nor more beautiful than any other.

Certain generalizations about Impressionism can be made using Monet's *Boulevard des Capucines, Paris*, 1873–1874, (see Fig. 12) as an example. This painting was exhibited at the first Impressionist show of 1874. Monet painted this scene from the second floor balcony of the photographer Nadar's studio in view of his subject. He painted tiny moving figures, light spread all over, wind moving through the branches of the trees, clouds moving through the sky.

Primary importance is given to the tiny, moving, brightly colored strokes that portray movement and create form. Though Monet's aim is to give an effect of a free, spontaneous execution, his method is a sensitive, painstaking weighing of tiny parts. Monet seeks to make the colors as luminous and as intense as possible. High-keyed tones are used as reflected hues in the shadows.

Monet's vantage point was high—a device learned from both photography and Japanese prints. The effect is to emphasize the two-dimensional qualities of the composition. Free ordering and scattering are suggested by the flicker of small colored strokes across the canvas. Distant parts of the surface are related by strokes of similar hue, intensity, value, weight, size, and direction. The frame crops parts of the image, and there is no focal point in the composition.

Impressionist form is open. There is no line, detail, weight, volume, or relief. Instead, with his colored strokes, Monet both creates and dissolves form. Seen from less than a foot away, the image is unclear; from a distance, the colored strokes suggest an everyday scene.

In sum, the stylistic hallmarks of Impressionism include: a feeling of freedom and randomness; a palette that is light and bright; strokes that are mobile and visible; an arrangement that is random and non-focused; and forms that are open and imprecise.

[11] *Ibid.*, pp. 286–88, 294, 348–49, 352 (illustrations).
[12] Compare Fig. 6 and illustration in Rewald's *Impressionism*, p. 562.

THE IMPRESSIONISTS'
WEEKLY JOURNAL (1877)

Georges Rivière

How many marvels, how many remarkable works, indeed how many masterpieces are accumulated in the showrooms on the rue Le Peletier! Nowhere and at no time has such an exhibit been offered to the public. One is dazzled and charmed upon entering, and the farther one advances, the more the delight grows. In the first room, there are several very beautiful canvases by Renoir and some paintings by Monet and Caillebotte. In the second room, the large painting of turkeys by Monet, paintings by Renoir, landscapes by Monet, Pissarro, Sysley [*sic*], Guillaumin, Cordey, Lamy, give to this group an inexpressible and almost musical gaiety.

Entering the middle room, our first glance is drawn to *Dancing at the Moulin de la Galette* [see Fig. 3] by Renoir and to a large landscape by Pissarro; you turn around, and you admire the masterly canvases by Cézanne, and the charming paintings so delicate and most of all so feminine by Berthe Morizot [*sic*].

In the large exhibition hall next to that one are gathered works of Monet, Pissarro, Sysley [*sic*] and Caillebotte.

And, in a little gallery in the rear, there are some astounding pictures by Degas and several ravishing watercolors by Berthe Morizot [*sic*].

Such is more or less the whole of the exhibition. Exquisite taste has presided over the arrangement of the paintings; each panel offers an

Georges Rivière, *The Impressionists' Weekly Journal* [Editor's title]. From "L'exposition des Impressionnistes," *L'Impressionniste, journal d'art* (April 6 and April 14, 1877). Reprinted in Lionello Venturi, *Les Archives de l'Impressionnisme* (Paris, New York: Durand-Ruel, 1939); II, pp. 308–13 and 317–21; trans. by Lucretia Slaughter Gruber. Reprinted by permission of Durand-Ruel, publisher. [A list of the 227 works exhibited at this third group show of April 1877, which took place at 6, rue Le Peletier, Paris, can be found in Venturi, *Archives*, II, pp. 259–61.–ED.]

agreeable eyeful. There is never a discordant note in this ensemble of works, which are, however, so different one from another.

The rue Le Peletier exhibition only shows us lively scenes which sadden neither the eye nor the spirit; luminous, joyous or grandiose landscapes; never any of those lugubrious notes which bring gloom to the eye of the beholder.

Let us begin with the works of Renoir, and by the most important of his works, *Dancing at the Moulin de la Galette* [see Fig. 3]. In a garden inundated with sunlight, barely shaded by some spindly acacia plants whose thin foliage trembles with the least breeze, there are charming young girls in all the freshness of their fifteen years, proud of their light homemade dresses fashioned of inexpensive material, and young men full of gaiety. These make up the joyous crowd whose brouhaha is louder than the band's music. Lost notes of a country dance are barely audible from time to time to remind the dancers of the beat. Noise, laughter, movement, sunshine, in an atmosphere of youth: such is *Dancing at the Moulin de la Galette* by Renoir. It is an essentially Parisian work. These young girls are the same ones with whom we rub elbows every day, and whose prattling fills Paris at certain hours. A smile and some shirt cuffs are enough to make them pretty. Renoir has proved it well. Look at the grace with which the girl leans on a bench! She is chatting, emphasizing her words with a subtle smile, and her curious glance tries to read the face of the young man speaking with her. And that young philosopher, leaning back on his chair and smoking his pipe, what profound disdain he must have for the jigging of the gallant dancers who seem oblivious to the sun in the ardor of a polka!

Surely Renoir has a right to be proud of *Dancing at the Moulin de la Galette*. Never has he been more inspired. It is a page of history, a precious monument to Parisian life, done with rigorous exactitude. No one before him had thought of portraying an event in ordinary life on a canvas of such big dimensions; it is an act of daring which will be rewarded by success, as is fitting. This painting has a very great significance for the future, which cannot be emphasized too much. This is an historical painting. Renoir and his friends have understood that historical painting is not the more or less ludicrous illustration of tales of the past; they have blazed a trail that others will certainly follow. Let those who want to do historical painting do the history of their own era, instead of raising the dust of past centuries. What do those operetta kings, rigged out in blue and yellow robes, bearing a sceptre in their hands and a crown on their heads, matter to us! When, for the hundredth time, we are shown Saint Louis dispensing justice under an oak, have we thereby made any progress? What documents will artists who indulge in such overlabored works bring to future centuries concerning the history of our own era?

Every conscientious artist tries to immortalize his work; by what right can such paintings, which bring nothing new in color or the choice of subject, hope for this immortality?

Treating a subject for the sake of tone and not for the sake of the subject itself, this is what distinguishes the Impressionists from other painters. For there are Italians, Belgians and others who paint miniatures of people in contemporary dress and who contribute also, it will be said, to the history of our period. We will not deny it, we will even add that the photographers and tailors who publish fashion illustrations contribute as least as much as they do; but are they artists for that reason? It is especially this pursuit, this new way of treating a subject, which is the very personal quality of Renoir; instead of seeking the secret of the great masters, of Velasquez or of Franz [*sic*] Hals, as do the obstinate children of the quai Malaquais, he sought and found a contemporary note, and *Dancing at the Moulin de la Galette*, whose coloring has so many charms and so much that is new, will surely be the big success of this year's exhibitions. . . .

It is evident that the Renoir exhibition is very important, not only because of the number of canvases shown but also because of their worth. The show is even more complete than those of previous years.

We shall not say any more about it, it is up to the public to appreciate for itself these works shown for its benefit; it is to the heart that this painting addresses itself; if the public is moved, the goal is met; nothing more can be asked of the artist, and the painter will be sufficiently rewarded for his labors, we are sure.

Monet, whose works we are going to try to describe, seems to be the absolute opposite of Renoir. |The strength, the animation, in a word, the life that the painter of *Dancing at the Moulin de la Galette* puts in his people, Monet puts in things; he has found their soul./ In his pictures, water splashes, locomotives work, the sails of boats swell with the wind, terrain, houses, everything in the work of this great artist has an intense and personal life that no one had discovered or even suspected before him.

Monet is not content to render only the awesome and grand aspect of nature, he makes it likeable and charming again, nature such as the eye of a young and happy man might perceive it. Never does a sad thought come to dishearten the viewer before the canvases of this powerful painter. One only experiences, after the pleasure of admiring it, the regret of being unable to live eternally in the midst of the luxuriant nature which unfolds in his paintings.

This year, Monet gives us several canvases depicting locomotives alone or hitched up to a string of cars at the St. Lazare station [see Fig. 4]. These paintings are enormously varied, in spite of the monotony and

the aridity of the subject. In these canvases more than anywhere else, Monet displays the knowledge of arranging and distributing elements on a canvas, which is one of his master qualities.

In one of the biggest paintings, the train has just pulled in, and the engine is going to leave again. Like an impatient and temperamental beast, exhilarated rather than tired by the long haul it has just performed, it shakes its mane of smoke, which bumps against the glass roof of the great hall. Around the monster, men swarm on the tracks like pygmies at the feet of a giant. Engines at rest wait on the other side, sound asleep. One can hear the cries of the workers, the sharp whistles of the machines calling far and wide their cry of alarm, the incessant sound of ironwork and the formidable panting of steam.

One sees the grandiose and wild movement of a station where the ground trembles with every turn of the wheels. The walkways are moist with soot, and the atmosphere is charged with that bitter odor given off by burning oil.

In looking at this magnificent painting, one is seized with the same emotion as in front of nature, and this emotion is perhaps stronger still because in this painting there is the artist's emotion as well.

Near this painting, another of the same dimensions depicts the arrival of a train in brilliant sunshine. It is a joyous and lively canvas. People hurry getting off the cars, the smoke escapes toward the background to rise higher, and the sun gilds the sand of the track and the machines as it passes through the glass panes. In some paintings, rapid and irresistible trains, enveloped in light rings of smoke, sweep into the quays. In others, huge engines, scattered about and immobile, wait to depart. In all of them, the same power animates these objects, which Monet alone has discovered how to render. . . .

We have chosen to begin this review of the exhibition with Renoir and Monet, two artists of equal talent whose names have unceasingly been associated with each other in praise or criticism, but whose works are so different, although originating from a common point of view.

We have shown them to be equally prolific and varied; anything that we could add would be superfluous. . . .

• • •

. . . Let us next consider a man accused of awkwardness, but who is encouraged as if he were a young man who will one day amount to something, I mean Pissarro.[1]

The painter and his Impressionist friends have been very amused by the encouragement that some critics of good will have had the kindness to give him. He will profit from their advice, let us not doubt it. How-

[1 Pissarro, at this time, was 47 years old.—ED.]

ever, permit me to attribute some value to these works of youth and to give to their author neither advice nor encouragement.

Pissarro was one of the first to take up the Impressionist struggle. He has changed; his talent often transformed itself before reaching its present form; his style of painting has become well defined. However, he was in the scuffle with Cézanne, Manet, and Monet, when they were getting themselves thrown out the door of the Salon, seeing their canvases saluted by the jeers and insults of their fellow painters, and persevering nevertheless in the struggle which was to lead them to the triumph they are achieving today, despite the peacock screeches of a few little journalists whose hollow brains need noise.

Where is one to find more grandeur, more truth and more poetry than in these beautiful landscapes, so calm and so full of that sort of country religiosity which covers the green fields with a tint of melancholy.

Some landscapes recall certain passages of Victor Hugo's *Les Misérables*. There is the same epic breadth, the same mystery, the same force, simple even in its solemnity.

These two women passing on the little road [*Jallais Hill, Pointoise*, Fig. 5] bordered with hedges, with enclosed fields on either side, and the great cloudy sky rising at the end of the valley, covered with a light vapor inhaled by the sun, is not all this a beautiful chapter from *Les Misérables*? It is the same style. Why then is that which is so exalted, so very justly, in literature not admired in painting? Profound mystery, difficult to solve, a bias that only time will destroy.

Even in painting, there are anomalies of public opinion which are always baffling.

For example, the canvases of Millet are worth their weight in gold. Well! If Pissarro has gone beyond Millet in the study of nature in the country, he nevertheless has many points in common with him; they are in the same furrow. If it is given to Pissarro to go a few steps farther, should we not esteem him the more, rather than cry out against him?

What is not enough noted in the works of the Impressionists, and especially Pissarro, is the variety of tones. Has the public ever noticed how different is the foliage of each tree and how exact is the relationship among these tones? It is, however, a thing worthy of notice, since it is this difference and these relationships which constitute the powerful harmony of the works of Pissarro. And these skies, so light, so marvelous in the background of the landscapes—one doesn't admire them as one should—because one has, upon entering the exhibition, a persistent bias.

Fortunately, Pissarro is above all this whining and complaining. It takes something more than the laughter or the scribbling of critics to shake such a talent, we can be reassured. . . .

This sums up the whole exhibition of the "Impressionists," and, I will add, the only exhibition which contains works of art. Therefore it is on this one that people hasten to vomit insults. They went into ecstasy before big, pretentious and stifled imitations which are intended, according to the painter, to decorate the tomb of music. They swooned before other parodies which decorate the Pantheon. How many articles were written on the famous hemicycle by Paul Delaroche, that horrible thing given as a model for the young people of the School of Fine Arts. They put in the Luxembourg a Françoise de Rimini which would appear honorably on the front of a traveling theater but which is out of place in a museum.

They were convulsed with admiration before that poor Henri Regnault, because he had copied Fortuny. They even erected a monument to him for this act of genius. They have committed the most horrible stupidities for the last half-century. They built the most ridiculous reputations, even though they deny ten years later that they contributed to the success of Delaroche at the same time that they scoffed at Delacroix.

Fear of ridicule is so great in France that people are prudent and they laugh at everything original. And then there are mediocre people everywhere, in France as elsewhere, and here as elsewhere, mediocre people make the law. What does it matter! Like their predecessors of 1830, the "Impressionists", strong in their talent, will fight until they triumph completely, which cannot be long in coming. "The other painters," someone said to me, "come to the exhibit of the 'Impressionists' in order to lighten their palettes." It is absolutely true; each year the painting of the Salon becomes brighter. Tomorrow Manet will be on the jury, and those who still disown him today will be forced to copy him. As for the "Impressionists", they think very little about the Salon, they know that this exhibition will change in vain; it always will retain a mercantile character harmful to an artistic exhibit.

When the public definitely abandons the old sad and bituminous painting for the attractive and gracious painting of the "Impressionists", the critics will have their turn to go into ecstasy, swearing that they always thought these painters had a great deal of talent. And the most prudent will write, as they bequeath their wisdom to posterity: "Shakespeare is a great playwright and Velasquez was a good painter."[2]

[2 The romantic revolution in literature which exploded in 1830 brought a wave of admiration for Shakespeare's plays even though they didn't conform to the rules of the French classical tradition. In the same way, Velasquez (inspirer of Manet) did not follow Poussin's classicism.—ED.]

CLAUDE MONET

Monet's Interview with T. Taboureux
(1880)

[Monet] "My studio! But I've never had a studio, and I don't understand how someone could shut himself up in a room. To draw, yes, to paint, no.

". . . For some time my friends and I had been systematically rejected by the jury previously mentioned. What was to be done? Painting isn't everything, you've got to sell, you've got to live. The dealers didn't want us. Nevertheless, we had to exhibit. But where? . . . Nadar, that wonderful Nadar, who is as good as the day is long, lent us a place to exhibit . . ."

I interrupted:

"You're keeping to yourself now; I don't see your name any more in the Impressionist showings."

"Not at all; I am and I always want to be an Impressionist. I'm the one who coined the word, or at least, through a painting I had exhibited, furnished some reporter from the *Figaro* with the chance to launch this new insult. He had some success, as you know. I say I'm an Impressionist; but I see my colleagues, men and women, only rarely. The little church has become a banal school which opens its doors to every dabbler who appears, so that the public, which began by laughing at what they considered an absurd way of painting, now doesn't stop making fun of an exhibition, should it have the nerve to call itself 'Impressionist,' until they are back out in the street. That's the way it is!"

T. Taboureux, *Monet's Interview with T. Taboureux* [Editor's title]. From "Claude Monet," *La Vie Moderne* (June 12, 1880). Reprinted in Lionello Venturi, *Les Archives de l'Impressionnisme* (Paris, New York: Durand-Ruel, 1939, II) 340; trans. by Lucretia Slaughter Gruber. Reprinted by permission of Durand-Ruel, publisher.

Reminiscences of Monet (1889—1909)
by a Young American Painter,
Lilla Cabot Perry (1927)

In spite of his intense nature and at times rather severe aspect, he was inexpressibly kind to many a struggling young painter. He never took any pupils, but he would have made a most inspiring master if he had been willing to teach. I remember his once saying to me:

"When you go out to paint, try to forget what objects you have before you—a tree, a house, a field, or whatever. Merely think, here is a little square of blue, here an oblong of pink, here a streak of yellow, and paint it just as it looks to you, the exact color and shape, until it gives your own naïve impression of the scene before you."

He said he wished he had been born blind and then had suddenly gained his sight so that he could have begun to paint in this way without knowing what the objects were that he saw before him. He held that the first real look at the *motif* was likely to be the truest and most unprejudiced one, and said that the first painting should cover as much of the canvas as possible, no matter how roughly, so as to determine at the outset the tonality of the whole. As an illustration of this, he brought out a canvas on which he had painted only once; it was covered with strokes about an inch apart and a quarter of an inch thick, out to the very edge of the canvas. Then he took out another on which he had painted twice, the strokes were nearer together and the subject began to emerge more clearly.

Monet's philosophy of painting was to paint what you really see, not what you think you ought to see; not the object isolated as in a test tube, but the object enveloped in sunlight and atmosphere, with the blue dome of Heaven reflected in the shadows.

He said that people reproached him for not finishing his pictures more, but that he carried them as far as he could and stopped only when

Reminiscences of Monet by a Young American Painter [Editor's title]. From Lilla Cabot Perry, "Reminiscences of Claude Monet from 1889 to 1909," in *The American Magazine of Art*, XVIII (March 1927), excerpts from pp. 119–25. Reprinted by permission of the American Federation of Arts.

he found he was no longer strengthening the picture. A few years later he painted his *Island in the Seine* [1897] series. They were painted from a boat, many of them before dawn, which gave them a certain Corot-like effect, Corot having been fond of painting at that hour. As he was showing them to me, I remarked on his having carried them further than many of his pictures, whereupon he referred to this conversation and said again that he always carried them as far as he could. This was an easier subject and simpler lighting than usual, he said, therefore he had been able to carry them further. This series and the *Peupliers* [Poplars, 1891] series also were painted from a broad-bottomed boat fitted up with grooves to hold a number of canvases. He told me that in one of his *Peupliers* [Poplars] the effect lasted only seven minutes, or until the sunlight left a certain leaf, when he took out the next canvas and worked on that. He always insisted on the great importance of a painter noticing when the effect changed, so as to get a true impression of a certain aspect of nature and not a composite picture, as too many paintings were, and are. He admitted that it was difficult to stop in time because one got carried away, and then added: "J'ai cette force-là, c'est la seule force que j'ai!"*

Monet's Letter to Paul Durand-Ruel (1905)

As to the colors I use, is it so interesting to talk about it? I don't think so, provided that one can paint better and brighter with an entirely different palette. . . .

In short, I use silver white, cadmium yellow, vermilion, dark madder, cobalt blue, emerald green, and that is all. . . .

* [Editor's note: The French, which appeared in Perry's text, can be translated as: "I have that strength; it is the only strength *I* have!"]

Monet's Letter to Paul Durand-Ruel (1905) [Editor's title]. From Lionello Venturi, *Les Archives de l'Impressionnisme* (Paris, New York: Durand-Ruel, 1939); I, 404. Reprinted by permission of Durand-Ruel, publisher. [Claude Monet wrote this letter to his art dealer, Paul Durand-Ruel, on June 3, 1905.—ED.]

Monet's Letters to Gustave Geffroy (1890)

JUNE 22, 1890

I have once more taken up things that can't be done: water with grasses weaving on the bottom. . . . It's wonderful to see, but it's maddening to try to paint it. But I'm always tackling that sort of thing!

JULY 21, 1890

. . . I am very depressed and deeply disgusted with painting. It is really a continual torture. Don't expect to see anything new; the little I was able to do is destroyed, scraped or torn apart. You can't imagine the dreadful weather we have had without interruption for two months. It's enough to drive one raving mad, when one tries to capture the weather, the atmosphere, the surroundings.

And with all these troubles, here I am stupidly afflicted with rheumatism. I am paying for my sessions out in the rain and snow, and it makes me unhappy to think that I will have to give up braving the weather and working out-of-doors, except when it is fine. What a nuisance life is!

Well, enough complaints; come see me as soon as possible. Best wishes to you.

Monet's Letters to Gustave Geffroy (1890) [Editor's title]. From *Claude Monet: Sa Vie, son temps, son oeuvre* by Gustave Geffroy (Monet's letters to his friend and biographer, Gustave Geffroy, 1855–1926). Paris: Les Editions G. Crès et Cie., 1922, pp. 188–89. English trans. from Linda Nochlin, *Impressionism and Post-Impressionism, 1874–1904: Sources and Documents* (Englewood Cliffs, N.J.: Prentice-Hall, Inc., 1966), p. 34. Reprinted by permission of Prentice-Hall, Inc. [As Nochlin points out, the first two letters are concerned with the series of waterlilies upon which the artist was then working at his Winter Garden at Giverny. The third letter is about his fifteen-painting series of haystacks [see Fig. 6], which he exhibited at Durand-Ruel's gallery in 1891.—ED.]

OCTOBER 7, 1890

. . . I am working away: I am set on a series of different effects
[see Fig. 6] (haystacks), but at this time of year, the sun goes down so
quickly that I cannot follow it. . . . I am working at a desperately slow
pace, but the further I go, the more I see that I have to work a lot in
order to manage to convey what I am seeking: "instantaneity," above all,
the envelopment, the same light spread over everywhere; and more than
ever, easy things achieved at one stroke disgust me. Finally, I am more
and more maddened by the need to convey what I experience and I vow
to go on living not too much as an invalid, because it seems to me that
I am making progress.

Monet's Letters to Gustave Geffroy
(1909; ca. 1915)

THE NYMPHÉAS [WATERLILIES] [1]

[1909]

I was tempted to use the theme of the *Nymphéas* for the decoration
of a salon: carried along the walls, its unity enfolding all the panels, it
was to produce the illusion of an endless whole, a wave without horizon
and without shore; nerves strained by work would relax in its presence,
following the reposing example of its stagnant waters, and for him who
would live in it, this room would offer an asylum of peaceful meditation
in the midst of a flowering aquarium . . .

I have painted for half a century and will soon have passed my
sixty-ninth year, but, far from decreasing, my sensitivity has sharpened

Monet's Letters to Gustave Geffroy (1909; ca. 1915) [Editor's title]. From *Artists on
Art: From the XIV to the XX Century,* compiled and edited by Robert Goldwater and
Marco Treves (p. 313, 315). Copyright 1945 by Pantheon Books, Inc. and renewed
1973 by Robert Goldwater and Marco Treves. Reprinted by permission of Pantheon
Books, a Division of Random House, Inc.

[1 Monet worked on the waterlily (Nymphéas) theme from the 1890s until his death.
In May 1909 he exhibited 48 waterlily paintings at the Durand-Ruel galleries. His
water landscapes at the Orangerie in Paris and at the Mueum of Modern Art in
New York are late works from around 1920.—ED.]

with age. As long as constant commerce with the outside world can maintain the ardor of my curiosity, and my hand remains the prompt and faithful servant of my perception, I have nothing to fear from old age. I have no other wish than a close fusion with nature, and I desire no other fate than (according to Goethe's precept) to have worked and lived in harmony with her laws. Beside her grandeur, her power, and her immortality, the human creature seems but a miserable atom.

TO PAINT . . . PAINT [*Ca. 1915*]

[I would advise young artists] to paint as they can, as long as they can, without being afraid of painting badly . . . If their painting doesn't improve by itself, it means that nothing can be done—and I wouldn't do anything! . . .

No one is an artist unless he carries his picture in his head before painting it, and is sure of his method and composition. Techniques vary, art stays the same: it is a transposition of nature at once forceful and sensitive. But the new movements, in the full tide of reaction against what they call "the inconstancy of the impressionist image," deny all that in order to construct their doctrine and preach the solidity of unified volume.

Pictures aren't made out of doctrines. Since the appearance of impressionism, the official salons, which used to be brown, have become blue, green, and red . . . But peppermint or chocolate, they are still confections.

AUGUSTE RENOIR

Renoir's Proposal:
"The Society of the Irregularists" (1884)

In all the controversies matters of art stir up daily, the chief point to which we are going to call attention is generally forgotten. We mean irregularity.

Nature abhors a vacuum, say the physicists; they might complete their axiom by adding that she abhors regularity no less.

Observers actually know that despite the apparent simplicity of the laws governing their formation, the works of nature are infinitely varied, from the most important to the least, no matter what their species or family. The two eyes of the most beautiful face will always be slightly unlike; no nose is placed exactly above the center of the mouth; the quarters of an orange, the leaves of a tree, the petals of a flower are never identical; it thus seems that every kind of beauty draws its charm from this diversity.

If one looks at the most famous plastic or architectural works from this viewpoint, one easily sees that the great artists who created them, careful to proceed in the same way as that nature whose respectful pupils they have always remained, took great care not to transgress her fundamental law of irregularity. One realizes that even works based on geometric principles, like St. Mark's,[1] the little house of Francis I in the

Pierre Auguste Renoir, "La Société des irrégularistes." From Lionello Venturi, *Les Archives de l'Impressionnisme* (Paris, New York: Durand-Ruel, 1939); I, 127–29. English trans. from Linda Nochlin, *Impressionism and Post-Impressionism, 1874–1904: Sources and Documents* (Englewood Cliffs, N.J.: Prentice-Hall, Inc., 1966), pp. 45–47. Reprinted by permission of Prentice-Hall, Inc., and Durand-Ruel. [Renoir sent a copy of his platform along with a letter to Paul Durand-Ruel in May 1884. —ED.]

[1] St. Mark's Cathedral in Venice. [Nochlin, 1966.—ED.]

Cours La Reine . . . as well as all the so-called Gothic churches . . . have not a single perfectly straight line, and that the round, square, or oval forms which are found there and which it would have been extremely easy to make exact, never are exact. One can thus state, without fear of being wrong, that every truly artistic production has been conceived and executed according to the principle of irregularity; in short, to use a neologism which expresses our thought more completely, it is always the work of an irregularist.

At a time when our French art, until the beginning of this century still so full of penetrating charm and exquisite imagination, is about to perish of regularity and dryness, when the mania for false perfection makes engineers diagram the ideal, we think that it is useful to react against the fatal doctrines which threaten to annihilate it, and that it is the duty of all men of sensitivity and taste to gather together without delay, no matter how repugnant they may otherwise find combat and protest.

An association is therefore necessary.

Although I do not want to formulate a final platform here, a few projected ideas are briefly submitted:

The association will be called the society of irregularists, which explains the general ideas of the founders.

Its aim will be to organize as quickly as possible exhibitions of all artists, painters, decorators, architects, goldsmiths, embroiderers, etc., who have irregularity as their aesthetic principle.

Among other conditions for admission, the rules stipulate precisely, as far as architecture is concerned: All ornaments must be derived from nature, with no motif—flower, leaf, figure, etc., etc.—being exactly repeated; even the least important outlines must be executed by hand without the aid of precision instruments; as far as the plastic arts are concerned, the goldsmiths and others . . . will have to exhibit alongside of their finished works the drawings or paintings from nature used to create them.

No work containing copies of details or of a whole taken from other works will be accepted.

A complete grammar of art, dealing with the aesthetic principles of the organization, setting forth its tendencies, and demonstrating its usefulness, will be published by the founding committee with the collaboration of the members who offer their services.

Photographs of celebrated monuments or decorative works which bring forth evidence of the principle of irregularism will be acquired at the expense of the society and placed in a special room for the public.

Renoir's Interview with C. L. de Moncade
(1904)

[MONCADE]: *One of the big attractions, if not the biggest, of the autumn Salon is certainly the exhibition of the works of the painter Renoir, the Impressionist master.*[1] *According to certain of our colleagues, the person who is generally portrayed as a fierce independent had always refused to have any of his canvases appear in any Salon.*

Let's see how this version of the story is commented upon by the artist.

I have been to see the painter Renoir, and I confess that my first impression was one of complete stupefaction. I thought I was going to meet an ardent, impetuous man, pacing feverishly the width and length of his studio, delivering indictments, demolishing established reputations, vindictive, if not to say full of hatred, in short, an intransigent revolutionary; and he is a sweet old man, with a long white beard, a thin face, very calm, very tranquil, with a husky voice, a good-hearted manner, who welcomes me with the most amiable cordiality.

[RENOIR]: It's a very big mistake . . . to think that I am an adversary of exhibitions. On the contrary, no one is more a proponent of them than I am, for painting, in my opinion, is meant to be shown. Now, if you are astonished not to have seen my canvases in the Salons and if you want to find out why, the reason is much simpler. My paintings were rejected. The jury generally welcomed them—welcomed them in a manner of speaking—with a burst of laughter. And when by chance these gentlemen found themselves one day in a less hilarious mood and decided to accept one, my poor canvas was placed under the moulding or under

Renoir's Interview with C. L. de Moncade [Editor's title]. From C.L. de Moncade, "Le peintre Renoir et le Salon d'Automne" in *La Liberté*, X: 13, n.p., Oct. 15, 1904; trans by Lucretia Slaughter Gruber.

[1 The Second Salon d'Automne of 1904 had a "Renoir room," with 35 of the artist's works.—ED.]

the awning, so that it would go as unnoticed as possible. I estimate that I sent in canvases for about twenty years; about ten times I was mercilessly rejected; the other ten times about one out of three were taken, and placed as I just told you.

[MONCADE]: *And as I remain a bit stunned:*

[RENOIR]: You see, . . . my existence has been exactly the opposite of what it should have been, and it's certainly the most comical thing in the world that I am depicted as a revolutionary, because I am the worst old fogey there is among the painters.

Moreover, the misunderstanding began when I was at the École des Beaux-Arts.[2] I was an extremely hard-working student; I ground away at academic painting; I studied the classics, but I did not obtain the least honorable mention, and my professors were unanimous in finding my painting execrable. I began sending canvases to the exhibitions in '63, when I was rejected, '64, rejected, '65 rejected, etc., etc.[3] Let's not be unjust! I did have one canvas, just one to be exact, but indeed a canvas which was very well-placed. It was, it's true, the portrait of Madame Charpentier [*Madame Charpentier and Her Children*, 1878; see Fig. 7]. Madame Charpentier wanted to be in a good position, and Madame Charpentier knew the members of the jury, whom she lobbied vigorously. This did not prevent what happened the day when I sent the little Mendès,[4] they were put under the awning where no one saw them.

All these rejections or these bad placements were not helping my paintings to sell, however, and it was necessary to earn enough money to buy food, which was difficult.

In 1874, we founded, Pissaro [*sic*], Monet, Degas and I, the Salon of the Impressionists. We had accepted the participation of any painters who wanted to join us. There were twenty-five in all, for it was surely necessary to fill the walls. Oh! It was a great success! The public came alright, but after having made a tour of all the rooms, screeching like peacocks, they would demand their twenty sous back.

I don't know what would have become of us if Durand-Ruel, who was convinced that we would be appreciated one day, hadn't kept us from dying of hunger.

He wasn't very rich himself at that time, but he did all that he

[2 Renoir entere dthe École des Beaux Arts in 1862.–ED.]
[3 Renoir's recollections aren't entirely in agreement with the facts. Here is a list of the Salons where Renoir's works were accepted (A) and a list of the Salons where Renoir's works were rejected (R): 1863, R; 1864, A; 1865, A; 1866, A, R; 1867, R; 1868, A; 1869, A; 1870, A; 1872, R; 1873, R; 1874, R; 1875, R; 1878, A; 1879, A; 1880, A; 1881, A; 1882, A; 1883, A, R; 1890, R.–ED.]
[4 In 1890 Renoir exhibited *The Daughters of Catulle Mendès at the Salon*.–ED.]

could and we owe him a great deal of gratitude. I was painting canvases then that I was selling at from twenty-five to a hundred francs. One of them, *The Dancer* [see Fig. 8], was on sale at the Hôtel Drouot. I myself pushed the price up to 120 francs, but since I didn't have the six louis needed to take it, one of my friends loaned them to me, and I let him have the canvas. Today it is the property of Durand-Ruel, who has refused a hundred thousand francs for it. It's strange, isn't it?

[MONCADE]: *And to what do you attribute this reversal on the part of the public?*

[RENOIR]: First of all, everyone does not appreciate us, and if a few patrons came to our aid, it is much more because of the violence with which the public had attacked us than because of their admiration for our works. Here is proof of it: Berthe Morizot [sic], Sisley, Monet and I had put our canvases up for sale. This sale was a disaster. The fine arts students even paraded by in single file to demonstrate against our painting, and the intervention of the city police was necessary. From that day on, we had our defenders and, even better, our patrons. We still had against us, it's true, the official painters.

[MONCADE]: *Not one of them was won over?*

[RENOIR]: Not one. Think of it! They're really big shots! I remember the day when Pillet-Will was devastated, because he was told that the paintings he had commissioned were bad. "It's very annoying," he said, "not being an expert in art, I commissioned those paintings from the most recognized painters I could find. These painters, with all their decorations and awards, asked me a pretty price, which seemed to me to be one more guarantee. And now today people come and tell me that my paintings are worthless. What do you want me to have done?" Believe me, these paintings were not, moreover, any worse than others.

[MONCADE]: *But the secession of the National group from the Society of French Artists must have opened new doors for you?*

[RENOIR]: The creation of the National simply proved to me that people are unjust in reproaching painters for not agreeing with each other. There was, in fact, between the two Societies, French Artists and the National, perfect unanimity in finding my painting detestable. I must nevertheless concede that several of the dissidents of the French Artists did come to me to ask my advice on the organization of their new society, but once it was established, they forgot me totally.

[MONCADE]: *And now, will you exhibit regularly?*

[RENOIR]: I really don't know. To tell you the truth, I'm not the one who's exhibiting, it's Durand-Ruel who asked me to permit him to

send several of my old canvases. Personally I would have preferred to exhibit some new canvases, although, fundamentally, I'm a little tired of sending things. And then, what do you want me to say? This autumn Salon seems to me fairly useless. Certainly I'm in favor of Salons, they're an excellent lesson in painting. One thinks one has a marvel which is going to bowl everyone over. In the studio, it's enormously effective, and your friends come and pronounce it a masterpiece. Once in the Salon among the other canvases, it's not at all the same thing any more, and it doesn't bowl anyone over. So it's also a lesson in modesty. But there really are too many exhibitions and it seems to me quite sufficient to bother the public once a year.

[MONCADE]: *There is my conversation with the painter Renoir. What I am unfortunately unable to reproduce here is the charming good-heartedness with which all these things were told to me.*

Renoir's Interview with Walter Pach (1912)

I arrange my subject as I want it, then go ahead and paint it, like a child. I want a red to be sonorous, to sound, like a bell; if it doesn't turn out that way, I put more reds and other colors till I get it. I am no cleverer than that. I have no rules and no methods; anyone can look over my materials or watch how I paint—he will see that I have no secrets. I look at a nude, there are myriads of tiny tints. I must find the ones that will make the flesh on my canvas live and quiver. Nowadays they want to explain everything. But if they could explain a picture it wouldn't be art. Shall I tell you what I think are the two qualities of art? It must be indescribable and inimitable.

Renoir's Interview with Walter Pach [Editor's title]. From Walter Pach, "Pierre Auguste Renoir" in *Scribner's Magazine* (May, 1912), p. 610. Reprinted by permission of the publisher.

CAMILLE PISSARRO

Pissarro's Advice to a Young Painter,
Louis Le Bail (1896–1897)

Look for the kind of nature that suits your temperament. The motif should be observed more for shape and color than for drawing. There is no need to tighten the form which can be obtained without that. Precise drawing is dry and hampers the impression of the whole; it destroys all sensations. Do not define too closely the outlines of things; it is the brush stroke of the right value and color which should produce the drawing. In a mass, the greatest difficulty is not to give the contour in detail, but to paint what is within. Paint the essential character of things, try to convey it by any means whatsoever, without bothering about technique. When painting, make a choice of subject, see what is lying at the right and at the left, then work on everything simultaneously. Don't work bit by bit, but paint everything at once by placing tones everywhere, with brush strokes of the right color and value, while noticing what is alongside. Use small brush strokes and try to put down your perceptions immediately. The eye should not be fixed on one point, but should take in everything, while observing the reflections which the colors produce on their surroundings. Work at the same time upon sky, water, branches, ground, keeping everything going on an equal basis and unceasingly rework until you have got it. Cover the canvas at the first go, then work at it until you can see nothing more to add. Observe the aerial perspective well, from the foreground to the horizon, the reflections of sky, of foliage. Don't be afraid of putting on color, refine the work little by little. Don't proceed according to rules and principles, but paint what you observe

Pissarro's Advice to a Young Painter, Louis Le Bail [Editor's title]. From John Rewald, *The History of Impressionism* (4th ed. rev., 1973), p. 456–58. 1st ed. © 1946, renewed 1974. All rights reserved by the Museum of Modern Art, New York. Reprinted by permission of the author and publisher. [This excerpt is from the notes of the painter Louis Le Bail.—ED.]

and feel. Paint generously and unhesitatingly, for it is best not to lose the first impression. Don't be timid in front of nature: one must be bold, at the risk of being deceived and making mistakes. One must have only one master—nature; she is the one always to be consulted.[1]

Pissarro's Talk with Henri Matisse
(late 1890s)

PISSARRO: Cézanne is not an impressionist because all his life he has been painting the same picture. [Matisse here explained that Pissarro was referring to the "bathers" picture which Cézanne repeated so obsessively, pursuing and developing the same qualities of composition, light, etc.] He has never painted sunlight, he always paints grey weather.

MATISSE: *What is an impressionist?*

PISSARRO: An impressionist is a painter who never paints the same picture, who always paints a new picture.

MATISSE: *Who is a typical impressionist?*

PISSARRO: Sisley.

Then, thinking of Pissarro's. words, Matisse added: "A Cézanne is a moment of the artist while a Sisley is a moment of nature."

Pissaro's Talk with Henri Matissc [Editor's title]. From Alfred H. Barr, Jr., *Matisse: His Art and His Public*, p. 38. © 1951 by The Museum of Modern Art, New York. All rights reserved. Reprinted by permission. Dictated September 9, 1950, by Henri Matisse, while answering the author's Questionnaire IV, in the archives of The Museum of Modern Art.

[1] Rewald, *History of Impressionism*, p. 479, n. 31: ". . . At about the same time Louis Le Bail also met Monet, who told him: 'One ought to be daring in the face of nature and never be afraid of painting badly nor of doing over the work with which one is not satisfied, even if it means ruining it. If you don't dare while you are young, what are you going to do later?' "

Pissarro's Letters to His Son, Lucien
(1898, 1900, 1903)

ROUEN, AUGUST 19, 1898

My dear Lucien,[1]

. . . I do not doubt that Morris'[2] books are as beautiful as Gothic art, but it must not be forgotten that the Gothic artists were *inventors* and that we have to perform, not better, which is impossible, but differently and following our own bent. The results will not be immediately evident. Yes, you are right, it is not necessary to be Gothic, but are you doing everything possible not to be? With this in view you would have to disregard friend Ricketts, who is of course a charming man, but who from the point of view of *art* seems to stray from the true direction, which is the return to *nature*. For we have to approach nature sincerely, with our own modern sensibilities; imitation or invention is something else again. We have today a general concept inherited from our great modern painters, hence we have a tradition of modern art, and I am for following this tradition while we inflect it in terms of our individual points of view. Look at Degas, Manet, Monet, who are close to us, and at our elders, David, Ingres, Delacroix, Courbet, Corot, the great Corot, did they leave us nothing? Observe that it is a grave error to believe that all mediums of art are not closely tied to their time. Well, then, is this the path of Ricketts? No. It has been my view for a long time that it is not a question of pretty *Italian elegance,* but of using our eyes a bit and disregarding what is in style. Reflect in all sincerity. . . .

John Rewald, ed. (with the assistance of Lucien Pissarro), *Camille Pissarro: Letters to His Son Lucien,* trans. Lionel Abel; pp. 329, 340–41, 355–56. Copyright 1943 by Pantheon Books, Inc. Reprinted by permission of Pantheon Books, a Division of Random House, Inc. [I would also like to thank John Rewald for his kind permission to reprint his work.–ED.]

[1] Lucien Pissarro, the eldest of Camille Pissarro's seven children, had gone to England in 1882 to practice his art. There he became associated with William Morris's arts and crafts movement, which was part of the general reaction against naturalism that began about 1885. In this letter Pissarro strongly opposes his son's movement away from naturalism.–ED.]

[2] William Morris (1834–96) and Charles Ricketts (1866–1931) were English book publishers. Morris founded the Kelmscott Press in 1890. Ricketts founded the Vale Press in 1896 where he was designer and editor. Lucien Pissarro founded the Eragny Press in 1896.–ED.]

PARIS, APRIL 26, 1900

My dear Lucien,

Decidedly, we no longer understand each other. What you tell me about the modern movement, commercialism, etc., has no relation to our conception of art, here at least. You know perfectly well that just as William Morris had some influence on commercial art in England, so here the real artists who seek have had and will have some effect on it. That we cannot prevent stupid vulgarization, even such things as the making of chromos for grocers from figures of Corot . . . is absolutely true. Yes, I know perfectly well that the Greek and the primitive are reactions against commercialism. But right there lies the error. Commercialism can vulgarize these as easily as any other style, hence it's useless. Wouldn't it be better to soak yourself in nature? I don't hold the view that we have been fooling ourselves and ought rightly to worship the steam engine with the great majority. No, a thousand times no! We are here to show the way! According to you salvation lies with the primitives, the Italians. According to me this is incorrect. Salvation lies in nature, now more than ever.

Let us pursue what we believe is good, soon it will be evident who is right. In short, money is an empty thing; let us earn some since we have to, but without departing from our roles!

PARIS, MAY 8, 1903

My dear Lucien,

This Mr. Dewhurst [3] understands nothing of the impressionist movement, he sees only a mode of execution and he confuses the names of the artists, he considers Jongkind inferior to Boudin, so much the worse for him! He says that before going to London [in 1870] we [Monet and Pissarro] had no conception of light. The fact is we have studies which

[3] Wynford Dewhurst was then preparing a work which appeared in 1904 under the title: *Impressionist Painting, Its Genesis and Development*. Pissarro himself supplied the author with certain data, and one of his letters, in which he tells of his stay in England in 1870, is quoted by Dewhurst: "In 1870 I found myself in London with Monet, and we met Daubigny and Bonvin. Monet and I were very enthusiastic over the London landscapes. Monet worked in the parks, whilst I, living at lower Norwood, at that time a charming suburb, studied the effects of fog, snow and springtime. We worked from Nature and later on Monet painted in London some superb studies of mist. We also visited the museums. The watercolors and paintings of Turner and of Constable, the canvases of Old Crome, have certainly had influence upon us. We admired Gainsborough, Lawrence, Reynolds, etc., but we were struck chiefly by the landscape-painters, who shared more in our aim with regard to 'plein air,' light, and fugitive effects. . . ."

prove the contrary. He omits the influence which Claude Lorrain, Corot, the whole eighteenth century and Chardin especially exerted on us. But what he has no suspicion of, is that Turner and Constable, while they taught us something, showed us in their works that they had no understanding of the *analysis of shadow*, which in Turner's painting is simply used as an effect, a mere absence of light. As far as tone division is concerned, Turner proved the value of this as a method, among methods, although he did not apply it correctly and naturally; besides we derived from the eighteenth century. It seems to me that Turner, too, looked at the works of Claude Lorrain, and if I am not mistaken one of Turner's paintings, *Sunset*, hangs next to one of Claude![4] Symbolic, isn't it? Mr. Dewhurst has his nerve.

[4] At Turner's request, one of his landscapes was hung next to a landscape of Claude Lorrain in the National Gallery in London.

PART TWO / Contemporary Writers' Viewpoints on Impressionism (1868-1896)

Émile Zola (1868)

We have in Monet a marine painter of the first rank. He interprets the genre in his own personal way, however, and here again I find a profound involvement with the realities present. This year only one of his paintings—*Boat Putting out from the Pier at Le Havre*—has been accepted. [See Fig. 9 for a similar painting.]

What struck me most about this work was the utterly free and even crude quality of the brush strokes. There is an unsavoriness to the water, a ruthlessness in the way the horizon stretches itself out; you feel that the high sea must be somewhere near.

Monet is one of the very few painters who understand how to paint water, without the usual simplistic transparency or deceptive reflections. His water is alive, and deep, and very convincing. It laps against the small boats in little greenish wavelets, interspersed with glimmers of white; it stretches away in gray-green marshes ruffled by the sudden passage of air; it elongates the masts by shattering their reflections upon its surface; and here and there pallid and lifeless hues become suddenly alight with intense translucence.

The other painting, refused by the jury, which represents the pier at Le Havre, is perhaps even more characteristic. I have seen very original works by Claude Monet which are most certainly of his very flesh and blood. Last year a figure painting [*Women in the Garden;* Louvre]— women in light-colored dresses—was refused. Nothing could be more bizarre in effect. An artist must be singularly at one with his own time in order to risk a comparable feat: the sharp contrast of sunlight and shadow upon fabrics.

What is distinctive about his talent is an astonishing ease of execution, a very versatile intelligence, and an alert, quick comprehension of any subject whatsoever. I am not the least bit anxious on his behalf. He will win over the crowd when he is ready.

From "Mon Salon (1868)," by Émile Zola, in *Salons*. Geneva, 1959, p. 131ff. English trans. by Gerd Muehsam, *French Painters and Paintings from the Fourteenth Century to Post-Impressionism: A Library of Art Criticism*. (New York: Frederick Ungar Pub., 1970) p. 497. Reprinted by permission of the publisher.

Henry James (1876)

An exhibition for which I may at least claim that it can give rise (at any rate in my own mind) to no dangerous perversities of taste is that of the little group of the Irreconcilables—otherwise known as the "Impressionists" in painting. It is being held during the present month at Durand-Ruel's, and I have found it decidedly interesting. But the effect of it was to make me think better than ever of all the good old rules which decree that beauty is beauty and ugliness ugliness, and warn us off from the sophistications of satiety. The young contributors to the exhibition of which I speak are partisans of unadorned reality and absolute foes to arrangement, embellishment, selection, to the artist's allowing himself, as he has hitherto, since art began, found his best account in doing, to be preoccupied with the idea of the beautiful. The beautiful, to them, is what the supernatural is to the Positivists—a metaphysical notion, which can only get one into a muddle and is to be severely let alone. Let it alone, they say, and it will come at its own pleasure; the painter's proper field is simply the actual, and to give a vivid impression of how a thing happens to look, at a particular moment, is the essence of his mission. This attitude has something in common with that of the English Pre-Raphaelites, twenty years ago,[1] but this little band is on all grounds less interesting than the group out of which Millais and Holman Hunt[2] rose into fame. None of its members show signs of possessing first rate talent, and indeed the "Impressionist" doc-

From "Parisian Festivity" by Henry James, in *The New York Tribune*, May 13, 1876. Reprinted as "The Impressionists, 1876" in Henry James, *The Painter's Eye*. Cambridge: Harvard University Press, 1956, pp. 114–15.

[1] In the summer of 1856 James saw "the first fresh fruits of the Pre-Raphaelite Effloresence", he tells us in *A Small Boy and Others*. "The very word Pre-Raphaelite wore for us that intensity of meaning, not less than of mystery, that thrills us in its perfection but for one season, the prime hour of first initiations."

[2 Sir John Everett Millais (1829–96) and William Holman Hunt (1827–1910) were (along with Dante Gabriel Rossetti (1828–82) founders of the PRB (Pre-Raphaelite Brotherhood).—ED.]

trines strike me as incompatible, in an artist's mind, with the existence of first-rate talent. To embrace them you must be provided with a plentiful absence of imagination. But the divergence in method between the English Pre-Raphaelites and this little group is especially striking, and very characteristic of the moral differences of the French and English races. When the English realists "went in", as the phrase is, for hard truth and stern fact, an irresistible instinct of righteousness caused them to try and purchase forgiveness for their infidelity to the old more or less moral properties and conventionalities, by an exquisite, patient, virtuous manipulation—by being above all things laborious. But the Impressionists, who, I think, are more consistent, abjure virtue altogether, and declare that a subject which has been crudely chosen shall be loosely treated. They send detail to the dogs and concentrate themselves on general expression. Some of their generalizations of expression are in a high degree curious. The Englishmen, in a word, were pedants, and the Frenchmen are cynics.

Jules Laforgue (1883)

Physiological origin of Impressionism: The prejudice of traditional line. It is clear that if pictorial work springs from the brain, the soul, it does so only by means of the eye, the eye being basically similar to the ear in music; the Impressionist is therefore a modernist painter endowed with an uncommon sensibility of the eye. He is one who, forgetting the pictures amassed through centuries in museums, forgetting his optical art school training—line, perspective, color—by dint of living and seeing frankly and primitively in the bright open air, that is, outside his poorly

From "Impressionism: The Eye and the Poet," by Jules Laforgue; trans. by William Jay Smith. From *ARTnews*, LV (May 1956), 43, 45. © ARTnews, May 1956. [Laforgue's essay was written for a small exhibit that included works by Pissarro, Degas, and Renoir, that took place at the Gurlitt Gallery in Berlin in October, 1883. Laforgue had planned to have this essay translated and published in a German paper; however, since he died four years later, this was not accomplished. The essay was later published as "L'Impressionnisme," in *Mélanges posthumes*, in Jules Laforgue, *Oeuvres complètes*, 4th ed. (Paris: Mercure de France, 1902–03), III, pp. 133–45. (This information from *ARTnews*.)–ED.]

lighted studio, whether the city street, the country, or the interiors of houses, has succeeded in remaking for himself a natural eye, and in seeing naturally and painting as simply as he sees. . . .

• • •

Definition of plein-air painting. Open air, the formula applicable first and foremost to the landscape painters of the Barbizon School (the name is taken from the village near the forest of Fontainebleau) does not mean exactly what it says. This open air concept governs the entire work of Impressionist painters, and means the painting of beings and things in their appropriate atmosphere: out-of-door scenes, simple interiors or ornate drawing rooms seen by candlelight, streets, gas-lit corridors, factories, market places, hospitals, etc.

Explanation of apparent Impressionist exaggerations. The ordinary eye of the public and of the non-artistic critic, trained to see reality in the harmonies fixed and established for it by its host of mediocre painters—this eye, as eye, cannot stand up to the keen eye of the artist. The latter, being more sensitive to luminous variation, naturally records on canvas the relationship between rare, unexpected and unknown subtleties of luminous variation. The blind, of course, will cry out against willful eccentricity. But even if one were to make allowance for an eye bewildered and exasperated by the haste of these impressionistic notes taken in the heat of sensory intoxication, the language of the palette with respect to reality would still be a conventional tongue susceptible to new seasoning. And is not this new seasoning more artistic, more alive, and hence more fecund for the future than the same old sad academic recipes?

Program for future painters. Some of the liveliest, most daring painters one has ever known, and also the most sincere, living as they do in the midst of mockery and indifference, that is, almost in poverty, with attention only from a small section of the press, are today demanding that the State have nothing to do with art, that the School of Rome (the Villa Medici) be sold, the Institute be closed, that there be no more medals or rewards, and that artists be allowed to live in that anarchy which is life, which means everyone left to his own resources, and not hampered or destroyed by academic training which feeds on the past. No more official beauty; the public, unaided, will learn to see for itself and will be attracted naturally to those painters whom they find modern and vital. No more official salons and medals than there are for writers. Like writers working in solitude and seeking to have their productions displayed in their publishers' windows, painters will work in their own way and seek to have their paintings hung in galleries. Galleries will be their salons.

Guy de Maupassant (1886)

Last year . . . [at Étretat] [see Fig. 10] I often followed Claude Monet in his search of impressions. To tell the truth he was no longer a painter but a hunter. He used to walk along followed by children who carried five or six of his canvases. Each of these canvases represented the same motif at different times of the day and with different effects. He took them up in turn and put them down according to the changes in the sky. And before his subject the painter lay in wait for the sun and shadows, capturing in a few brush strokes the falling ray or the passing cloud. Scorning falseness and convention, he put them rapidly on his canvas.

It was in this way that I saw him snatch a glittering shower of light on the white cliff and render it as a stream of yellow tones, which depicted amazingly the surprising and fleeting effect of this elusive and dazzling brilliance.

At another time he captured, at the height of its intensity, a rainstorm beating down on the sea, tossing it on his canvas; and, indeed, it was the rain itself he had thus painted.

From "La Vie d'un paysagiste (1886)" [The Life of a Landscape Painter] by Guy de Maupassant, in *Études, chroniques et correspondance* (Paris, 1938), p. 167ff. English trans. from Gerd Muehsam, *French Painters and Paintings from the Fourteenth Century to Post-Impressionism: A Library of Art Criticism* (New York: Frederick Ungar Pub. Co., Inc., 1970), p. 500. Reprinted by permission of Frederick Ungar Pub. Co.

Oscar Wilde (1889)

Where, if not from the Impressionists, do we get those wonderful brown fogs that come creeping down our streets, blurring the gas-lamps and changing the houses into monstrous shadows? To whom, if not to them and their master, do we owe the lovely silver mists that brood over our river, and turn to faint forms of fading grace curved bridge and swaying barge? The extraordinary change that has taken place in the climate of London during the last ten years is entirely due to a particular school of art. You smile. Consider the matter from a scientific or a metaphysical point of view, and you will find that I am right. For what is Nature? Nature is no great mother who has borne us. She is our creation. It is in our brain that she quickens to life. Things are because we see them, and what we see, and how we see it, depends on the arts that have influenced us. To look at a thing is very different from seeing a thing. One does not see anything until one sees its beauty. Then, and then only, does it come into existence. At present, people see fogs, not because there are fogs, but because poets and painters have taught them the mysterious loveliness of such effects. There may have been fogs for centuries in London. I dare say there were. But no one saw them, and so we do not know anything about them. They did not exist until Art had invented them. Now, it must be admitted, fogs are carried to excess. They have become the mere mannerism of a clique, and the exaggerated realism of their method gives dull people bronchitis. Where the cultured catch an effect, the uncultured catch cold. And so, let us be humane, and invite Art to turn her wonderful eyes elsewhere. She has done so already, indeed. That white quivering sunlight that one sees now in France, with its strange blotches of mauve, and its restless violet shadows, is her latest fancy and, on the whole, Nature reproduces it quite admirably. Where she used to give us Corots and Daubignys, she

From "The Influence of Impressionism upon the Climate" by Oscar Wilde, in *The Decay of Lying* (1889). Quoted in Eugen Weber, *Paths to the Present: Aspects of European Thought from Romanticism to Existentialism* (New York and Toronto: Dodd, Mead & Company, Inc., 1964), pp. 187–88.

gives us now exquisite Monets and entrancing Pissarros. Indeed there are moments, rare, it is true, but still to be observed from time to time, when Nature becomes absolutely modern. Of course, she is not always to be relied upon. The fact is that she is in this unfortunate position. Art creates an incomparable and unique effect, and, having done so, passes on to other things. Nature, upon the other hand, forgetting that imitation can be made the sincerest form of insult, keeps on repeating this effect until we all become absolutely wearied of it. Nobody of any real culture, for instance, ever talks nowadays about the beauty of a sunset. Sunsets are quite old-fashioned. They belong to the time when Turner was the last note in Art. To admire them is a distinct sign of provincialism of temperament. Upon the other hand they go on.

JOURNALISTS (1876-1883)
ON "VIOLETTOMANIA"

Oscar Reutersvärd (1950)

THE SPECTRUM

Infra red	RED ORANGE YELLOW GREEN BLUE INDIGO VIOLET	Ultra violet

Present-day writers have often referred with indignation mingled with astonishment to the horror with which the painting of the impressonists was received in the 70's. With this attitude, however, they have obscured or belittled the significance of what actually occurred at that time—I refer to the open conflict between two widely different conceptions of art. The impressionists surprised the art-public of the period with a mode of expression that was fundamentally new and that disregarded most of the traditional requirements of art. It is therefore unreasonable for the historian of art to expect an immediate understanding from the contemporaries of the first impressionists for this new, untried school of painters. It is more instructive to try dispassionately to follow the critics' attempts to cope with the difficulties, and to see how, in the absence of relevant perspectives for judgment, they were often led astray. Many of the specifics of impressionism, though unproblematical for our time, fell outside the contemporary limits of art-understanding, and when judged by the criteria of the period were sheer absurdities.

I will here draw attention to only one of these new features, the

Journalists (1876–1883) on "Violettomania" [Editor's title]. From Oscar Reutersvärd, "The 'Violettomania' of the Impressionists," in *Journal of Aesthetics and Art Criticism,* IX: 2 (Dec. 1950), 106–10; trans. of French quotes by Lucretia Slaughter Gruber. Reprinted by permission of the publisher and author.

violet tinting, and show the confusions to which it gave rise. While the color-scale of traditional painting was concentrated towards the center of the spectrum, the color-register of the impressionists often showed a slight tendency towards its short-wave end, that is to say, towards blue, indigo and violet. Today we should take this for what it was, a recomposing in a special coloristic key, and we should regard it as a completely legitimate artistic device. For the great art critics of the 70's this was a confusing mystification, which called for an explanation—and banishment. But the art public in general was unaccustomed to the pure colors of the impressionists direct from the tube, and the most unexpected feature was their tints between pure blue and pure violet. Indeed, people had for so long been habituated to a blue faintly toned down towards green, that when they saw the color in the unmixed state it seemed in their eyes to be shot with violet. Blue sections of paintings that can now be ascertained to be painted with genuine cobalt are characterized by the art critics of the period as indigo or blue-violet[1]; they felt an attraction or pull towards the red that is no longer felt by us.

The most important literary documents from this period unanimously stress the striking rôle played by the new tinting on the canvases of the impressionists. Edmond Duranty declares that these painters apply an artistic system "almost always proceeding from a violet or bluish spectrum."[2]

When the Swedish writer August Strindberg first saw a collection of impressionistic paintings at Durand-Ruel's in 1876 he described them, in a report to his homeland, as "thin, reddish blue, all the same."[3] Huysmans christened this predilection of the impressionists "indigomania," and varied the pronouncements of Duranty and Strindberg as follows:

> I don't want to name names here, suffice it to say that the eye of most of them had turned monomaniacal; this one saw parrot blue in all of nature; that one saw violet; earth, sky, water, flesh, everything in his work was tinged with lilac and deep purple.[4]

But Alfred de Lostalot capped them all, and in a review of a Monet exhibition he tried to show that the impressionists saw ultraviolet:

[1] Cf. Victor Cherbuliez' description of the opinion of the public: "The characteristic of impressionism is painting . . . lilac skies." From *Revue des Deux Mondes,* "Le Salon de 1876. Les impressionnistes," . . . 1 juin 1876, p. 516.

[2] Edmond Duranty, "La quatrième exposition faite par un groupe d'artistes indépendants." *La Chronique des Arts,* 19 avril 1879, p. XX.

[3] Strindberg's interesting reaction is quoted in its entirety in Oscar Reutersvärd, *Monet.* Stockholm 1948, pp. 98–100.

[4] Karl Joris Huysmans, "L'exposition des indépendants en 1880." Reprinted in *L'art moderne,* Paris 1883, p. 90.

It is well known that in the solar spectrum there is a band of rays which are intercepted in passing by the crystalline lens of the eye and which, consequently, do not fall upon the retina. This zone, called ultra-violet because it extends beyond the violet waves everyone perceives, plays a considerable role in nature, but its effects are not optical. However, recent experiments by M. de Chardonnet have demonstrated conclusively that this invisible part of the spectrum keenly affects the senses of some people. Monet is certainly one of them; he and his friends see violet; the ordinary man sees otherwise, and this explains the disagreement.[5]

While impressionism was in most quarters still being ridiculed, it was in a high degree the new coloring that excited people's mirth. In the Paris *Journal* Gyges remarks that at the auction held in 1875 in Hotel Drouot the public were vastly amused by the violet fields and blue children of the impressionists. And when serious criticism set in in earnest it appeared that it was the violet color that gave rise to much of the displeasure. I will quote two passages from Théodore Duret's brochure from the year 1878:

> . . . the Impressionist paints people in violet woods; so the public goes absolutely mad, the critics raise their fists, call the painter a communist and a scoundrel. As I write this, I have before my eyes a canvas by Sisley, a view of Noisy-le-Grand, and, horror! I discover in it just that lilac tone which, all by itself, has the power to suggest to the public at least as many monstrosities as all the others attributed to the Impressionists.[6]

The redoubtable Wolff, a powerful connoisseur in the art-world of Paris, came forward in 1876 and aimed a death-blow at the impressionists. He found them mad, and gave expression to his loathing of the element of violet. It would be just as difficult, he opined, to convince Pissarro that trees are not violet as to persuade the inmate of a lunatic asylum that he was not the Pope in the Vatican. He likens Renoir's violet-shimmering female bodies to corpses in a state of decay.[7] [See Fig. 11.]

Strindberg's spontaneous question when confronted by the "red-blue" paintings on the occasion mentioned above was: "They are mad?" And his companion replied: "Yes. Indeed they are!"[8]

When Huysmans vehemently opposed the tendency of the impressionists to occupy themselves devastatingly with the "delicious subtlety

[5] Alfred de Lostalot, "Exposition des oeuvres de M. Claude Monet." *Gazette des Beaux-Arts,* 1 avril 1883, p. 344.

[6] Théodore Duret, *Les peintres impressionistes,* Paris, May 1878.

[7] Albert Wolff, review of the Impressionists' 2nd exhibition. *Figaro,* April 3, 1876.

[8] See note 3.

of ephemeral nuances" that Nature presented to the sight of the artist, it was above all the new color-scale that repelled him: "These iridescences, these reflections, these vapors, these dust clouds (in nature), were changed on their canvases into a mud of pulverized chalk of crude blue or strident lilac. . . ."[9] Even the human subjects on their canvases he found to be marred by this violet: "They brushed over faces with curds of intense violet, leaning heavily where the shade was a mere suspicion."[9]

Huysmans, too, regarded this as a mark of insanity. He summarizes the conclusions to which he has been led by the exhibitions of the impressionists between the years 1876 and 1880 as follows:

> Most of them in fact could confirm the experiments of Dr. Charcot on the alterations in the perception of color which he noted in many of the hysterics at the Salpêtrière [home for aged and mentally afflicted women in Paris] and in a number of people suffering from diseases of the nervous system.[10]

In order to find scientific evidence that the "indigomania" of the impressionists was a mental disease, the celebrated writer turns to the professional psychopathologists, which is in itself an indication of how seriously the matter was regarded. Huysmans states the results of his researches:

> Their retinas were diseased. The cases certified by the oculist Galezowski and cited by Véron concerning the atrophy of several nerve fibers of the eye and notably the loss of the notion of green, which is the warning symptom of this type of ailment, were without a doubt like the cases of these painters. For green has almost disappeared from their palettes, whereas blue, acting on the retina the most freely and acutely, persisting until the end in this disorder of sight, dominates and drowns everything in their canvases. The result of these ophthalmias and nerve disorders was soon apparent. The most afflicted, the weakest of these painters have been overcome; others have recovered little by little and now have only rare recurrences.[11]

9 Huysmans, *L'art moderne*, p. 89.
10 *Ibid.*, p. 90. [Dr. Jean-Martin Charcot was a Parisian neurologist who specialized in the treatment of hysteria. In 1885, Freud came to study at Charcot's clinic. —ED.]
11 Cf. the following pronouncement by Huysmans: "One can say, however, that a change has taken place in the attitude of the public, which used to die laughing in the past at the showings of the intransigents (= Impressionists), without taking into consideration the efforts that failed, the ravages of daltonism and of other eye ailments, without understanding that pathological cases are not laughable, but simply interesting to study." *L'art moderne*, p. 121.

If we cast a glance at Huysmans' source,[12] we find an account of Jean-Martin Charcot's and Xavier Galezowski's observations of changes of color-perception in hysterics and other psychopathic subjects, and the latter does actually point out that under certain conditions some of these patients lose the capacity to perceive green, whereas blue and violet are more easily perceived by them than other colors. But Charcot adds the consolation: "These changes are not continuous. When the patient returns to a normal state, the various color sensations reappear in the inverse order of their disappearance."

Such a return to normal on the part of the impressionists was later to be admitted by Huysmans. To this his friend de Lostalot, just mentioned, contributed in a high degree. Also the latter, although a great admirer of the impressionists, thought he observed an excess of violet in their painting. But he was unwilling to acknowledge this as a pathological phenomenon; he turned to optical science to find a natural explanation, and was soon persuaded that he had found it. The violet visions were an involuntary sequential phenomenon, the negative after-image of yellow, for every sensitive eye out in the sunlight. This viewpoint was strongly advocated by de Lostalot in the circle of art-critics, and he also advanced it when he published his above-mentioned review of Monet's exhibition:

> The point when the eyes of the public start to rebel, is when Monet begins to struggle with the sun. The brilliance of the yellow rays exalts the nervous sensibility of the painter, blinds him, and then there arises in him the well-known physiological phenomenon of the evocation of complementary color; he sees violet. Those who like this color will be satisfied: Monet executes for them an exquisite symphony in violet.[13]

This explanation, however, is based upon a double mistake. Yellow gives a violet after-image, but sunlight is white, with a black or grey after-image. And one who sees everything with a violet tinting does not paint in violet tints, for the colors in his box of paints will also seem violet-tinted to him.

Huysmans was further influenced by another widespread error, launched I know not by whom, to the effect that the shadows in nature were in point of fact always blue and violet, "a discovery of the impressionists."[14] And at the impressionist exhibition in 1882 he capitulated. He declared Monet—in the van of the violet painting—free from his

[12] Eugène Véron, *L'Esthétique*, Paris, 1878, p. 271.
[13] *Gazette des Beaux Arts*, 1883, p. 346.
[14] Cf. Théodore Duret, *Histoire des peintres impressionnistes*, Paris, 1906. 3rd ed., 1939, p. 27: "Then, the impressionists having discovered that shadows, according to the effects of light, are variously colored outdoors, painted without hesitating blue, violet and lilac shadows."

disease, although it was the eye of the great writer and analyst himself that had become reconciled to the new coloring! "Surely, the artist who painted these pictures is a great landscape painter whose eye, now cured, grasps with a surprising fidelity all the phenomena of light."[15]

Nor did Manet's violet painting escape attack. There was a great to-do when to the 1881 Salon he submitted the portrait of the society-lion Pertuiset in an "African" landscape tinted with the offensive color—and was awarded a medal for it. Jules Claretie tried to swallow his chagrin: "Pertuiset, the lion hunter, stalking the king of the wilds in a purplish-blue landscape. But let's not discuss it."[16] Huysmans shares the opinion of his colleague about this painting: "To distinguish himself from the canvases which surround him, Manet took pleasure in smearing his earth with violet; this is a novelty of little interest and much too facile."[17]

But Claretie gives an interesting detail concerning Manet's "novelty": "Manet was saying the other day to friends: 'I have finally discovered the true color of the atmosphere. It's violet. Fresh air is violet. I've got it! . . . Three years from now, everyone will work in violet!'" And Claretie adds resignedly: "And it's very possible."[16]

[15] Huysmans, *L'art moderne*, Appendice 1882, p. 269. Caillebotte was already recovered according to Huysmans, in 1880: "Indigo-mania, which so ravaged the ranks of these painters, seems to have definitely failed to overcome Caillebotte. After having been cruelly affected, this artist was cured and, except for one or two reversals, he seems to have finally succeeded in clearing up his eye, which is fine, in a normal state." (*L'art moderne*, p. 93). And Pissarro in 1881: "First, one great achievement predominates, the flowering of impressionist art arrives at its maturity with Pissarro. Just as I have written many times, until that day the eye of the impressionist painters was becoming increasingly worse." (*L'art moderne*, p. 253).

[16] Jules Claretie, *La vie à Paris 1881*. Paris, 1881, p. 226. Cf. Manet's reply to Moore in: George Moore, *Modern Painting*, London 1898, p. 87.

[17] Huysmans, "Le Salon officiel de 1881." Reproduced in *L'art moderne*, p. 182.

JOURNALISTS (1874-1896)
ON THE ACCENTUATED BRUSH STROKE

Oscar Reutersvärd (1952)

The characteristics of the impressionists started to appear in 1869 in the works of Monet and Renoir, and when the movement made its public debut in 1874, the new pictural structure was also found accomplished in the works of Sisley, Berthe Morisot, Pissarro and Guillaumin. Its most striking new features were the decomposition and the color scheme out of tune. The former was by no means the least startling; the paintings were broken up in abrupt, sharply detached accents, the brush touches had become an independent element, an accentuated component of creating. The medium values, middle tones and outer levelling means were being superseded, as were the outlines and the modelling of volumes. This open form with its new specific texture was developed at the cost of the classic image being broken, and sharpness of detail and tactile palpability were inevitably sacrificed.

The great French critics, watchdogs of the joint demands of idealism and naturalism on figurative integrity, violently opposed this free composition, which could only be interpreted as "disorganization" and "disintegration of style." Simon Boubée, the author, who presented the new trend in the clerical *Gazette de France*, patriarch of French journals, described it as "a destructive system,"[1] the historian Henry Houssaye called it "the negation of art,"[2] and Paul Mantz "anarchy."[3] Marius

Journalists (1874–1896) on the Accentuated Brush Stroke [Editor's title]. From Oscar Reutersvärd, "The Accentuated Brush Stroke of the Impressionists: The Debate Concerning Decomposition in Impressionism," in *Journal of Aesthetics and Art Criticism*, X, 3 (March, 1952), pp. 273–78; trans. of French quotes by Lucretia Slaughter Gruber. Reprinted by permission of the publisher and author.

[1] *Gazette de France*, April 5, 1876, p. 2.
[2] *Revue des Deux-Mondes*, June 1882.
[3] *Le Temps*, April 22, 1877, p. 3.

Chaumelin christened impressionism "the school of spots" and complained that the abrupt technique thoroughly tried the eyes.[4] To Charles Bigot, the painters' canvases were "a shimmering chaos of brutal brush strokes"[5] and Émile Bergerat, too, accused them of brutality.[6]

The accentuated brush stroke appeared to be unintelligible to the majority. That most industrious chronicler of impressionists, Gustave Geffroy, saw at first no meaning in the presence of this element on the canvas; "the spots of color come to confuse everything and obliterate everything."[7] In 1880, Huysmans was equally baffled by these "fluttering spots, luminous points distributed without reason."[8] The maniacal Arthur d'Echerac, concealed by the pseudonym Dargenty, stamped it as "pictorial twaddle"[9] and Paul de Charry as a "mystifying way of proceeding."[10] Chaff and mockery were soon levelled at the impressionists on account of their work. Félicien Champsaur called them the clowns of painting; the dotting technique was their entry number.[11] Philippe Gille interpreted it as the performance of a monkey who had got hold of a box of paints,[12] while Roger Ballu,[13] Edmond Lepelletier[14] and Marc de Montifaud, the pseudonym adopted by the highly gifted Marie-Amelie Chartroule,[15] attributed it to children daubing with paint. It was said that the impressionist loaded a gun with paint and fired it at the canvas, and the style was called "shot-gun painting." In regard to this joke, Albert Wolff declared: "If that is not the real procedure, it could be"[16] seconded by Andreas Aubert, who seriously likened Monet's painting to a rain of shot.[17] Many critics rejected the new touch as treachery. Richard Graul vehemently repeated that the "visible brushstroke technique" of impressionism was humbug,[18] Henry Houssaye described it as "charlatanism"[2] and Émile Cardon, that sworn antagonist, pictured the impressionist entrusting the disciple with his recipe:" Dirty three-quarters of a canvas with black and white, rub the rest with yellow, then dash on haphazardly

[4] *Gazette des étrangers,* April 8, 1876, p. 1.
[5] *Rev. polit. et litt.,* April 8, 1876, p. 350.
[6] *Journal officiel,* April 17, 1877, p. 2917.
[7] *La Justice,* April 19, 1881, p. 3.
[8] *L'Art moderne,* 1883, pp. 94, 98.
[9] *Courrier de l'art,* April 12, 1883, p. 172.
[10] *Le Pays,* April 10, 1880, p. 3.
[11] *A travers les ateliers. Silhouettes impressionnistes,* p. 135.
[12] *Le Figaro,* March 24, 1875, sign. "Masque de fer."
[13] *Chron. d. Arts,* April 14, 1877, p. 147.
[14] *Le Radical,* April 8, 1877, pp. 2–3.
[15] *L'Artiste,* May 1, 1874, pp. 308–309.
[16] *Le Figaro,* March 2, 1882, p. 1.
[17] *Illustreret Tidende,* Copenh. 1884, p. 266.
[18] *Zeitschr. f. Bild. Kunst,* 1885, p. 237.

green, red or blue spots and you will finally attain a *true impression* of spring."[19]

The inner phalanx, defenders of the new tendencies within their circle of friends, and mostly amateurs without deeply entrenched points of view, were headed by Théodore Duret, Georges Rivière, Ernest d'Hervilly and Ernest Chesneau, and these hastened to the rescue. They launched the idea that the abrupt strokes of the brush played a representative role. The art of the impressionists, they explained, was an advanced stage of plein-airism, a groping towards the phenomena in their surroundings which had previously been neglected—the effect of air and light in Nature. Duret maintained in his known brochure, the first presentation of the impressionists, that these elements, difficult to grasp, they could reproduce by use of their simplifying handling of the brush, their "spontaneous touch."[20] The writers in the main accepted this and competed to find words for what the impressionists were said to have captured in their pictures, "the mobility of the atmosphere," "the iridescence of the surrounding air," "the aerial quivering," "the sensation of high wind," "the movement of the vibrations of heat" etc. Monet especially was the subject for comments of this kind. His friend Octave Mirbeau circulated the assertion that his paintings reproduced the objects and persons mantled in visible atmosphere, and Séailles, the philosopher, willingly adopted this conception in his descriptive account of impressionism: "He paints the impalpable, the atmosphere, its fluidities, its transparencies."[21] According to Georges Lecomte[22] and Richard Muther,[23] Pissarro exactly analyzed the surrounding atmosphere, and Alfred de Lostalot considered that in his landscapes, "the air circulates widely."[24]

All these arguments and assurances had their effect upon the ruling critics, but they were not accepted without reserve. To an increasing extent, the seriousness of the impressionists' images was gradually acknowledged, but not, however, the plausibleness of them: the alleged agreement between the debatable paintings and the phenomena of the visible world was not absolutely convincing. Amongst many others, Théodore de Banville at once expressed doubt as to the idea that "nature, instead of being an ensemble of forms and contours, as we have imagined it for centuries, is only an accumulation of many-colored spots"[25] and Charles Bigot resolutely stated:

19 *Le Soleil*, April 12, 1877, p. 3.
20 *Les peintres impressionnistes*, 1878, pp. 12, 13.
21 *L'Origine et les destinées de l'art*, p. 122.
22 *Les hommes d'aujourd' hui*, vol. 8, no. 366, p. 4.
23 *Gesch. d. Malerei im xix. Jahrh.*, II, 1893, p. 640.
24 *Chron. d. Arts*, February 6, 1892, p. 41.
25 *Le National*, April 13, 1877, p. 3, sign. "Baron Shop."

Out in the fresh air, exactly, nothing is abrupt, nothing is brutal, nothing is flickering. In the transparence of the atmosphere, all tones grow softer, fuse together, unite harmoniously. Whoever will take the trouble to spend only a few days in the country will convince himself without difficulty; he will come back with an impression of serenity, of clarity, of light both sparkling and gentle; and what will strike him in return, if he sets foot in the exhibition on the rue le Peletier, is the unfaithfulness of the translation. . . .[26]

But some critics of the naturalistic school cunningly did away with the opposition. The accents of Nature blend together to form a continuous whole for our sight, they pointed out; with some simple media, the observers could also consolidate the dissolutions in the impressionists' paintings, namely by looking at them from an exaggerated distance and with narrowed eyes. As early as in 1874, Chesneau had warned the public not to go too near the impressionists' pictures; of Monet's *Boulevard des Capucines* [see Fig. 12] he wrote: "From a distance, in this shimmering of great shadows and great effects of light, one salutes a masterpiece. You approach, and everything fades away; there remains a chaos of scrapings from an unintelligible palette."[27] One year later, Philippe Gille likened the work of the impressionists to "painting at which one must look from a distance of fifteen paces, while half closing one's eyes"[12] and Henrie Mornand considered all appreciation excluded if this measure of precaution were not taken; "the spectator must keep himself at the required distance and squint so as to attenuate the effect of the abrupt, violent brush strokes."[28]

Huysmans with all his authority also joined forces in this respect. In 1880 he started to show a positive interest for "the impressionist system of visible brush strokes which force the eye to squint in order to reestablish the identity of beings and things"[29] and in his criticisms justified the methods for smoothing out the emphasized strokes. Through conjuring away the decomposition in the impressionists' canvases and launching them as a kind of concealed puzzle picture, he contributed to guiding the eyes of the public towards the new form of art. For instance, of Pissarro, he himself writes: "Up close, the *Cabbage Path* is a piece of masonry, a bizarre, rough patchwork, a ragout of all sorts of tones covering the canvas; at a distance, it is air circulating, water vanishing into thin air, sunlight spreading," etc. And of Guillaumin; "at first sight, his canvases are a mishmash of warring tones and rough contours, a mass of

[26] *Rev. polit. et litt.*, April 28, 1877, p. 1046.
[27] *Paris Journal*, May 7, 1874, p. 2.
[28] *Rev. litt. et artistique*, May 1, 1880, p. 67.
[29] *L'Art moderne*, pp. 235–36.

stripes; back off and squint and everything is put back in place, the planes stand firm, the howling tones calm down," etc.[29]

This hocus-pocus with the work of the impressionists is an oft-repeated intimation in the following treatises. André Michel carries it to absurdity: "Be careful not to get near!" "Up close, it is a formless roughcast, an accumulation of frayed and twisted bundles which produces exactly the effect of a plate of cream with jam, in which dozens of little cats have apparently splashed about." "Step back, and the sky blazes, the leaves quiver in the air, the waters spread in supple, mirrored sheets; you have sudden visions of sunny horizons where light palpitates, where there explodes, like a hosannah, a lyricism of light colors," etc.[30] At a Monet exhibition, Michel found the right distance: "In the center of the room, eight or ten meters from the painting, there is a point, a unique point, where the optical blend is produced on your retina."[30] Henry Havard suggested approximately the same distance, "ten paces"[31] and Gille fifteen paces.[12]

The above-mentioned Bigot was entirely of the opposite opinion. He acknowledged that a representative of tradition felt prompted to smooth out, work on and finish the impressionists' paintings, but "that is exactly what the new school does not allow. They want us to be able to count the strokes of the brush or, better yet, those of the palette knife."[5] With that remark, Bigot is the first who emphasizes the brush stroke as an independent factor with which the impressionists calculate. The enigmatical Frédéric Chevalier, superior to his contemporary art judges as regards clear-sightedness, followed this line of thought. In his opinion, his contemporaries lacked the qualifications for grasping the significance in the broken structure of the impressionists' pictures: "The brutal workmanship . . . for which they have a fondness, the appearance of spontaneity that they seek above all, the intentional incoherence" was an expression of a new and complicated spirit which no one was as yet mature enough to explain and which also had its counterpart outside the sphere of art, its "analogy with the chaos of opposing forces" in everyday life.[32] In other words, Chevalier was the only one at that time who could conceive an inner meaning in the decomposing painting.

With the positivistic ideology of art, the question of the disaggregated picture was placed in a somewhat new light. This doctrine was an offspring of Comté's philosophy and consequently rejected everything creative in art which did not emerge from "positive experience," from cognizance of the senses. This meant a revolutionizing emphasis being placed on the visual moment in art. The painter was to discover new

[30] *Notes sur l'art moderne*, 1896, pp. 259, 291–92.
[31] *Le Siècle*, March 1882, p. 2.
[32] *L'Artiste*, May 1, 1877, p. 331.

Out in the fresh air, exactly, nothing is abrupt, nothing is brutal, nothing is flickering. In the transparence of the atmosphere, all tones grow softer, fuse together, unite harmoniously. Whoever will take the trouble to spend only a few days in the country will convince himself without difficulty; he will come back with an impression of serenity, of clarity, of light both sparkling and gentle; and what will strike him in return, if he sets foot in the exhibition on the rue le Peletier, is the unfaithfulness of the translation. . . .[26]

But some critics of the naturalistic school cunningly did away with the opposition. The accents of Nature blend together to form a continuous whole for our sight, they pointed out; with some simple media, the observers could also consolidate the dissolutions in the impressionists' paintings, namely by looking at them from an exaggerated distance and with narrowed eyes. As early as in 1874, Chesneau had warned the public not to go too near the impressionists' pictures; of Monet's *Boulevard des Capucines* [see Fig. 12] he wrote: "From a distance, in this shimmering of great shadows and great effects of light, one salutes a masterpiece. You approach, and everything fades away; there remains a chaos of scrapings from an unintelligible palette."[27] One year later, Philippe Gille likened the work of the impressionists to "painting at which one must look from a distance of fifteen paces, while half closing one's eyes"[12] and Henrie Mornand considered all appreciation excluded if this measure of precaution were not taken; "the spectator must keep himself at the required distance and squint so as to attenuate the effect of the abrupt, violent brush strokes."[28]

Huysmans with all his authority also joined forces in this respect. In 1880 he started to show a positive interest for "the impressionist system of visible brush strokes which force the eye to squint in order to reestablish the identity of beings and things"[29] and in his criticisms justified the methods for smoothing out the emphasized strokes. Through conjuring away the decomposition in the impressionists' canvases and launching them as a kind of concealed puzzle picture, he contributed to guiding the eyes of the public towards the new form of art. For instance, of Pissarro, he himself writes: "Up close, the *Cabbage Path* is a piece of masonry, a bizarre, rough patchwork, a ragout of all sorts of tones covering the canvas; at a distance, it is air circulating, water vanishing into thin air, sunlight spreading," etc. And of Guillaumin; "at first sight, his canvases are a mishmash of warring tones and rough contours, a mass of

[26] *Rev. polit. et litt.*, April 28, 1877, p. 1046.
[27] *Paris Journal*, May 7, 1874, p. 2.
[28] *Rev. litt. et artistique*, May 1, 1880, p. 67.
[29] *L'Art moderne*, pp. 235–36.

stripes; back off and squint and everything is put back in place, the planes stand firm, the howling tones calm down," etc.[29]

This hocus-pocus with the work of the impressionists is an oft-repeated intimation in the following treatises. André Michel carries it to absurdity: "Be careful not to get near!" "Up close, it is a formless roughcast, an accumulation of frayed and twisted bundles which produces exactly the effect of a plate of cream with jam, in which dozens of little cats have apparently splashed about." "Step back, and the sky blazes, the leaves quiver in the air, the waters spread in supple, mirrored sheets; you have sudden visions of sunny horizons where light palpitates, where there explodes, like a hosannah, a lyricism of light colors," etc.[30] At a Monet exhibition, Michel found the right distance: "In the center of the room, eight or ten meters from the painting, there is a point, a unique point, where the optical blend is produced on your retina."[30] Henry Havard suggested approximately the same distance, "ten paces"[31] and Gille fifteen paces.[12]

The above-mentioned Bigot was entirely of the opposite opinion. He acknowledged that a representative of tradition felt prompted to smooth out, work on and finish the impressionists' paintings, but "that is exactly what the new school does not allow. They want us to be able to count the strokes of the brush or, better yet, those of the palette knife."[5] With that remark, Bigot is the first who emphasizes the brush stroke as an independent factor with which the impressionists calculate. The enigmatical Frédéric Chevalier, superior to his contemporary art judges as regards clear-sightedness, followed this line of thought. In his opinion, his contemporaries lacked the qualifications for grasping the significance in the broken structure of the impressionists' pictures: "The brutal workmanship . . . for which they have a fondness, the appearance of spontaneity that they seek above all, the intentional incoherence" was an expression of a new and complicated spirit which no one was as yet mature enough to explain and which also had its counterpart outside the sphere of art, its "analogy with the chaos of opposing forces" in everyday life.[32] In other words, Chevalier was the only one at that time who could conceive an inner meaning in the decomposing painting.

With the positivistic ideology of art, the question of the disaggregated picture was placed in a somewhat new light. This doctrine was an offspring of Comté's philosophy and consequently rejected everything creative in art which did not emerge from "positive experience," from cognizance of the senses. This meant a revolutionizing emphasis being placed on the visual moment in art. The painter was to discover new

[30] *Notes sur l'art moderne*, 1896, pp. 259, 291–92.
[31] *Le Siècle*, March 1882, p. 2.
[32] *L'Artiste*, May 1, 1877, p. 331.

values with the aid of his eyes and not improvize on and deal with literary subjects which in themselves lacked visual effect. And exactly as in the positivistic epistemology, they made a study of deciding the "actual subjects" of art, the empirically gained visual phenomena right down to their slightest constituents, and to determine the capability and function of the organ of cognizance—the eye.

Thus a sensual aestheticism crystallized, recognizable by its peculiar admixture of physiological and optic-physical principles. Painting was to be upheld by the geniuses of sight who could master the world as a visual appearance and analyze and reproduce it in detail. But in contrast to naturalism, which sought to attain illusory fiction dealing with "reality," the new sensualism postulated an optically exact reproduction from nature without regard to the plausibility or literary effect of the image. And the impressionists were held up as those who applied the new aesthetic doctrine. Their painting was propounded as being scientific reports of the chromo-luminaristic conditions in nature, the decomposed structure was said to correspond with the disaggregation of sunlight into different prismatic elements and by fusing on the observer's retina, the impressionists' touches of color would give rise to the same effects as the spectral phenomena in physical reality.

The erudite Charles Ephrussi contributed powerfully both in word and writing to spreading this manner of viewing. He presented impressionism as a "system which necessitates a very special organization and training of the visual faculties" and which was able to "seize the least quiver of light, the least particle of color, the least tint of shadow."[33] Ephrussi injected his sensualistic doctrine into his young disciple Jules Laforgue, who codified it in his "esthetic physiological explanation of the impressionist formula." He considered that the eye up to that time had seen visible phenomena in general lines and only been capable of distinguishing their components approximately. With the impressionists, he found that at last the power of vision had reached complete sharpness and sensibility, and with it, painting could now record actual optical experience, the disaggregation of light, the degradation of colors, etc. He writes:

> In a landscape bathed in light, where the academic painter sees only white light, the impressionist sees it suffused with a thousand vibrant clashes, with rich, prismatic decompositions. Where the academic sees only the exterior design, he sees the real lines constructed of a thousand irregular strokes which, from far away, establish life. Where the academic sees things placed in their respective planes, he sees perspective created by the thousand little nothings of tone and touch. In sum, the impres-

[33] *Chron. d. Arts*, April 23, 1881, p. 134.

sionist eye is the more advanced in the evolution of the human eye, the one which until now has seized and rendered the most complex combinations of nuance known to man.[34]

The positivistic interpretation of the free impressionistic brush stroke was also taken up inter alia by Gustave Goetschy,[35] and later by Georges Lecomte[36] and Camille Mauclair.

With the exception of Pissarro, the impressionists were relatively untouched by the doctrine of positivism. It was the pointillists who started with intentional division of color and optical recomposition of the isolated color dots. They looked askance at the forerunners of scientific color systems and read their original publications by Chevreul, Rood and Helmholtz and attempted to apply their lesson to their painting. Is it now possible to examine the diverging intentions by the "disjointing technique" between the impressionists and pointillists? Yes, for instance in their black-and-white drawings; in a drawing of Monet or Renoir, there is a marked staccato; each short stroke is marked for its own sake; in the work of Seurat, in his famous black chalk drawings, the lines are calculated to fuse into soft formations.

It is not until the end of the 1880's, with Albert Aurier and other devoted art critics with an open mind for the problems of expression, that the meaning of the disaggregation in the impressionists' work is obvious. They understand that it is the visible sign of a new power which is starting to find scope within painting, the spontaneous impulse to create. The actual painting process is jerked into the foreground, the mark of the brush work is given its own stimulating role to excite the emotions. This formalistic interpretation has never won general recognition. The history of art is ruled by the earlier, more naive views that the decomposition in the impressionists' works only has an illustrative signification. The foremost connoisseur of our time, Mr. John Rewald, represents these views staunchly. Of Renoir and Monet, he says that

> . . . they adopted a comma-like brushstroke, . . . which permitted them to record every nuance they observed. The surfaces of their canvases were thus covered with a vibrating tissue of small dots and strokes, none of which by themselves defined any form, yet all of which contributed to recreating not only the particular features of the chosen motif but even more the sunny air which bathed it and marked trees, grass, houses or water with the specific character of the day, if not the hour.[37]

[34] *Mélanges posthumes*, pp. 136–137, 268.
[35] *Le Voltaire*, April 5, 1881, p. 2.
[36] *L'Art impressionniste*, 1892, pp. 24, 27.
[37] *The History of Impressionism*, New York, 1946, p. 234. [See also Rewald's 4th revised edition of this title (1973).—ED.]

PART THREE / Major Painters' Reflections on Impressionism (1884–1952)

George Inness (1884)

. . . Now there has sprung up a new school, a mere passing fad, called Impressionism, the followers of which pretend to study from nature and paint it as it is. All these sorts of things I am down on. I will have nothing to do with them. They are shams.

The fact came to my mind in the beginning of my career. I would sit down before nature, and under the impulse of a sympathetic feeling put something on canvas more or less like what I was aiming at. It would not be a correct portrait of the scene, perhaps, but it would have a charm. Certain artists and certain Philistines would see that and would say: "Yes, there is a certain charm about it, but did you paint it outdoors? If so, you could not have seen it this and that and the other." I could not deny it, because I then thought we saw physically and with the physical eye alone. Then I went to work again and painted what I thought I saw, calling on my memory to supply missing details. The result was that the picture had no charm; nothing about it was beautiful. What was the reason? When I tried to do my duty and paint faithfully I didn't get much; when I didn't care so much for duty I got something more or less admirable. As I went on I began to see little by little that my feeling was governed by a certain principle that I did not then understand as such.

But these are merely scientific formulae. Every artist must, after all, depend on his feeling, and what I have devoted myself to is to try to find out the law of the unit; that is, of impression. Landscape is a continued repetition of the same thing in a different form and in a different feeling. When we go outdoors our minds are overloaded; we do not know where to go to work. You can only achieve something if you have an ambition so powerful as to forget yourself, or if you are up in the science of your art. If a man can be an eternal God when he is outside, then he is all right; if not he must fall back on science.

George Inness, letter to "Editor Ledger" from Tarpon Springs, Florida, 1884, to an unidentified newspaper; from *The Life, Art, and Letters of George Inness* by George Inness, Jr., pp. 168–73. Reprinted by permission of Prentice-Hall, Inc., Englewood Cliffs, N.J.

The worst of it is that all thinkers are apt to become dogmatic, and every dogma fails because it does not give you the other side. The same is true of all things—art, religion, and everything else. You must find a third as your standpoint of reason. That is how I came to work in the science of geometry, which is the only abstract truth, the diversion of the art of consciousness and so on, which I have already mentioned.

And no one can conceive the mental struggles and torment I went through before I could master the whole thing. I knew the principle was true, but it would not work right. I had constantly to violate my principle to get in my feeling. This was my third. I found I was right, and went on in perfect confidence, and I have my understanding under perfect control, except when I overwork myself, when I am liable to get wriggly, like anybody else. Then I shut myself up with my books and write, applying the principles I have found true in art to pure reasoning on the subject of theology. That is what you see in my pictures, that is the feeling and the sentiment. I have always had it, but have not always understood the principles which govern it.

Vincent Van Gogh (1888)

What a mistake Parisians make in not having a palate for crude things, for Monticellis,[1] for clay! But there, one must not lose heart because Utopia is not coming true. It is only that what I learned in Paris is leaving me, and that I am returning to the ideas I had in the country before I knew the impressionists. And I should not be surprised if the impressionists soon find fault with my way of working, for it has been fertilized by the ideas of Delacroix rather than by theirs. Because, instead of trying to reproduce exactly what I have before my eyes, I use color more

Vincent Van Gogh's letter to his brother Theo, from Arles, August, 1888, from *Artists on Art: From the XIV to the XX Century*, compiled and edited by Robert Goldwater and Marco Treves; pp. 382–83. Copyright 1945 by Pantheon Books, Inc. and renewed 1973 by Robert Goldwater and Marco Treves. Reprinted by permission of Pantheon Books, a Division of Random House, Inc.

[1][Adolphe Monticellis (1824–86), French romantic painter and follower of Delacroix. —ED.]

arbitrarily so as to express myself forcibly. Well, let that be as far as theory goes, but I am going to give you an example of what I mean.

I should like to paint the portrait of an artist friend, a man who dreams great dreams, who works as the nightingale sings, because it is his nature. He'll be a fair man. I want to put into the picture my appreciation, the love that I have for him. So I paint him as he is, as faithfully as I can, to begin with.

But the picture is not finished yet. To finish it I am now going to be the arbitrary colorist. I exaggerate the fairness of the hair, I come even to orange tones, chromes, and pale lemon yellow.

Beyond the head, instead of painting the ordinary wall of the mean room, I paint infinity, a plain background of the richest, intensest blue that I can contrive, and by this simple combination of the bright head against the rich blue background, I get a mysterious effect, like a star in the depths of an azure sky.

Wassily Kandinsky (1918)

It was around that time, that two events took place, both of which were to influence me strongly in my future life. The first was the exhibition of French Impressionists that was held in Moscow [in 1895], one of the pictures being *The Stack of Hay* [see Fig. 6] by Claude Monet. The second was the production of Wagner's *Lohengrin* at the Grand Theatre.

Up to this time I was familiar with the realistic school of painting, and—at that—chiefly with the work of the Russian painters. . . .

And then suddenly, for the first time in my life, I found myself looking at a real painting. It seemed to me, that, without a catalogue in my hand, it would have been impossible to recognize what the painting was meant to represent. This irked me, and I kept thinking that no artist has the right to paint in such a manner. But at the same time, and to my surprise and confusion, I discovered that it captivated and troubled me,

From "Text Artista: Autobiography of Wassily Kandinsky, 1918," by Wassily Kandinsky, from *In Memory of Wassily Kandinsky* (New York: Solomon R. Guggenheim Foundation, 1945), p. 53ff. Reprinted by permission of the Guggenheim Foundation. [Kandinsky is recalling the year 1895 in this excerpt.—ED.]

imprinting itself indelibly on my mind and memory down to its smallest detail. . . .

What did become clear to me, was the previously unimagined, unrevealed and all-surpassing power of the palette. Painting showed itself to me in all its fantasy and enchantment. And deep inside of me, there was born the first faint doubt as to the importance of an "object" as the necessary element in a painting.

Paul Gauguin (1896—1897)

The Impressionists study color exclusively insofar as the decorative effect, but without freedom, retaining the shackles of verisimilitude. For them the dream landscape, created from many different entities, does not exist. They look and perceive harmoniously, but without any aim. Their edifice rests upon no solid base which is founded upon the nature of the sensation perceived by means of color.

They heed only the eye and neglect the mysterious centers of thought, so falling into merely scientific reasoning. . . . They are the officials of tomorrow, as bad as the officials of yesterday. . . . The art of yesterday has plumbed the depths, it has produced masterpieces and will continue to do so. Meanwhile, the officials of today are aboard a boat that is vacillating, badly constructed and incomplete. . . . When they speak of their art, what is it? A purely superficial art, full of affectations and purely material. There is no thought there.

. . . "But you have a technique?" they will demand.

No, I have not. Or rather I do have one, but it is very fugitive, very flexible, according to my disposition when I arise in the morning; a technique which I apply in my own manner to express my own thought

From "Three selections from the manuscript *Diverses Choses, 1896–1897*," by Paul Gauguin, Tahiti (an unpublished manuscript, part of which appears in Jean de Rotochamp, *Paul Gauguin, 1848–1903* (Paris: Crès, 1925, pp. 210, 211, 216.) English trans. from Herschel B. Chipp, *Theories of Modern Art: A Source Book by Artists and Critics* (Berkeley and Los Angeles: Univ. of California Press, 1969), p. 65. Copyright © 1968 The Regents of the University of California; reprinted by permission of the University of California Press.

without any concern for the truth of the common, exterior aspects of Nature.

Paul Signac (1899)

Paris, 1899

AIM

Delacroix
Impressionism
Neoimpressionism

To give color its greatest possible brilliance.

MEANS

Delacroix

1. A palette made up of both pure colors and re-duced colors.
2. Mixture (of colors) on the palette, and optical mixture.
3. Cross-hatching.
4. Methodical and scientific technique.

Impressionism

1. A palette composed solely of pure colors, ap-proximating those of the solar spectrum.
2. Mixture (of colors) on the palette, and optical mixture.
3. Brush strokes of comma-like or swept-over form.
4. A technique depending on instinct and the in-spiration of the moment.

Neoimpressionism

1. The same palette as impressionism.
2. Optical mixture (of colors).
3. Divided brush strokes.
4. Methodical and scientific technique.

From *Artists on Art: From the XIV to the XX Century*, compiled and edited by Robert Goldwater and Marco Treves. Copyright 1945 by Pantheon Books, Inc. and renewed 1973 by Robert Goldwater and Marco Treves; pp. 377–78. Reprinted by permission of Pantheon Books, a Division of Random House, Inc.

RESULTS

Delacroix	Through the rejection of all flat color-tones, and thanks to shading, contrast, and optical mixture, he succeeds in creating from the partially incomplete elements at his disposal a maximum brilliance whose harmony is insured by the systematic application of the laws governing color.
Impressionism	By making up his palette of pure colors only, the impressionist obtains a much more luminous and intensely colored result than Delacroix; but he reduces its brilliance by a muddy mixture of pigments, and he limits its harmony by an intermittent and irregular application of the laws governing color.
Neoimpressionism	By the elimination of all muddy mixtures, by the exclusive use of the optical mixture of pure colors, by a methodical divisionism and a strict observation of the scientific theory of colors, the neoimpressionist insures a maximum of luminosity, of color intensity, and of harmony—a result that had never yet been obtained.

Paul Cézanne (1907)

". . . Pissarro drew near to nature; Renoir created the woman of Paris; Monet supplied vision. What follows does not count."

Paul Cézanne is quoted in "Souvenirs sur Paul Cézanne," by Émile Bernard.[1] From *Mercure de France* (Oct. 1907), p. 24. Reprinted in Michel Florisonne, *Renoir* (Paris and Los Angeles, The Hyperion Press, 1941), p. 165; trans. by G.F. Lees.

[1] Émile Bernard (1868–1941) was associated with the birth of the Symbolist movement in painting. He published much art criticism, founding in 1905 an art review dealing with esthetics.—ED.]

Henri Matisse (1908)

The impressionist painters, Monet, Sisley especially, had delicate, vibrating sensations; as a result their canvases are all alike. The word "impressionism" perfectly characterizes their intentions, for they register fleeting impressions. This term, however, cannot be used with reference to more recent painters who avoid the first impression and consider it deceptive. A rapid rendering of a landscape represents only one moment of its appearance. I prefer, by insisting upon its essentials, to discover its more enduring character and content, even at the risk of sacrificing some of its pleasing qualities.

Giorgio de Chirico (1920)

By subjecting himself to the influence of the Impressionists Renoir showed that he was neither spiritually profound nor intellectually strong; being only a *painter* he inevitably underwent the same influences as al-

From "Notes of a Painter, 1908," by Henri Matisse; originally published in *La Grande Revue* (Paris, Dec. 25, 1908), pp. 731–45. Reprinted in *Matisse: His Art and His Public* by Alfred H. Barr, Jr., p. 120. © 1951 by The Museum of Modern Art, New York. All rights reserved. Reprinted by permission. The first complete English translation of *Notes d'un peintre* is by Margaret Scolari Barr.

From "Augusto Renoir" by Giorgio de Chirico, in *Il Convegno*, I (1920), p. 43ff. English trans. from Gerd Muehsam, *French Painters and Paintings from the Fourteenth Century to Post-Impressionism: A Library of Art Criticism* (New York: Frederick Ungar Pub., 1970), pp. 514–15. Reprinted by permission of Frederick Ungar Pub. Co.

most all the Impressionists. . . . When this period was over, Renoir
found his way. He returned to large figure paintings, the portrait and
the nude. But the solidity of his early years, the profound pictorial sense
of his first works, was gone. The Impressionist period left an indelible
mark on all his subsequent paintings. He neglects drawing; violet and
orange are his predominant colors. He later eliminates, or, rather, reduces
the use of these two colors so characteristic of Impressionism, and uses
more reds and ochres. In this period he treats the figure in an exaggerated
manner which often lends his pictures a fascinating psychological and
caricature-like aspect.

 The Luncheon of the Boating Party [see Fig. 13] [is a work] full of
melancholy and deep *ennui*. . . . The boredom of a Sunday afternoon,
of a trip to the country, of the minor daily tragedies, are fixed in the
gestures and expressions of his obscure characters. This aspect of bore-
dom and melancholy is devoid of certain metaphysical implications, of a
subtle, inexplicable feeling which always accompanies a true work of
art. . . .

 The type of woman whom Renoir left us [is] the petit bourgeois,
the housewife, the mother, the maid, or the young girl; she may be at
the piano, in the backyard, or in the garden, but always in a somewhat
stifling setting. These women, when indoors, always seem to be in low-
ceilinged rooms. When outdoors, they work in the still, sultry heat of a
summer evening, or in one of those heavy, oppressive late spring after-
noons like that in which Flaubert makes the unhappy husband of
Madame Bovary die, with the solemn pathos of a Greek tragedy.

Pierre Bonnard (1943)

Renoir painted Renoirs first and foremost. He often had models with
dull complexions, not pearly, and he painted them pearly. He used the

Pierre Bonnard's conversation with Angèle Lamotte, 1943, from "Le Bouquet de
Roses," by Angèle Lamotte. From *Verve*, V, 17 & 18 (Paris, 1947); reprinted from
Richard Friedenthal, ed., *Letters of the Great Artists: From Blake to Pollock*, trans.
by Daphne Woodward (New York: Random House, Inc., 1963), pp. 244–45. Re-
printed by permission of *Verve* and Random House, Inc.

model for a movement, a shape, but he did not copy, he never lost the idea of what he could do. One day I was out walking with him and he said, "Bonnard, one must embellish." By "embellish" he meant the share the artist has to bring to his picture in the first place.

Claude Monet used to paint from the motif, but only for ten minutes. He did not allow time for things to capture him. He would come back to work again when the light was as it had been the first time. He knew how to wait—he kept several pictures going at once.

The Impressionists went out to the motif, but they were better defended from the actual object than other painters, because of their methods, their ways of painting. With Pissarro it is even more visible, he used to rearrange things—there is more system in his painting. Seurat did only tiny studies from nature, all the rest was composed in his studio.

Pablo Picasso (ca. 1943–1953)

I told Pablo he was making progress in the order of sanctity: first Hegel, then Christ. Who next? He thought about that for a moment. "I'm not sure," he said. "Perhaps Aristotle. Someone, at least, who might be able to get painting back on the rails again." Where had it gone off, I asked him.

"That's a long story," he said, "but you're a good listener, so I'll tell you. You have to go all the way back to the Greeks and the Egyptians. Today we are in the unfortunate position of having no order or canon whereby all artistic production is submitted to rules. They—the Greeks, the Romans, the Egyptians—did. Their canon was inescapable because beauty, so-called, was, by definition, contained in those rules. But as soon as art had lost all link with tradition, and the kind of liberation that came in with Impressionism permitted every painter to do what he wanted to do, painting was finished. When they decided it was the

From *Life With Picasso* by Françoise Gilot and Carlton Lake (New York, Toronto, London: McGraw-Hill Book Co., 1964), pp. 66–67. Reprinted by permission of McGraw-Hill Book Co. [Pablo Picasso's discussion with Françoise Gilot took place sometime between 1943–53.–ED.]

painter's sensations and emotions that mattered, and every man could recreate painting as he understood it from any basis whatever, then there was no more painting; there were only individuals. Sculpture died the same death.

"Beginning with van Gogh, however great we may be, we are all, in a measure, autodidacts—you might almost say primitive painters. Painters no longer live within a tradition and so each one of us must recreate an entire language. Every painter of our times is fully authorized to recreate that language from A to Z. No criterion can be applied to him *a priori*, since we don't believe in rigid standards any longer. In a certain sense, that's a liberation but at the same time it's an enormous limitation, because when the individuality of the artist begins to express itself, what the artist gains in the way of liberty he loses in the way of order, and when you're no longer able to attach yourself to an order, basically that's very bad."

I brought up the question of Cubism. Wasn't that a kind of order, I asked him. He shrugged. "It was really the manifestation of a vague desire on the part of those of us who participated in it to get back to some kind of order, yes. We were trying to move in a direction opposite to Impressionism. That was the reason we abandoned color, emotion, sensation, and everything that had been introduced into painting by the Impressionists, to search again for an architectonic basis in the composition, trying to make an order of it."

Robert Motherwell (1948)

The history of modern art can be conceived of as a military campaign, as a civil war that has lasted more than a hundred years—if movements of the spirit can be dated—since Baudelaire first requested a painting that was to be specifically modern in subject and style. Perhaps the first dent in the lines of traditional conceptions was made by the English landscapists and by Courbet, but the major engagement begins, earlier

From "The Tour of the Sublime" by Robert Motherwell, in *Tiger's Eye*, Dec. 15, 1948. Reprinted by permission of the author.

model for a movement, a shape, but he did not copy, he never lost the idea of what he could do. One day I was out walking with him and he said, "Bonnard, one must embellish." By "embellish" he meant the share the artist has to bring to his picture in the first place.

Claude Monet used to paint from the motif, but only for ten minutes. He did not allow time for things to capture him. He would come back to work again when the light was as it had been the first time. He knew how to wait—he kept several pictures going at once.

The Impressionists went out to the motif, but they were better defended from the actual object than other painters, because of their methods, their ways of painting. With Pissarro it is even more visible, he used to rearrange things—there is more system in his painting. Seurat did only tiny studies from nature, all the rest was composed in his studio.

Pablo Picasso (ca. 1943–1953)

I told Pablo he was making progress in the order of sanctity: first Hegel, then Christ. Who next? He thought about that for a moment. "I'm not sure," he said. "Perhaps Aristotle. Someone, at least, who might be able to get painting back on the rails again." Where had it gone off, I asked him.

"That's a long story," he said, "but you're a good listener, so I'll tell you. You have to go all the way back to the Greeks and the Egyptians. Today we are in the unfortunate position of having no order or canon whereby all artistic production is submitted to rules. They—the Greeks, the Romans, the Egyptians—did. Their canon was inescapable because beauty, so-called, was, by definition, contained in those rules. But as soon as art had lost all link with tradition, and the kind of liberation that came in with Impressionism permitted every painter to do what he wanted to do, painting was finished. When they decided it was the

From *Life With Picasso* by Françoise Gilot and Carlton Lake (New York, Toronto, London: McGraw-Hill Book Co., 1964), pp. 66–67. Reprinted by permission of McGraw-Hill Book Co. [Pablo Picasso's discussion with Françoise Gilot took place sometime between 1943–53.–ED.]

painter's sensations and emotions that mattered, and every man could recreate painting as he understood it from any basis whatever, then there was no more painting; there were only individuals. Sculpture died the same death.

"Beginning with van Gogh, however great we may be, we are all, in a measure, autodidacts—you might almost say primitive painters. Painters no longer live within a tradition and so each one of us must recreate an entire language. Every painter of our times is fully authorized to recreate that language from A to Z. No criterion can be applied to him *a priori*, since we don't believe in rigid standards any longer. In a certain sense, that's a liberation but at the same time it's an enormous limitation, because when the individuality of the artist begins to express itself, what the artist gains in the way of liberty he loses in the way of order, and when you're no longer able to attach yourself to an order, basically that's very bad."

I brought up the question of Cubism. Wasn't that a kind of order, I asked him. He shrugged. "It was really the manifestation of a vague desire on the part of those of us who participated in it to get back to some kind of order, yes. We were trying to move in a direction opposite to Impressionism. That was the reason we abandoned color, emotion, sensation, and everything that had been introduced into painting by the Impressionists, to search again for an architectonic basis in the composition, trying to make an order of it."

Robert Motherwell (1948)

The history of modern art can be conceived of as a military campaign, as a civil war that has lasted more than a hundred years—if movements of the spirit can be dated—since Baudelaire first requested a painting that was to be specifically modern in subject and style. Perhaps the first dent in the lines of traditional conceptions was made by the English landscapists and by Courbet, but the major engagement begins, earlier

From "The Tour of the Sublime" by Robert Motherwell, in *Tiger's Eye*, Dec. 15, 1948. Reprinted by permission of the author.

means being now obsolete, with Manet and the Impressionists who, whatever their subjective radiance and rhythms, represent objectively the rise of modern realism (in the sense of everyday subjects), that is, the decisive attack on the Sublime. . . . The story is interesting if the essence of their goal is taken to be a passionate desire to get rid of what is dead in human experience, to get rid of concepts, whether aesthetic or metaphysical or ethical or social, that, being garbed in the costumes of the past, get in the way of their enjoyment. As though they had the sensation, while enjoying nudes in the open air, that someone was likely to move a dark Baroque decor into the background, altering the felt quality of their experience. No wonder they wanted to bury the past permanently. I pass over how remarkable it seems to some of us that small groups of men should have had, for a century or more, as one of their ideals getting rid of what is dead in human experience.

André Masson (1952)

The Orangerie of the Tuileries is the Sistine Chapel of Impressionism, . . . one of the summits of French art.

From "Monet le fondateur" by André Masson, in *Verve*, VII, 27–28 (Paris, 1952), p. 68. English trans. from Gerd Muehsam, *French Painters and Paintings from the Fourteenth Century to Post-Impressionism: A Library of Art Criticism* (New York: Frederick Ungar Publishing Co. Inc., 1970), p. 509. Reprinted by permission of Frederick Ungar Pub. Co.

THE SOCIAL HISTORY
OF IMPRESSIONISM

Arnold Hauser (1951)

The frontiers between naturalism and impressionism are fluid; it is impossible to make a clear-cut historical or conceptual distinction between them. The smoothness of the stylistic change corresponds to the continuity of the simultaneous economic development and the stability of social conditions. 1871 is of merely passing significance in the history of France. The predominance of the upper middle class remains essentially unchanged and the conservative Republic takes the place of the "liberal" Empire—that "republic without republicans",[1] which is acquiesced in only because it seems to guarantee the smoothest possible solution of the political problems. But a friendly relationship is established with it only after the supporters of the Commune have been rooted out and comfort has been found in the theory of the necessity and the healing power of bleeding.[2] The intelligentsia confronts events in a state of absolute helplessness. Flaubert, Gautier, the Goncourts, and with them most of the intellectual leaders of the age, indulge in wild insults and imprecations against the disturbers of the peace. From the Republic they hope at the most for protection against clericalism, and they see in democracy merely the lesser of the two evils.[3] Financial and industrial capitalism develops consistently along the lines long since laid down;

The Social History of Impressionism [Editor's title]. From Arnold Hauser, *The Social History of Art*, Vol. 2, pp. 869–79; 974–75. Copyright 1951 by Alfred A. Knopf, Inc. Reprinted by permission of Alfred A. Knopf, Inc. and Routledge and Kegan Paul, Ltd.

[1] André Bellessort: *Les Intellectuels et l'avènement de la troisième République*, 1931, p. 24.
[2] Paul Louis: *Hist. du socialisme en France*, pp. 236–37.
[3] A. Bellessort, *Les Intellectuels*, p. 39.

but, under the surface, important, though for the time being still un-obtrusive changes are taking place. Economic life is entering the stage of high capitalism and developing from a "free play of forces" into a rigidly organized and rationalized system, into a close-meshed net of spheres of interest, customs territories, fields of monopoly, cartels, trusts and syndicates. And just as it was feasible for this standardization and concentration of economic life to be called a sign of senility,[4] so the marks of insecurity and the omens of dissolution can be recognized throughout middle-class society. It is true that the Commune ends with a more complete defeat for the rebels than any previous revolution, but it is the first to be sustained by an international labour movement and to be followed by a victory for the bourgeoisie associated with a feeling of acute danger.[5] This mood of crisis leads to a renewal of the idealistic and mystical trends and produces, as a reaction against the prevailing pessi-mism, a strong tide of faith. It is only in the course of this development that impressionism loses its connection with naturalism and becomes transformed, especially in literature, into a new form of romanticism.

The enormous technical developments that take place must not induce us to overlook the feeling of crisis that was in the air. The crisis itself must rather be seen as an incentive to new technical achievements and improvements of methods of production.[6] Certain signs of the at-mosphere of crisis make themselves felt in all the manifestations of technical activity. It is above all the furious speed of the development and the way the pace is forced that seems pathological, particularly when compared with the rate of progress in earlier periods in the history of art and culture. For the rapid development of technology not only accelerates the change of fashion, but also the shifting emphases in the criteria of aesthetic taste; it often brings about a senseless and fruitless mania for innovation, a restless striving for the new for the mere sake of novelty. Industrialists are compelled to intensify the demand for improved products by artificial means and must not allow the feeling that the new is always better to cool down, if they really want to profit from the achievements of technology.[7] The continual and increasingly rapid replacement of old articles in everyday use by new ones leads, however, to a diminished affection for material and soon also for intel-lectual possessions, too, and readjusts the speed at which philosophical and artistic revaluations occur to that of changing fashion. Modern tech-

[4] Werner Sombart: *Der mod. Kapit*, III/1, pp. xii/xiii.
[5] Paul Louis, *Hist.*, pp. 242, 216–17.
[6] Cf. Henry Ford: *My Life and My Work*, 1922, p. 155.
[7] W. Sombart: *Ded mod. Kapit.*, III/2, pp. 603–7.—*Die deutsche Volkswirtschaft*, pp. 397–98.

nology thus introduces an unprecedented dynamism in the whole attitude to life and it is above all this new feeling of speed and change that finds expression in impressionism.

The most striking phenomenon connected with the progress of technology is the development of cultural centres into large cities in the modern sense; these form the soil in which the new art is rooted. Impressionism is an urban art, and not only because it discovers the landscape quality of the city and brings painting back from the country into the town, but because it sees the world through the eyes of the townsman and reacts to external impressions with the overstrained nerves of modern technical man. It is an urban style, because it describes the changeability, the nervous rhythm, the sudden, sharp but always ephemeral impressions of city life. And precisely as such, it implies an enormous expansion of sensual perception, a new sharpening of sensibility, a new irritability, and, with the Gothic and romanticism, it signifies one of the most important turning points in the history of Western art. In the dialectical process represented by the history of painting, the alternation of the static and the dynamic, of design and colour, abstract order and organic life, impressionism forms the climax of the development in which recognition is given to the dynamic and organic elements of experience and which completely dissolves the static world-view of the Middle Ages. A continuous line can be traced from the Gothic to impressionism comparable to the line leading from late medieval economy to high capitalism, and modern man, who regards his whole existence as a struggle and a competition, who translates all being into motion and change, for whom experience of the world increasingly becomes experience of time, is the product of this bilateral, but fundamentally uniform development.

The dominion of the moment over permanence and continuity, the feeling that every phenomenon is a fleeting and never-to-be-repeated constellation, a wave gliding away on the river of time, the river into which "one cannot step twice," is the simplest formula to which impressionism can be reduced. The whole method of impressionism, with all its artistic expedients and tricks, is bent, above all, on giving expression to his Heraclitean outlook and on stressing that reality is not a being but a becoming, not a condition but a process. Every impressionistic picture is the deposit of a moment in the perpetuum mobile of existence, the representation of a precarious, unstable balance in the play of contending forces. The impressionistic vision transforms nature into a process of growth and decay. Everything stable and coherent is dissolved into metamorphoses and assumes the character of the unfinished and fragmentary. The reproduction of the subjective act instead of the objective

substratum of seeing, with which the history of modern perspective painting begins, here achieves its culmination. The representation of light, air and atmosphere, the dissolution of the evenly coloured surface into spots and dabs of colour, the decomposition of the local colour into *valeurs*, into values of perspective and aspect, the play of reflected light and illuminated shadows, the quivering, trembling dots and the hasty, loose and abrupt strokes of the brush, the whole improvised technique with its rapid and rough sketching, the fleeting, seemingly careless perception of the object and the brilliant casualness of the execution merely express, in the final analysis, that feeling of a stirring, dynamic, constantly changing reality, which began with the re-orientation of painting by the use of perspective.

A world, the phenomena of which are in a state of constant flux and transition, produces the impression of a continuum in which everything coalesces, and in which there are no other differences but the various approaches and points of view of the beholder. An art in accordance with such a world will stress not merely the momentary and transitory nature of phenomena, will not see in man simply the measure of all things, but will seek the criterion of truth in the "hic et nunc" of the individual. It will consider chance the principle of all being, and the truth of the moment as invalidating all other truth. The primacy of the moment, of change and chance implies, in terms of aesthetics, the dominion of the passing mood over the permanent qualities of life, that is to say, the prevalence of a relation to things the property of which is to be non-committal as well as changeable. This reduction of the artistic representation to the mood of the moment is, at the same time, the expression of a fundamentally passive outlook on life, an acquiescence in the rôle of the spectator, of the receptive and contemplative subject, a standpoint of aloofness, waiting, non-involvement—in short, the aesthetic attitude purely and simply. Impressionism is the climax of self-centred aesthetic culture and signifies the ultimate consequence of the romantic renunciation of practical, active life.

Stylistically, impressionism is an extremely complex phenomenon. In some respects it represents merely the logical development of naturalism. For, if one interprets naturalism as meaning progress from the general to the particular, from the typical to the individual, from the abstract idea to the concrete, temporally and spatially conditioned experience, then the impressionistic reproduction of reality, with its emphasis on the instantaneous and the unique, is an important achievement of naturalism. The representations of impressionism are closer to sensual experience than those of naturalism in the narrower sense, and replace the object

of theoretical knowledge by that of direct optical experience more completely than any earlier art. But by detaching the optical elements of experience from the conceptual and elaborating the autonomy of the visual, impressionism departs from all art as practised hitherto, and thereby from naturalism as well. Its method is peculiar in that, whilst pre-impressionist art bases its representations on a seemingly uniform but, in fact, heterogeneously composed world-view, made up of conceptual and sensual elements alike, impressionism aspires to the homogeneity of the purely visual. All earlier art is the result of a synthesis, impressionism that of an analysis. It constructs its particular subject from the bare data of the senses, it, therefore, goes back to the unconscious psychic mechanism and gives us to some extent the raw material of experience, which is further removed from our usual conception of reality than the logically organized impressions of the senses. Impressionism is less illusionistic than naturalism; instead of the illusion, it gives elements of the subject, instead of a picture of the whole, the bricks of which experience is composed. Before impressionism, art reproduced objects by *signs,* now it represents them through their components, through *parts* of the material of which they are made up.[8]

In comparison with the older art, naturalism marked an increase in the elements of the composition, in other words, an extension of the motifs and an enrichment of the technical means. The impressionistic method, on the other hand, involves a series of reductions, a system of restrictions and simplifications.[9] Nothing is more typical of an impressionist painting than that it must be looked at from a certain distance and that it describes things with the omissions inevitable in them when seen from a distance. The series of reductions which it carries out begins with the restriction of the elements of the representation to the purely visual and the elimination of everything of a nonoptical nature or that cannot be translated into optical terms. The waiving of the so-called literary elements of the subject, the story or the anecdote, is the most striking expression of this "recollection by painting of its own particular means." The reduction of all motifs to landscape, still life and the portrait, or the treatment of every kind of subject as a "landscape" and "still life," is nothing more than a symptom of the predominance of the specifically "painterly" principle in painting. "It is the treatment of a subject for the sake of the tones, and not for the sake of the subject itself, that distinguishes the impressionists from other painters," as one

[8] Cf. Pierre Francastel: *L'Impressionnisme,* 1937, pp. 25–26, 80.
[9] Georg Marzynski: "Die impressionistische Methode." *Zeitschr. f. Aesth, u. allg. Kunstwissenschaft,* XIV, 1920.

of the earliest historians and theorists of the movement points out.[10] This neutralization and reduction of the motif to its bare material essentials can be considered an expression of the antiromantic outlook of the time and seen as the trivialization and stripping bare of all the heroic and stately qualities of the subject-matter of art, but it can also be regarded as a departure from reality, and the restriction of painting to subjects of "its own" can be looked upon as a loss from the naturalistic point of view. The "smile" that the Greeks discovered in the plastic arts and that, as has been observed, is being lost in modern art[11] is sacrificed to the purely pictorial aspect; but it means that all psychology and all humanism disappears from painting altogether.

The replacement of tactile by visual values, in other words, the transfer of physical volume and plastic form to the surface, is a further step, bound up with the new "painterly" trend, in the series of reductions to which impressionism subjects the naturalistic picture of reality. This reduction is, however, in no sense the aim, but only a by-product of the method. The emphasis on colour and the desire to turn the whole picture into a harmony of colour and light effects is the aim, the absorbing of the space and the dissolving of the solid structure of the bodies nothing more than a concomitant. Impressionism not only reduces reality to a two-dimensional surface but, within this two-dimensionality, to a system of shapeless spots; in other words, it forgoes not only plasticity but also design, not only spatial but also linear form. That the picture makes up in energy and sensual charm for what it loses in clarity and evidence is obvious, and this gain was also the main concern of the impressionists themselves. But the public felt the loss more strongly than the gain and now that the impressionistic way of looking at things has become one of the most important components of our optical experience, we are unable even to imagine how helplessly the public confronted this medley of spots and blots. Impressionism formed merely the last step in a process of increasing obscurity that had been going on for centuries. Since the baroque, pictorial representations had confronted the beholder with an increasingly difficult problem; they had become more and more opaque and their relation to reality more and more complex. But impressionism represented a more daring leap than any single phase of the earlier development, and the shock produced by the first impressionist exhibitions was comparable to nothing ever experienced before in the whole history of artistic innovation. People con-

[10] Georges Rivière: "L'Exposition des Impressionnistes." In *L'Impressionniste. Journal d'Art*, 6th April 1877.—Reprinted in L. Venturi: *Les Archives de l'Impressionnisme*, 1939, II, p. 309.
[11] André Malraux: "The Psychology of Art." *Horizon*, 1948, No. 103, p. 55.

sidered the rapid execution and the shapelessness of the pictures as an insolent provocation; they thought that they were being made fun of and the revenge they took was as cruel as they were able to contrive.

With these innovations, however, the succession of reductions employed by the impressionist method is by no means exhausted. The very colours which impressionism uses alter and distort those of our everyday experience. We think, for example, of a piece of "white" paper as white in every lighting, despite the coloured reflexes which it shows in ordinary daylight. In other words: the "remembered colour" which we associate with an object, and which is the result of long experience and habit, displaces the concrete impression gained from immediate perception;[12] impressionism now goes back behind the remembered, theoretically established colour to the real sensation, which is, incidentally, in no sense a spontaneous act, but represents a supremely artificial and extremely complicated psychological process.

Impressionistic perception, finally, brings about one further and very severe reduction in the usual picture of reality, inasmuch as it shows colours not as concrete qualities bound to a particular object, but as abstract, incorporeal, immaterial phenomena—as it were colours-in-themselves. If we hold a screen with a small opening in front of an object that is big enough to reveal the colour, but not big enough to enlighten us as to the form of the object and the relationship of the colour in question to the object, it is a well-known fact that we get an indefinite, hovering impression, which is very different from the character of the colours adherent to plastic form we habitually see. In this way the colour of fire loses its radiance, the colour of silk its lustre, the colour of water its transparency, etc.[13] Impressionism always represents objects in these incorporeal surface colours, which make a very direct and lively impression, owing to their freshness and intensity, but considerably reduce the illusionistic effect of the picture and most strikingly reveal the conventionality of the impressionistic method.

In the second half of the nineteenth century painting becomes the leading art. Impressionism here develops into an autonomous style at a time when in the literary world a conflict is still raging around naturalism. The first collective exhibition of the impressionists takes place in 1874, but the history of impressionism begins some twenty years earlier, and already comes to an end with the eighth group exhibition in the year 1886. About this time impressionism as a uniform group movement breaks up and a new, post-impressionist period begins which lasts until

12 G. Marzynski, *Methode*, p. 90.
13 *Ibid.*, p. 91.

about 1906, the year of Cézanne's death.[14] After the predominance of literature in the seventeenth and eighteenth centuries and the leading part played by music in the age of romanticism, a change in favour of painting occurs about the middle of the nineteenth century. The art critic Asselineau places the dethronement of poetry by painting as early as 1840,[15] and, a generation later, the Goncourt brothers already exclaim with enthusiasm in their voices: "What a happy profession that of the painter is compared with that of the writer!"[16] Painting dominates all the other arts not only as the most progressive art of the age, but its productions also surpass the literary and musical achievements of the same period qualitatively, especially in France, where it was perfectly correct to maintain that the great poets of this period were the impressionist painters.[17] It is true that nineteenth-century art remains romantic to some extent and the poets of the century profess a belief in music as the highest artistic ideal, but what they understand thereby is more a symbol of sovereign, unfettered creation, independent of objective reality, than the concrete example of music. Impressionist painting discovers, on the other hand, sensations which poetry and music also attempt to express and in which they adapt their means of expression to painterly forms. Atmospherical impressions, especially the experience of light, air and colour, are perceptions native to painting, and when the attempt is made to reproduce moods of this kind in the other arts, we are quite within our rights to speak of a "painterly" style of poetry and music. But the style of these arts is also painterly, when they express themselves, forgoing distinct "contours," with the aid of colour and shade effects, and attach more importance to the vivacity of the details than the uniformity of the total impression. When Paul Bourget points out that, in the style of his time, the impression made by the single page is always stronger than that of the whole book, that made by a sentence deeper than that of a page and that of the single words more striking than that of a sentence,[18] what he is describing is the method of impressionism—the style of an atomized, dynamically-charged world-view.

Impressionism is not, however, merely the style of a particular period dominating all the arts, it is also the last universally valid "European" style—the latest trend based on a general consensus of taste. Since its dissolution it has been impossible to classify stylistically either the various arts or the various nations and cultures. But impressionism neither ends

[14] John Rewald: *The History of Impressionism*, 1946, pp. 6–7.
[15] Albert Cassagne: *La Théorie de l'art pour l'art en France*, 1906, p. 351.
[16] E. and J. de Goncourt: *Journal.* 1st May 1869, III, p. 221.
[17] Henri Focillon: *La Peinture aux 19 e et 20 e siècles*, 1928, p. 200.
[18] Paul Bourget, *Essais de psych. contemp.*, 1885, p. 25.

nor begins abruptly. Delacroix, who discovered the law
colours and the coloration of shadows, and Constable,
the complex composition of colour effects in nature, al
much of the impressionistic method. The energizing of
the essence of impressionism, at any rate begins with th
ments of plein-airism in the painters of Barbizon repres
step in this development. But what contributes to the ris ...pres-
sionism as a collective movement is above all, on the one hand, the
artistic experience of the city, the beginnings of which are to be found
in Manet, and, on the other hand, the amalgamation of the young
painters which is brought about by the opposition of the public. At first
sight, it may seem surprising that the metropolis, with its herding to-
gether and intermingling of people, should produce this intimate art
rooted in the feeling of individual singularity and solitude. But it is a
familiar fact that nothing seems so isolating as the close proximity of
too many people, and nowhere does one feel so lonely and forsaken as
in a great crowd of strangers. The two basic feelings which life in such
an environment produces, the feeling of being alone and unobserved,
on the one hand, and the impression of roaring traffic, incessant move-
ment and constant variety, on the other, breed the impressionistic outlook
on life in which the most subtle moods are combined with the most rapid
alternation of sensations. The negative attitude of the public as a motive
for the rise of impressionism as a movement seems just as surprising at
first sight. The impressionists never behaved aggressively towards the
public; they had every desire to remain within the framework of tradi-
tion, and often made desperate efforts to be recognized in official quarters,
above all in the Salon, which they considered the normal road to success.
At any rate, the spirit of contradiction and the desire to attract attention
by flabbergasting the public play a much smaller part with them than
with most romantics and many naturalists. All the same, there may never
have existed such a deep divergence between official circles and the
younger generation of artists, and the feeling of being jeered at may
never have been so strong as now. The impressionists certainly did not
make it easy for people to understand their artistic ideas—but in what
a bad way the art appreciation of the public must have been to allow
such great, honest and peaceable artists as Monet, Renoir and Pissarro
almost to starve.

Impressionism also had nothing of the plebeian about it, to make an
unfavourable impression on the bourgeois public; it was rather an "aristo-
crats' style," elegant and fastidious, nervous and sensitive, sensual and
epicurean, keen on rare and exquisite subjects, bent on strictly personal
experiences, experiences of solitude and seclusion and the sensations of

ver-refined senses and nerves. It is, however, the creation of artists who not only come very largely from the lower and middle sections of the bourgeoisie, but who are much less concerned with intellectual and aesthetic problems than the artists of earlier generations; they are less versatile and sophisticated, more exclusively craftsmen and "technicians" than their predecessors. But there are also members of the well-to-do bourgeoisie and even of the aristocracy amongst them. Manet, Bazille, Berthe Morisot and Cézanne are the children of rich parents, Degas is of aristocratic and Toulouse-Lautrec of high aristocratic descent. The re-fined intellectual style and cultivated well-bred manners of Manet and Degas, the elegance and delicate artistry of Constantin Guys and Toulouse-Lautrec, show the genteel bourgeois society of the Second Empire, the world of the crinoline and the décolleté, the equipages and the riding horses in the Bois, from its most attractive side.

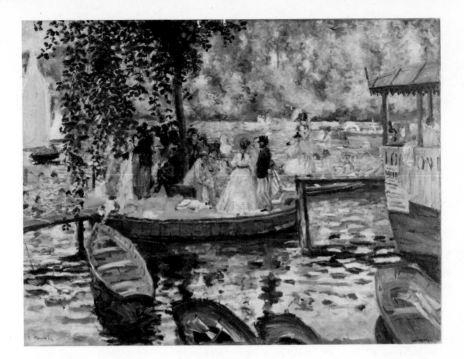

Fig. 1
PIERRE AUGUSTE RENOIR:
La Grenouillère (1869)
(Nationalmuseum, Stockholm, Sweden)

Fig. 2
CLAUDE MONET:
La Grenouillère (1869)
(The Metropolitan Museum of Art:
The H.O. Havemeyer Collection: Bequest of
Mrs. H.O. Havemeyer, 1929)

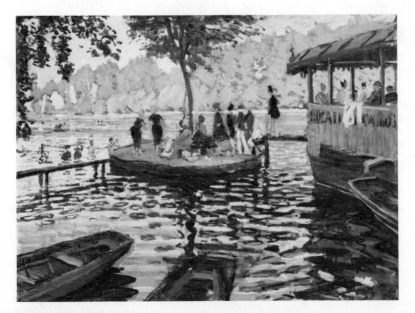

Fig. 3
PIERRE AUGUSTE RENOIR:
*Dancing at the Moulin
de la Galette* (1876)
(The Louvre, Paris:
Photo, National Museum,
Paris)

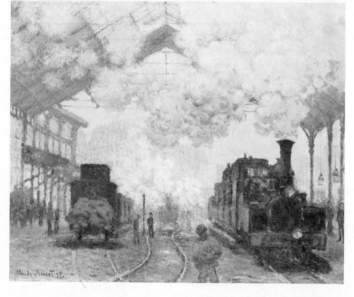

Fig. 4
CLAUDE MONET:
Gare St. Lazare, Paris
(1877)
(Courtesy of the Fogg
Art Museum, Harvard
University: Bequest-
collection of Maurice
Wertheim)

Fig. 5
CAMILLE PISSARRO:
Jallais Hill, Pointoise
(1867)
(The Metropolitan
Museum of Art: Bequest
of William Church
Osborn, 1951)

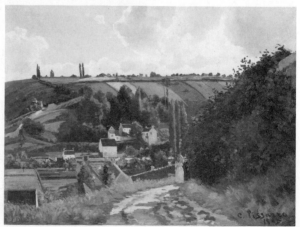

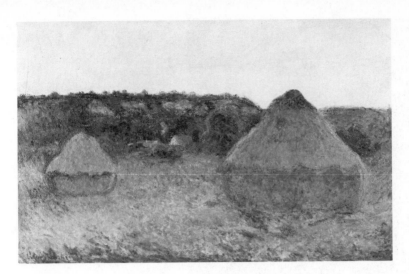

Fig. 6
CLAUDE MONET:
Two Haystacks (1891)
(Courtesy of The Art Institute of Chicago:
Mr. and Mrs. Lewis L. Coburn Memorial Collection, 1933)

Fig. 7
PIERRE AUGUSTE RENOIR:
Madame Charpentier and Her Children (1878)
(The Metropolitan Museum of Art:
Wolfe Fund, 1907)

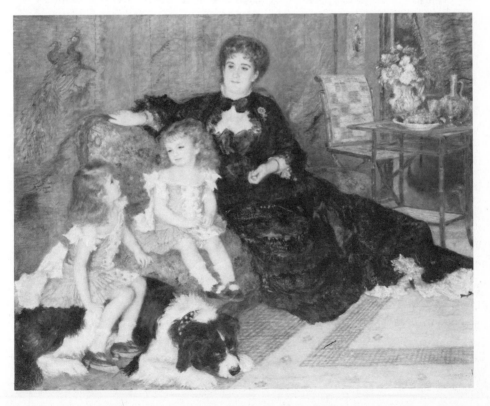

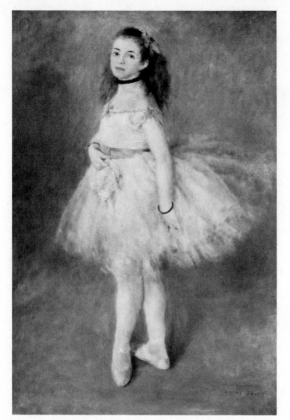

Fig. 8
PIERRE AUGUSTE RENOIR:
The Dancer (1874)
(National Gallery of Art,
Washington, D.C.:
Widener Collection)

Fig. 9
CLAUDE MONET:
*Terrace at Sainte-
Adresse* (ca. 1866–67)
(The Metropolitan
Museum of Art:
Purchased with special
contributions and pur-
chase funds given or
bequeathed by friends
of the Museum, 1967)

Fig. 10
CLAUDE MONET:
The Cliffs at Etretat (1885)
(Sterling and Francine Clark Art Institute,
Williamstown, Massachusetts)

Fig. 12
CLAUDE MONET:
Boulevard des Capucines, Paris
(*Les Grands Boulevards*) (1873–74)
(Nelson Gallery-Atkins Museum,
Kansas City, Missouri:
Nelson Fund)

Fig. 11
PIERRE AUGUSTE RENOIR:
Nude in the Sun (1876)
(The Louvre, Paris:
Photo, National Museum, Paris)

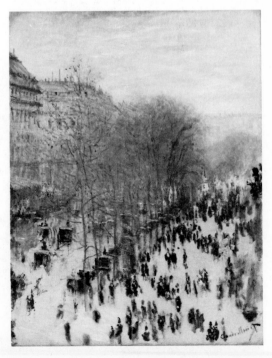

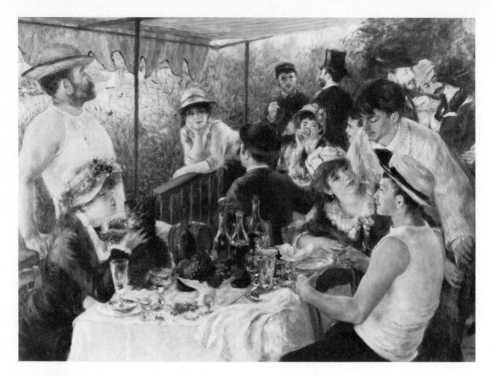

Fig. 13
PIERRE AUGUSTE RENOIR:
The Luncheon of the Boating Party (1881)
(The Phillips Collection, Washington, D.C.)

Fig. 14
PIERRE AUGUSTE RENOIR:
The Pont des Arts, Paris (1868)
(The Norton Simon Foundation, Los Angeles,
California)

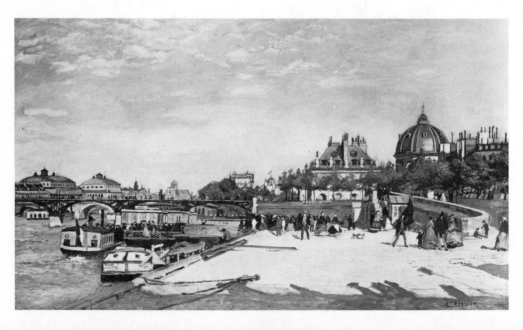

Fig. 15
ADOLPHE BRAUN:
The Pont des Arts, Paris (1867)
(detail of panoramic photograph)
(Société Française de Photographie, Paris)

Fig. 16
CAMILLE PISSARRO:
Factory Near Pointoise (1873)
(Museum of Fine Arts, Springfield, Massachusetts:
The James Philip Gray Collection)

Fig. 17
CAMILLE PISSARRO:
Port of Rouen, Saint-Sever (1896)
(The Louvre, Paris:
Photo, National Museum, Paris)

Fig. 18
CLAUDE MONET:
Regatta at Argenteuil (ca. 1872)
(The Louvre, Paris:
Photo, National Museum, Paris)

Fig. 15
ADOLPHE BRAUN:
The Pont des Arts, Paris (1867)
(detail of panoramic photograph)
(Société Française de Photographie, Paris)

Fig. 16
CAMILLE PISSARRO:
Factory Near Pointoise (1873)
(Museum of Fine Arts, Springfield, Massachusetts:
The James Philip Gray Collection)

Fig. 17
CAMILLE PISSARRO:
Port of Rouen, Saint-Sever (1896)
(The Louvre, Paris:
Photo, National Museum, Paris)

Fig. 18
CLAUDE MONET:
Regatta at Argenteuil (ca. 1872)
(The Louvre, Paris:
Photo, National Museum, Paris)

Fig. 19
CLAUDE MONET:
Lavacourt (?) Winter
(1881)
(The National Gallery,
London)

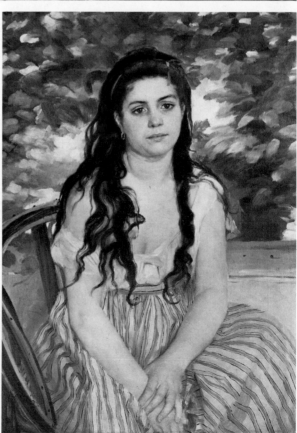

Fig. 20
PIERRE AUGUSTE RENOIR:
In the Summertime
[The Bohemian] (1868)
(Nationalgalerie,
Berlin)

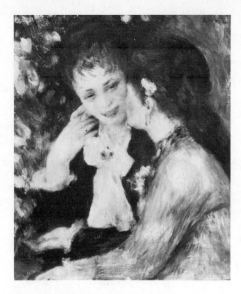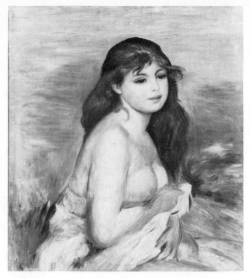

Fig. 21
PIERRE AUGUSTE RENOIR:
Confidences (1878)
(Collection Oskar Reinhart,
"Am Römerholz,"
Winterthur, Zurich, Switzerland)

Fig. 22
PIERRE AUGUSTE RENOIR:
After the Bath (ca. 1885–87)
(Nasjonalgalleriet, Oslo, Norway)

Fig. 23
CAMILLE PISSARRO:
Spring Pasture (1889)
(Courtesy, Museum of Fine Arts, Boston, Massachusetts:
Deposited by the Trustees of the White Fund, Lawrence,
Massachusetts)

Fig. 24
UTAGAWA HIROSHIGE:
Evening Scene in Saruwakacho
(No. 40 from the series
100 Views of Edo) (1856–57),
color woodblock print
(The Brooklyn Museum, New York)

Fig. 25
PIERRE AUGUSTE RENOIR:
Still Life with Bouquet
(1871)
(The Museum of Fine
Arts, Houston, Texas:
Gift of Mrs. Sarah
Campbell Blaffer; Robert
Lee Blaffer Memorial
Collection)

Fig. 26
CAMILLE PISSARRO:
Girl in Field with Turkeys (1885), watercolor on fabric
(The Brooklyn Museum, New York:
Gift of Mrs. Edwin C. Vogel)

Fig. 27
ADOLPHE WILLIAM
BOUGUEREAU:
Nymphs and Satyr (1873)
(Sterling and Francine
Clark Art Institute,
Williamstown,
Massachusetts)

THE SOCIOLOGY OF CAREER SUPPORT
BY THE DEALER AND BY THE GROUP
SHOW

Harrison and Cynthia White (1965)

THE DEALER AS SPECULATOR

No one was to use the speculative motif more daringly and effectively than the Impressionists' principal dealer, Durand-Ruel.[1] Paul Durand-Ruel learned the picture trade from his father. The elder Durand, beginning in the 1820's as a merchant of artists' paper, canvas, and colors (an adjunct to the family paper mill), became the exclusive dealer in works of the then "modern" school. Constable, Delacroix, and the Barbizon landscapists were his first "collection." By 1865, when the father died and Paul took over, a clientele had been established and branch operations created in London, Holland, Belgium, and Germany. The picture shop became a "gallery" and dealt exclusively in paintings and prints, rather than combining the sale of antiques and *objets de luxe* as many dealers still did.

A more astute gambler than his father, Durand the younger began an aggressive program to create and maintain a bullish market. He bought up large numbers of works by the "School of 1830," offering larger-than-usual prices at the many sales of private collections. Thus he attracted attention and, when buyers appeared at his door, he resisted

The Sociology of Career Support by the Dealer and by the Group Show [Editor's title]. From Harrison C. White and Cynthia A. White, *Canvases and Careers: Institutional Change in the French Painting World* (New York: John Wiley & Sons, Inc., 1965); these excerpts, pp. 124–30; 134–45; 148–54. Copyright © 1965 by John Wiley & Sons, Inc. Reprinted by permission of John Wiley & Sons, Inc. [I would also like to thank Harrison and Cynthia White for granting permission to reprint this work. –ED.]

[1] For sources of the following history, see "Mémoires de Paul Durand-Ruel" in L. Venturi, *Les Archives de l'Impressionnisme*, Vol. 2, Paris–New York, Durand-Ruel, 1939.

all but the highest offers. (With taste and acumen, he also acquired, in this period, works by Rembrandt, Goya, Velasquez, and Ruysdael at low prices. These he kept, biding his time, until conditions were ripe for making a killing.)

Then, as now, paintings from a prestigious private collection brought higher prices. Durand-Ruel arranged with a banker, Edwards, to receive an advance of capital in exchange for paintings which were to be kept by the banker until the proper moment for sale of "The Edwards Collection."

In 1869 Durand founded a *Revue Internationale de l'Art et de la Curiosité,* a journal designed to push the "modern school." He recruited liberal writers and made sure his name did not appear in connection with the publication. (The writers, however, got out of hand and the *Revue* folded in 1871.)

Following the examples of Martinet and other dealers, he exhibited his wares in his "galleries." However, Durand-Ruel commented in retrospect that exhibitions were good for a painter's reputation, but a poor way to sell pictures. People are more likely to buy when presented with individual works, one at a time. They are also more likely to pay a high price.[2] But the idea of public exhibition had so permeated the art world that the dealers took it up, willy-nilly.

His "campaign in favor of those called Impressionists" began in 1870, when he met Monet and Pissarro in London. It was a case of the fortunes of war. In 1870, as the Prussians neared Paris, he fled to England, shipping his stock of paintings ahead. In London he opened a gallery on New Bond Street and exhibited his pictures, as well as the collections of several French *amateurs* who had entrusted them to him for safe-keeping. Since his own name was not well-enough known, he used a fictitious sponsor: "The Society of French Artists." Among the pictures, mostly "School of 1830," appeared several paintings by Monet and Pissarro.

Both artists were living in London for the duration of the war. Monet met the dealer through Daubigny, who brought him and his paintings to the Bond Street gallery. Pissarro happened in there, left a canvas, and received this note:

> My dear sir; you brought me a charming picture and I regret not having been in my gallery to pay you my respects in person. Tell me, please, the price you want and be kind enough to send me others when you are able

[2] For the perfection of *this* technique, see S. N. Berman's biography of *Duveen* (Modern Library paperback).

to. I must sell a lot of your work here. Your friend Monet asked me for your address. He did not know you were in England.[3]

Durand did buy a number of paintings, paying, generally, 300 francs for the Monets and 200 for the Pissarros. This was not a fortune, but it was double what they had customarily received for their works.

Back in Paris after the war's end, Durand was introduced to the rest of the group. His prices for Renoir's and Sisley's works ranged from 200–300 francs during the early 1870's. He began buying Degas' works, particularly the pastels, for 800–3000 francs. Visiting Manet's studio one day, he bought every painting on hand, 23 pictures for 35,000 francs, an average of 1500 francs each. These 23 paintings were eventually sold for well over 800,000 francs, mostly to various American collectors and museums.[4]

THE DEALER AS PATRON

Durand-Ruel was far more willing than other dealers to acquire a painting even though he had no prospective buyer in sight. Moreover, he would make substantial advances to the painters, to be paid off in pictures.[5] In return, although this seems to have been a gentlemen's agreement rather than a contract, he did expect sole rights to their work. He was incensed when they strayed to other dealers like his rival, Petit. As Durand could not always pay advances when they were needed, the painters were forced to leave pictures with other dealers in hopes of selling them. However, other dealers seldom bought outright and did not often advance funds. The painters became increasingly dependent on Durand-Ruel for any sort of steady income.

The Impressionist's dealer, in effect, had recreated the role of patron —in the Renaissance sense of the word. He worked from a different economic base than the patron of earlier centuries and his motives were different. Yet the support artists received from him was a close approximation of the patronage relationship of earlier times. This relationship was not merely a matter of money. Often Durand, like Renaissance patrons, simply did not have the cash, or was in too precarious a financial position to pay his painters a steady living allowance. But the Impressionists, unlike other painters excluded from the tight circles of govern-

[3] Quoted in J. Rewald, *History of Impressionism* (rev. ed.) (New York: Museum of Modern Art, 1961), p. 254. [See also 4th revised edition, 1973–ED.]
[4] See "Memoires" in Venturi, *Archives*, II, pp. 189–92.
[5] See, particularly, Monet's letters to Durand-Ruel in Venturi, *Archives*, I, pp. 223ff.; also, Pissarro letters in Vol. 2, pp. 10ff.

ment patronage, had someone of whom they could *demand* regular support, recognition, and praise.

"I am counting on you." . . . "Please don't forget your devoted servant." . . . "Your silence really worries me . . . I beg you to tell me frankly if you are not able to help me . . . I am surprised that you haven't answered me." Plaints like these are a theme repeated over and over in Impressionist letters to Durand-Ruel. These letters could very well have been written in an earlier age to a great princely patron. There is the typical mixture of fawning and arrogance, interlaced with threats to go over to another dealer (prince) and work for his glory, or to sell privately to amateurs.

Thus Pissarro:

> I see myself forced to sell, if possible, a few paintings. I greatly regret being obliged to come to this, for necessarily the prices on my pictures will be lowered, but I have no choice, having many debts. . . . I must make money, whatever the cost. Have the goodness to tell me, my dear M. Durand-Ruel, what I should do.[6]
>
> Would you let me know, please if you will take them [some of the painted fans which were Pissarro's specialty] for I have other outlets; I have shown them to you first.[7]
>
> I still have the intention of recovering my complete liberty in the sale of my works.

And Monet:

> You are not going to believe that I doubt you. No, I know your courage and your energy. . . . Briefly, tell me the situation; are you certain that you can give me some money today? If not, I am going to take up my former method [of] running about to the *amateurs*. . . . Send your reply by the bearer [of this letter], it irritates me to come continually to the shop to importune you.[8]
>
> Here it is a month and a half since your departure and not a word from you, not a sou from your son. I don't know what you think I'm living on, but I remain amazed by your indifference. . . . The last straw came (and the news was joyfully thrown in my face) when I heard that you had sold my paintings at very low prices.[9]
>
> The house of Boussod [rival firm] has now Degas and Monets and will have Sisleys and Renoirs as well. . . . I have been surprised and a bit pained, I must say, at your silence and if Boussod had not given me an advance, and without the Petit exhibition, I would doubtless have found myself in difficulties.[10]

6 Venturi, *Archives*, Vol. II, p. 12.
7 Venturi, *Archives*, Vol. II, p. 30.
8 Venturi, *Archives*, Vol. I, p. 311.
9 Venturi, *Archives*, Vol. I, p. 325.
10 Venturi, *Archives*, Vol. I, p. 329.

The technique of playing off one dealer against another was necessarily soon learned. Through dealer-patrons the free market was coagulated into a few competing nuclei, stable enough to serve as effective substitutes for government patronage. And the social and emotional content of the patronage relation lay closer to that of the pre-nineteenth-century role than to the patronage of contemporary Academic bureaucracy.

Once England, Germany, and the United States had taken their taste secondhand from the official French preferences. After a few "campaigns" by Durand-Ruel, among others, they began to look more to individual dealers and to be receptive to antiofficial art. Although Germany had shown an early flutter of interest in Courbet and the Barbizon School, America was the most important market tapped by Durand-Ruel.

Soon enterprising Americans were searching out the painters themselves—particularly Monet. In 1891 Pissarro wrote to his son Lucien: "All that Monet does goes to Americans for four, five, six thousand francs." And in 1893, he mentioned this episode:

> I was introduced . . . to an American dealer interested exclusively in the painters of 1830. He admitted to me that great steps had been taken forward since then.
> Well then, get something before it is too dear!
> "Oh," said the dealer, "we are not that confident. Sueton has too many Monets. If he doesn't make a good deal soon, it may turn out to be a poor investment!"
> Sueton, the big American dealer who has one hundred and twenty Monets, has become Durand's competitor. . . .[11]

American collectors were on the march all over Europe toward the turn of the century. In France they bought contemporary art. Frenchmen realized, too late in the game, that a great many choice Impressionist works had left the country for good. Pissarro mentioned, in 1894, that the Parisian art world was stirred up because most of Monet's "Cathedrals" series were being sold to Americans who could afford and were willing to pay the 15,000 each asked by Monet.[12] The prosperity of most of the Impressionists from 1890 on was due to this largess, attracted by Durand-Ruel in his "American Ventures."

Although Durand-Ruel had his ups and downs with the Impressionists, although the big money did not begin to come to them until

[11] J. Rewald (Ed.), *Camille Pissarro: Letters to His Son, Lucien* (New York: Pantheon Books, a division of Random House, Inc., 1943), p. 159.
[12] *Ibid.*, p. 215.

they had acquired some other dealers as well, nevertheless he retained rightly the title of "Dealer for the Impressionists." He possessed daring, taste, and imagination as well as a family tradition in the trade. The former qualities made him an innovator in the selling of art; the latter gave him a commitment to the support of new art and an ability to discern its qualities. Thus, as speculator and patron, he set a pattern that was soon adopted by other contemporary dealers and, later, by men such as Vollard and Kahnweiler.

"IT'S A WONDERFUL BUSINESS BEING A BOURGEOIS— WITHOUT A CENT!"

By the early 1890's Pissarro, Monet, and Renoir were making substantial incomes. Degas (who had spent his resources bailing a relative out of bankruptcy) was not wealthy, but was comfortable. Sisley, consistently the least successful, signed a contract with Petit for his total production and had a secure, though small, income. Cézanne was living and painting in seclusion at Aix, having come into his inheritance. He was now sought out by the younger generation, as Corot had been.

From their first appearances as professional painters in the early 1860's, it had taken thirty years. That is a long haul, and much has been written in popular literature about their "poverty and early struggles," probably through dissemination of the "unrecognized genius" theories in the critical writing earlier described. We were curious to find out exactly what their yearly income was and, just as important, how their financial situation looked *to them*.

Any picture of the Impressionists as living at a laborer's standard, of course, is not true. What is true and significant is that they were paid, as most painters (and writers) are, on a manual piecework basis—that is, a lower-class basis; at the same time, their backgrounds and their aspirations decreed that they adhere to a middle-class standard of living. A painter is a learned professional—and a learned professional is middle class.

This middle-class standard meant steady support for one's family, dignified, reasonably furnished living quarters, and at least one servant; it meant decent middle-class clothing, good food served in the dining room with a white tablecloth; it meant the ability to entertain guests and to buy a train ticket to Paris from the suburban town where one lived. The tension between this standard and the unpredictability and insecurity of the Impressionists' income caused a genuine anguish.

Pissarro's wry exclamation expressed it very neatly: "It's a wonderful business being a bourgeois—without a cent!"[13] What they needed was a salary, a steady income. Durand-Ruel was able to give them its equivalent in certain periods—but then, when he was forced to cut it off, the problem became all the more acute.

TABLE 1
Parisian Wages, in Francs per Day

1844	Typesetters, 4.25; bakers, jewelers, and tailors, 4.50.
1848	Jewelers and goldsmiths, 5.
1857	Printers and stonecutters, 5; roofers, 6; metal workers, 7.
1878	Carriage builders and wheelwrights, 5.50; industrial workers, 4.90.
1878–1884	Shop clerks average 100 francs per month.

SOURCE: Paul Louis, *La Condition Ouvrière en France Depuis Cent Ans*, Paris, Presses Universitaires de France, 1950.

Piecing together information on the yearly incomes of the Impressionists is a difficult job. What we have collected from various sources is not adequate for a complete picture. But we have enough to make some inferences about their living standard and their incomes. In Tables 1 and 2 some data on wages and cost of living for workers are presented for comparison. . . .

• • •

PISSARRO'S FINANCES

Married before the others in the group and with a large family (by 1884, six children) to support, Pissarro was in the most difficult situation. Moreover, his Jewishness no less than his Frenchness dictated values of family stability and protection which he often was hard put to fulfill. The Pissarros, however, had relatives in Paris and in London, as well as a wealthy friend, Ludovic Piette, and these provided some cushion of security in time of need.

Specific information is scarce for the 1860's. Even for the period from 1870–1880 we can give only a few of the actual prices on Pissarro's works. We do not know how many were sold—there are only a few clues.

13 *Ibid.*, p. 248.

TABLE 2

Yearly Expenses, in Francs, for Average Skilled Worker in Paris with Household of Four Persons

EXPENSES	Years									
	1848–1851	1855	1860	1865	1870	1875	1880	1884	1908	
Amount for food and fuel	752	1,132	984	907	1,101	1,000	1,100	1,064	87	
Rent: Slum						91			87	
Average	200							277		
Good						294			350	
Total Expenses*	1,150							1,263		

* Estimated separately.

SOURCE: Same as Table 1.

Pissarro had dealt much with Père Martin, a little dealer who was willing to buy fairly regularly at low prices; 40–50 francs was the usual price.[14] Durand-Ruel paid a flat rate of 200 francs per painting in these early years. In the 1872 London show of his Barbizon and Impressionist works, Durand exhibited 9 Pissarros, which makes a total of 1800 francs worth from 1871–1872.[15]

In 1873 five Pissarros sold from a private collection brought prices startlingly high for him: 270, 320, 350, 700, and 900 francs.[16] Although these auctions of private collections do not usually reflect the prices the painter himself gets for his works, they can push his prices up a little. If the positive effect on prices was negligible, the negative effect, if auction prices were abysmally low, could be drastic; so it was important that bids be at least at the level of the going price.

Pissarro's high prices at auctions of private collections were maintained through 1874.[17] In 1873 he wrote with confidence to Duret: "You are right, mon cher, we are beginning to make our mark. . . . Durand-Ruel stands firm, and we hope to go straight ahead without worrying as to what people think about us."[18] Durand-Ruel put on a special show, with elaborate catalogue, at his Paris gallery in 1873. This apparently helped raise Pissarro's prices, for Rewald stated that he was getting 500 francs for recent works in that year.[19] . . . his "high" prices do not compare with prices for good landscapes at auctions even of a generation earlier.

A painter, unlike most other modern pieceworkers, has to pay for his own materials. He must have a certain amount of capital if he is even to produce works, which may or may not sell. The Impressionists' yearly color-and-canvas bills ranged from 500 to almost 2000 francs.[20] The solution to this problem was to exchange paintings for materials. Père Tanguy, the little color dealer who was to be immortalized in a portrait by Van Gogh, had early entered into this arrangement with Pissarro.[21] Then there was often the expense of framing, essential for pictures to be exhibited.

The group exhibitions, which began in 1874, did not produce much in the way of direct sales in this decade. (Their social effects will be discussed later.) In 1874 Pissarro got only 130 francs from sales at the

[14] A. Tabarant, *Pissarro*, London, 1925, p. 24.
[15] Venturi, *Archives*, Vol. II, p. 179.
[16] Tabarant, *Pissarro*, p. 28.
[17] *Ibid.*, p. 30.
[18] *Ibid.*, p. 25.
[19] Rewald, *Impressionism*, p. 309.
[20] Venturi, *Archives*, Letters of Pissarro, Monet, Renoir, Sisley, *passim*.
[21] Tabarant, *Pissarro*, p. 24.

exhibition.[22] In 1876 the highest bid on his four works at the auction held after the show was 230 francs.[23]

In the late 1870's recorded sales direct to collectors were not high either. Eugène Murer, who began to buy from Pissarro around 1877, paid 50 francs "for all canvases up to 20"—that is, 20 cm. in one dimension. For a portrait of himself he is recorded as paying, after some grumbling, 150 francs. The 50-franc price was also Pissarro's usual one for occasional sales to the dealers Latouche and Petit.[24]

From 1870 to 1876, then, Pissarro's prices were on the rise, reaching in some instances 500 francs. In the following five years, they dropped back to the low levels of the 1860's. An economic depression which forced Durand to suspend his purchases and sell out all his paintings had a strong effect. Without Durand to push up bidding at a large private collection sale in 1878, Impressionist prices fell drastically.

The Parisian painter's financial year was not characterized by steady sales. In summer, the dreaded "dead" period, sales always dropped to practically nothing. The best time was from late winter through the spring Salon. Thus, in October 1874 and in the summer of 1875, the Pissarro family was forced to accept the hospitality of Piette at his farm in Brittany.[25] As with Pissarro, so with the other Impressionists: the unsteadiness of income seemed to eat up even comfortable profits. Bills piled up and as soon as money was again available, it went to creditors. Pissarro wrote, in a later year, "The rent paid, I have left only 50 francs for eight persons."[26] When credit was exhausted, the only solution in a bad period was to go around to friends or to seek, once more, advance funds from a dealer.

The Pissarros' residences testify to a middle-class standard of life. In the late 1860's they rented a villa in Louveciennes, a middle-class suburb near Versailles. After the war they settled down for the decade in a rented house in the town of Pontoise farther out to the north of Paris.[27] In 1884 they made a final move to the farther outlying town of Eragny. The rent was "not too dear: a thousand francs" [per year—compare with Table 2] "with garden and fields."[28] The house, judging from a photograph,[29] is two-storied, substantial, gracious, mansard-roofed. In 1892 Pissarro bought this house for 15,000 francs.

Pissarro's frequent trips to Paris from these outlying towns meant

22 Rewald, *Impressionism*, p. 334.
23 Tabarant, *Pissarro*, p. 38.
24 *Ibid.*, p. 40.
25 Rewald, *Impressionism*, pp. 336, 363.
26 Venturi, *Archives*, Vol. II, p. 15.
27 Tabarant, *Pissarro*, p. 24.
28 Rewald, *Pissarro Letters*, p. 58.
29 *Ibid.*, p. 128.

having the money for railway fare—5 francs from Eragny to Paris, for instance. To keep "one foot in Paris" he also maintained, from 1878 to 1883, a small apartment in Montmartre.[30] When in Paris, Pissarro usually went to the "Impressionist dinners" held on Thursday nights. The bill was 13 to 15 francs each.[31] During the 1880's the family nearly always had a maid and Pissarro sometimes spent several days at the business of hiring one and transporting her from Paris.[32] One month's grocery bill in 1883 amounted to 200 francs, with an additional 282 francs for 2 casks of wine.[33]

By 1884–1885, Pissarro was asking about 900 francs for oils, 200 francs for watercolors, 150 francs for pastels, and 100 francs for a painted fan. Finding a better market for the less-expensive works, he produced a great many of these, which he could sell here and there, in driblets. Thus he was even less likely to have a large, solid sum on hand to support him through several months of serious painting. The figures quoted for the 1880's, again, are incomplete, for we had no continuous record. But we may conclude that somehow the difference between Pissarro's expenses and the minimum sales quoted was made up. There is no mention of seizure by creditors or of eviction from the Eragny house, with its annual rent of a thousand francs.

The year 1887, for which we have a more complete record, gives a concrete picture of the insecurity and unpredictability of Pissarro's income. Durand-Ruel had thrown all his resources into a second American venture and was away in New York for most of the year. Pissarro, moreover, was experimenting with the new *pointillisme,* not a popular style with buyers. In January he asked Durand to take a group of paintings, at lowered prices to "rescue him from embarrassment."[34] "Tell your mother I am enormously concerned about the rent," he wrote to Lucien, noting that he was unable to afford the Impressionist dinner that week.[35] From Durand or possibly another dealer came 1100 francs. By the end of February, it was all gone. Meanwhile, Pissarro accepted a loan of 50 francs from a friend, money which he sent to Lucien. He managed to sell a small painting to Seurat's mother for 100 francs in late January, 80 francs of which he sent to Lucien. The rest of January he spent in going from dealer to dealer, leaving paintings with them, asking for prospective buyers' names. He decided, at last, to sell his Degas pastel—

[30] Tabarant, *Pissarro,* pp. 48–49.
[31] Rewald, *Pissarro Letters,* p. 36.
[32] *Ibid.,* pp. 28, 29, 34, 100.
[33] Venturi, *Archives,* p. 12.
[34] *Ibid.,* p. 26.
[35] Rewald, *Pissarro Letters,* p. 91. For the following financial information, see pp. 89–121.

"but not the drawing—that was a gift, it would be indelicate"—for 800 francs.

Back in Eragny, money was dwindling fast. The last of it went to send the maid by train to a neighboring town so that she could find a place to board her two children. "It took money, and your mother has— she told me—nothing left! And you know how she is in such circumstances!" Lucien managed to send 60 francs on March 1. Pissarro went back to Paris that week to try for some more sales and to prepare for an exhibition at Petit's. On March 15 he mentioned the sale of two fans—now priced at 200 francs apiece—and some watercolors. In mid-April he received 250 francs "for a canvas I left at Pavlin's and mentioned another that was about to be sold. To this 500 francs was added a 40-franc loan from a dealer. Until June there was no mention of specific financial difficulty or of any new sales. Pissarro worked at Eragny, producing a few oils and numerous watercolors. In July he was "waiting for a letter from Theo Van Gogh" (at Boussod and Valadon, dealers). "Things are becoming very serious. . . . I have just five francs for train fare. As soon as I have a supply of gouaches, I shall leave" (for Paris). He had just received a bill from the framer for 995 francs. In August, however, Madame Pissarro took matters into her own hands, setting off for Auvers to see Murer, the collector, and then to Paris. "Your mother assured me she could do better. . . . I am afraid she is deluding herself." As Pissarro had foreseen, his wife returned empty-handed. Murer's only suggestion was that Pissarro hold a kind of fake auction, that is, an auction of works advertised as being from a private collection. This Pissarro rejected as impractical and risky. On September 24 he wrote: "things are picking up. . . . I received a letter along with 800 francs from Theo Van Gogh." An oil had been sold at 500 francs and a watercolor at 300. "Your mother is a little calmer, so I will be able to work. . . . How long it takes! I don't know whether I will be able to bring my two Autumn canvases; it has been raining for more than a week, the days are cold and grey. What a nuisance!"

So closes the record of 1887. We have quoted in detail to give a more vivid sense of the painter's own perception of his life and situation. Pissarro had a resilient and courageous personality, but the precariousness of maintaining his family in the style of life they had chosen obviously weighed him down. At most, his periods of steady, relatively unworried painting lasted for two months. Then the money was gone, Madame Pissarro fearful and angry, and it was back to Paris for a month of making the rounds.

The letters end in October and since we know that "things are picking up" with Theo Van Gogh's firm, it is probable that Pissarro made at least 4500 francs in the year 1887. Subtracting the framer's bill and

the rent, this leaves 2500 francs for food, fuel, clothing, and travel. In a precarious year, when there was no arrangement for monthly funds from Durand, Pissarro still had a total income that was relatively high.

MONET'S MONEY

Monet was the first of the younger Impressionists to succeed financially.[36] Although his prices were no more stable than those of the other Impressionists in the 1870's, individual works from time to time brought 800 to 1500 francs. At auction and exhibition, his prices were generally the highest. He was a better businessman than the others, could shrewdly appraise the market, and was capable of refusing an offer from a dealer if he thought it too low. Even when a collector like Murer bailed him out of financial trouble, Monet instructed him to choose, as payment, "pictures of smaller dimensions . . . for after all, you wouldn't want me to make you a present."[37]

From 1867 on, Monet had a mistress, Camille (whom he married in 1870), and a child to support. Camille died in 1879, leaving Monet with two children. The wife of one of his patrons, Hoschedé, left her husband in 1878 and came to live with the Monets, bringing her six children and, presumably, an income of her own. She and Monet were later married.

Monet's existence was far more irregular than Pissarro's. In the first few years of his life with Camille and his son, they were separated most of the time. As in Cézanne's case, it was only thus that Monet could continue to receive an allowance from his father. After their marriage, however, they settled at Argenteuil, down the Seine from Paris in a small house by the river. Argenteuil was a suburb and a favorite boating resort for Parisians. Monet was often behind in his rent and in trouble with landlords. In 1874 he had to vacate the riverside house. Monet found, through friends, another house with garden in Argenteuil. Here Monet and his family lived until Camille's death, after which with Madame Hoschedé he finally settled for good in Giverny. He bought the house there for 20,000 francs in 1891.[38]

Because he was constantly living on credit, even comparatively large sums were eaten up quickly. One notes, for instance, that he made some 4000 francs in the 1875 auction; yet soon afterward urgent requests for help were pouring out to his roster of friends and patrons. In 1876

[36] We will not go into as much detail here as we did above for Pissarro. Many transactions between Monet and Durand-Ruel are reported in detail in Venturi, *Archives*, Vol. I, and Rewald, *Impressionism*.

[37] Rewald, *Impressionism*, p. 414.

[38] Venturi, *Archives*, Vol. I, p. 340.

he received 2000 francs for a painting as well as a commission from a patron for decorative work, and the purchase, by the same patron, of a number of paintings. He had room and board at the patron's home while he was executing the commission. Yet, that same year, he wrote Zola to ask for "699 francs by tomorrow or we shall be thrown out into the street." Again, in January 1878, Manet lent him 1000 francs. In February and March he was again writing pleas for money to Zola and Dr. Gachet.

As with Pissarro, the expenses incurred by a middle-class level of living were coupled with irregularity of income. Monet saw himself as poverty stricken, as indeed he was for short periods. But a middle-class standard was never abandoned. Monet did revert to the old role of the artist who lives in his patron's home (in 1868 at Le Havre, and in 1876 with Hoschedé), but this kind of patronage was very sparse.

None of the Impressionists entered the area of applied art in any permanent way. Monet painted some decorative panels for the homes of Durand-Ruel and Hoschedé. Pissarro painted his fans and, with Renoir, made some etchings for the magazine *La Vie Moderne*, but these were only occasional stopgaps. Thus they shared the universal problem of the "pure" painter, cut off from the applied arts. They shared, also, a commitment to the middle-class way of life that went hand-in-hand with their "pure" painter status. Later generations of young artists were to revive the Bohemian strain which allowed them to live in the lower class but not of it. Gauguin, who left his middle-class wife and children to live in a Tahitian hut, represents the extreme denial of values that often was needed, in that era, to wrench a painter out of his middle-class role.

AN EXPENDABLE WEAPON:
THE GROUP SHOW

The long period between debut and acceptance by the buying public meant, as in the Impressionists' case, that a painter was burdened with family responsibilities long before he attained a stable income. As we have said, the Academic-governmental system made little provision for the artists' support over this long haul. Acceptance and even success at the Salon did not guarantee a steady income.

The Impressionists, over the years, had quite a good record at the Salon, as Table 3 shows.[39] The only across-the-board rejection came in 1867. It was at this time that Bazille, who was not to live to exhibit with

[39] Unless otherwise noted all facts and quotations in this subsection are from Rewald, *Impressionism* (see his detailed index), pp. 171, 309, and 472.

the Impressionists, proposed an independent exhibition. There were a number of precedents for the idea. Courbet began it with his "Pavilion of Realism" outside the 1855 *Exposition Universelle;* Manet joined him in 1867 with this statement (written by the critic Astruc):

> Since 1861, M. Manet has been exhibiting or attempting to exhibit. This year he decided to offer directly to the public a collection of his works. . . . M. Manet has never desired to protest. On the contrary, it is against him, who did not expect it, that there has been protest, because there exists a traditional teaching . . . because those brought up on such principles do not admit any others. . . . [T]o exhibit is the vital question . . . for the artist, because it happens that after several examinations people become familiar with what surprised them and, if you will, shocked them.

The dealers Martinet and Durand, from 1861 on, also assembled works by groups of similar painters in their galleries.

The *Salons des Refusés* provided by the Academic system in 1863, 1864, and 1873, under government pressure, had stressed the "right to exhibit," but few painters wanted the stigma of being included, especially in the latter two years.[40] For this reason the Impressionists went to great lengths to avoid the connotation that their group shows were exhibitions of rejected works. The rule was that those exhibiting in a group show were not, that year, to send anything to the Salon. Curiously, the painters most faithful to the group exhibitions were those who had the best Salon acceptance records: Degas, Pissarro, and Berthe Morisot.

It was probably the sample of financial independence given them by Durand-Ruel from 1871 to 1873 that encouraged the Impressionists to disdain the Salon. One notes that only Renoir and Manet sent anything to the 1872 and 1873 Salons; as Rewald suggested, support from Durand made it unnecessary for the others to do so. But in 1874, Durand's fortunes plunged; he was forced to stop buying the Impressionists' works and was unable to advance them money. Although the painters had found a circle of collectors and had been enjoying prosperous times, the general financial depression that hit Durand in 1874 also affected private sales.

According to Rewald, there had been a discussion in print of the idea of independent exhibitions in 1873 by the critic Paul Alexis. His

[40] One-third of the art objects rejected by the jury for the Salon of 1863 were actually withdrawn by their authors to prevent their being included in the official *Salon des Refusés: Moniteur des Arts,* May 9, 1863, p. 1.

TABLE 3

Salons and Group Exhibitions *

YEAR	MANET	DEGAS	PISSARRO	CÉZANNE	MONET	RENOIR	SISLEY	BAZILLE	MORISOT
1859	R		A						
1861	AM		R						
1863	SDR		SDR	SDR					
1864	A		A	R					A
1865	A	A	A		A	A	A	A	A
1866	R	A	A	R	A	A	R	R	A
1867		A	R	R	R	R	A	A	
1868	A	A	A	R	A	A	R	A	A
1869	A	A	A	R	R	A	A	A	
1870	A	A	A		R	A	A	A	A
1872	A					R			A
1873	A					R		†	A
1874	A	GE	GE	GE	GE	GE	GE		GE
1875	A								
1876	R	GE	GE	R	GE	GE	GE		GE
1877	A	GE	GE	GE	GE	GE	GE		GE
1878				R		A			
1879	A	GE	GE	R	GE	A	R		GE
1880	A	GE	GE	R	A	A			GE
1881	AM	GE	GE	R		A			GE
1882	AM		GE	A	GE	GE, A	GE		GE
1883	†		GE	R		A	GE		GE
1884				R					
1885				R					
1886		GE	GE	R					GE

article in *L'Avenir National* was followed by a published letter from Monet: "We are happy to see you defend ideas which are ours too, and we hope that, as you say, *L'Avenir National* will kindly give us assistance when the society we are about to form will be completely constituted."

Artists' syndicates or mutual aid societies had been formed earlier in the century, in the hard times of the 1840's. The principal one still in existence in 1874 was the *Association des Artistes Peintres d'Histoire et de Genre, Sculpteurs, Graveurs, Architectes et Dessinateurs,* to which Pissarro had belonged since 1860. This pension fund society was a far cry from the original guilds, but it attempted to fill some of the financial gaps left by the Academic system. Pissarro, an intellectual political radical, was delighted with Monet's proposal that a society be formed. He wanted a cooperative with a regular charter (modeled after a charter of a professional bakers' association which he had seen in Rouen). The charter idea was adopted and a joint stock company set up, although Renoir managed to squelch Pissarro's long list of rules and prohibitions.

Although most of the Impressionists adhered to the rule of no Salon exhibition, the group shows usually included several outsiders who were Salon exhibitors. This was at Degas' insistence, and many battles raged over this issue. Since Degas seldom sent to the Salon himself after 1874, one may conclude that he had the clearest idea of the purpose of independent exhibition. It was not so much that he revered the Salon and its painters, but that he wished the group shows to be a valid and sensible procedure for all painters rather than a temporary "rebel movement." The unjuried group exhibition, in fact, was later regularized in the *Salons des Indépendents.* Be that as it may, the public and most of the Impressionists saw the first group shows as rebellion.

Notoriety the Impressionists created for themselves in the next five years of exhibitions and group auctions grew until the tide began to turn in their favor. Already, in 1875 and 1876, critics commented that the Impressionists had imitators within the Salon's portals. (Probably they had been there all the while, but the public recognition of Impressionism as a *style* made their imitators more noticeable.) The 1882 show was organized, for the first time, by Durand-Ruel himself, now enjoying good fortune once more. "Durand-Ruel is taking care of everything and seems to have worked on the press. Wolff has shown and praised the exhibition to some friends," wrote Eugène Manet to his wife, Berthe Morisot. The growing acceptance of the Impressionists was probably helped by the early defections of Renoir and Monet from the group shows. Their contacts with patrons like the editor Charpentier, and their admittance to the Salon made the other painters in the group exhibitions more identi-

fiable and palatable. Then by 1886 and the last group show, the Salon was no longer the only important focus for any of the Impressionists. The growing number of dealer shows had taken its place:

1885: Petit: *Exposition Internationale*—Monet.
1886: Petit: *Exposition Internationale*—Monet, Renoir.
1887: Petit: *Exposition Internationale*—Monet, Renoir, Sisley, Pissarro.
　　　 Durand-Ruel: New York show.
1888: Durand-Ruel: Exhibition of the works of Sisley, Renoir, Pissarro.
　　　 Boussod and Valadon: Works by Monet.
1889: Petit: Exhibition of works by Rodin and Monet.
　　　 Durand-Ruel: *Exposition des Peintres-Graveurs* (Pissarro, Morisot).
1890: Durand-Ruel: *Exposition des Peintres-Graveurs.*
　　　 Boussod and Valadon: One-man show—Pissarro.
1891: Durand-Ruel: New York show—Monet, Sisley, Pissarro.
1892: Durand-Ruel: One-man shows—Monet, Pissarro, Renoir.

Table . . . 4 summarizes available information on changing sponsorship of public showings of paintings by . . . Pissarro. In Table 5 is presented simply the number of exhibitions of various kinds in which Sisley paintings were exhibited by five-year periods, together with information on sales of his pictures during his lifetime. The general tendency was for official exhibitions to be predominant early in their careers, independent shows—including the Impressionists' group shows—in mid-career, and shows sponsored by dealers to be the largest channel of exhibition late in their careers.

The average number of showings per painting during the lifetime of Manet was largest for paintings produced fairly early in his career, and the same was true for Degas, . . . Pissarro used dealer exhibitions more extensively, and one might expect a different pattern. In fact, in Table 4 the average number of showings per painting during his lifetime rose steadily for each successive decade of production—even though there were obviously fewer years in which the later paintings could be exhibited during his lifetime.

In 1892, after seven years' absence from the Salon, Renoir exhibited there, and the state bought his work. Also in 1892 the first history of Impressionism was published. The painters' work had been publicly accepted as a maincurrent of French art, a current channeled through a new system which had little to do with the state. (This is not to say that the conservatives had no fight left. The bequests of the Caillebotte and Comte Doria Impressionist collections in the 1890's created a grand hullaballoo.)

TABLE 4

Changing Sponsors for Showings of Pissarro's Paintings, by Decade of Production, for Five Periods of His Career *

Number of Showings in His Life: Each Exhibition of Each Painting Counted Once

PAINTINGS PRODUCED FROM:	DECADE AND SPONSOR † OF EXHIBITIONS															TOTAL SHOWINGS	NUMBER OF PAINTINGS PRODUCED
	1861–1870			1871–1880			1881–1890			1891–1900			1901–1910				
	S&M	I	D	S&M	I	D	S&M	I	D	S&M	I	D	S&M	I	D		
1851–1860																1‡	11
1861–1870	9											2			1	12	86
1871–1880					25	2		5	3	1		9				45	393
1881–1890								18	11			23				52	220
1891–1900										2§		102			36	140	398
1901–1910															6	6	159
Subtotal, by sponsor	9	0	0	0	25	2	0	23	14	3	0	136	0	0	43		
Total		9			27			37			139			43		256	1267

* Completed oil paintings only.

† S&M = Official Paris Salon (or its successor) plus French and foreign museum shows;

 I = Independent show: group show, studio show, show at café, etc.;

 D = Show sponsored by commercial dealers in paintings.

‡ Includes one exhibit at the Salon of 1859.

§ Both at American museums.

SOURCE: L. R. Pissarro and L. Venturi, *Camille Pissarro (Catalogue Raisonné)*, Paris, 1939.

TABLE 5

*Alfred Sisley * : Production and Sales † of Finished Oil Paintings, and Number of Exhibitions, by Sponsor, for Five-Year Periods*

	1861–'65	'66–'70	'71–'75	'76–'80	'81–'85	'86–'90	'91–'95	'96–1900	TOTALS
Number of paintings produced in	2	15	175‡	216	222	123	93	38	884
Number of paintings known sold in	0	2	23	33	80	17	23	23	201
Number of Salons entered	0	3	0	0	0	1	5	0	9
Number of independent shows entered	0	0	2	2	2	1	0	1	8
Number of dealer exhibitions entered	0	0	2	0	2	4	1	1	10

* Born 1839, died 1899.

† Only exactly dated first sales included. About ninety per cent were sold to Durand-Ruel, with whom a flexible contract for his total production was signed by Sisley in 1880 (and terminated in 1892). Petit and Boussod and Valadon handled his paintings in the late nineties.

‡ After his father suffered financial losses in 1871, Sisley had to support himself.

SOURCE: F. Dault, Sisley (*Catalogue Raisonné*), Paris, 1959.

IMPRESSIONISTS
AND THE DEALER–CRITIC SYSTEM

The Impressionists contributed to and were sustained by the new system. As it evolved, it came to provide:

Visibility. The Impressionists were lost in the mass of Salon paintings, even when accepted. With the dealer's exhibition, the one-man show, and the independent group show, they could gain the public's eye. The identification with a "school" and with a specific dealer enabled the public to place them.

Publicity. The laudatory review became a substitute for a Salon medal. The negative review was no less important in drawing attention to a painter or a movement.

Purchases. The dealer, unlike any Academic institution, was able to offer a ready-made clientele and to personally influence its taste. From this base the painter could gain a personal contact with patrons and make some direct sales.

A More Steady Income. A contract with the dealer, or at least a fairly steady system for loans and advances, guaranteed the painter a minimum income, something the Academic system had not been able to do.

Social Support. The Impressionists' circle of dealers, critics, and buyers gave them recognition, sympathy, and encouragement. A painter was no longer a nobody when he could count on the social support of people like Durand-Ruel, Zola, the editor Charpentier, the singer Faure, and the financier Hoschedé, or lesser known but faithful buyers and friends like Chocquet.

In the Impressionists' story there do appear a number of old familiar themes, changed to fit the times. The needs once fulfilled by the guild system were met by the "workshop" technique of the painters; in the informal practices of mutual financial aid, both directly and in the sharing of new patrons; in the decision to band together for public exhibition as a "school." The dealer, as we have seen, took up the old role of entrepreneur, running a string of painters; and he combined the taste and financial guarantees of a patron. The critics became theoreticians of art; the techniques of Impressionism and Neo-Impressionism were explained with as much solemnity and science as a treatise by Lebrun expounded classical style and content.

The dealers and critics, once marginal figures to the Academic system, became, with the Impressionists, the core of the new system. The Academy and the state were once arbiters of taste, patrons, educators

of the young, and publicists. Now these functions were spread out and assumed by different parts of the new system. The painter had more flexibility because, for instance, dealer-patrons were in competition with one another and each critic was eager to be spokesman for his own artistic movement. This may appear to be anarchy, and the dizzy succession of new movements after Impressionism seems to bear out what has been called the breakdown of social stability in the art world. Yet, this framework provided more widely and generously for a larger number of artists and particularly for the young untried painter than did the Academic arrangements.

The Impressionists, still tied to a concept of the artist as middle-class professional, were financially insecure, for they came along before the new system was fully developed and legitimate. The dealers' speculation in taste was not the most satisfactory way of supporting a young painter, for it implied that one bought low and sold high. To take advantage of such a system for the financial support it could give, a painter felt pressure to go along with it, to curtail his standard of living and to make a good thing out of enforced Bohemianism. Once the tide turned and prices were high, a dealer could buy all the output at much higher prices from the artist, as with the Impressionists from 1890 onward.

To younger generations in France, pockets of the old recruitment system of provincial art schools still gave basic ambition and training. But more and more the excitement and vitality of new movements like Impressionism drew young men to a Paris in which the *Ecole des Beaux-Arts* was no longer the automatic destination. Van Gogh and Picasso went to Paris because there the newest, the most interesting art was found. Gauguin, Signac, and Seurat had been nurtured in the Impressionists' world of café discussions, joint learning and experimentation, group exhibition and dealer competition. Later generations entered the same framework, and with this constant supply of young artists from at home and abroad, the new system flourished. The succession of artistic movements speeded up because of the need of each generation to make a new noise in the world. The Impressionists became grandfathers before they could even quite realize their own success.

A LIST OF PARTICIPANTS IN THE IMPRESSIONIST GROUP SHOWS (1874-1886)

John Rewald (1973)

	1874	1876	1877	1879	1880	1881	1882	1886
Astruc	■							
Attendu	■							
Béliard	■	■						
Boudin	■							
Bracquemond, F.	■			■	■			
Bracquemond, Mme.				■	■			■
Brandon	■							
Bureau	■							
Caillebotte		■	■	■	■		■	
Cals	■	■	■	■				
Cassatt				■		■		■
Cézanne	■		■					
Colin	■							
Cordey			■					
Debras	■							
Degas	■	■	■	■	■	■		■
Desboutin		■						
Forain				■	■	■		■
François		■	■					
Gauguin				■	■	■	■	■
Guillaumin	■		■		■	■	■	■
Lamy				■				
Latouche	■							
Lebourg				■	■			
Legros		■						
Lepic	■	■						
Levert	■							
Lépine	■	■	■		■			

	1874	1876	1877	1879	1880	1881	1882	1886
Maureau			■					
Meyer	■							
Millet, J. B.		■						
de Molins	■							
Monet	■	■	■	■			■	
Morisot	■	■	■		■	■	■	■
Mulot-Durivage	■							
de Nittis	■							
Ottin, A.	■							
Ottin, L.	■	■						
Piette			■	■				
Pissarro, C.	■	■	■	■	■	■	■	■
Pissarro, L.								■
Raffaëlli					■	■		
Redon								■
Renoir	■	■	■				■	
Robert	■							
Rouart	■	■	■	■	■	■		
Schuffenecker								■
Seurat								■
Signac								■
Sisley	■	■	■				■	
Somm				■				
Tillot		■	■	■	■	■		■
Vidal					■	■		
Vignon					■	■	■	■
Zandomeneghi				■	■	■		■

THE FLUCTUATING DOLLAR PRICES FOR IMPRESSIONIST PAINTINGS
(1860s-1960s)

François Duret-Robert (1973)

MONET

At the age of fifteen, Claude Monet was famous. And the prices he asked for his works scandalized his parents, who were honest grocers and used to modest profit. It is true that his glory scarcely extended beyond the limits of Le Havre, where he lived with his family, and that the works in question were commissioned by well-known people in the city. Monet sold them for 10 or 20 francs ($6 or $12).

The year 1859 found him in Paris where he managed to live on sales of his caricatures. After two years of military service in Africa, he returned to the easel. His father proved understanding and agreed to pay him a monthly sum. But he warned him, "I want to see you in a studio, disciplined by a well-known teacher. If you go off on your own again, I shall at once stop sending you money." Consequently Monet was forced to frequent Gleyre's studio. He exhibited his work at the Salon of 1865 and won a certain success. His works, influenced by the Realism then in favor, thanks to Courbet, found favor in the public's

The Fluctuating Dollar Prices for Impressionist Paintings (1860s–1960s) [Editor's title]. From François Duret-Robert, "Prices," in *Impressionism* by the editors of Hachette-Réalitiés, under the direction of Jean Clay (Librairie Hachette et Société d'Études et de Publication Économiques, 1973), pp. 305–7. Reprinted by permission of Librairie Hachette, publisher. [Ruth Krimsky Ehrlich was kind to locate the publisher of this article.–ED.]

[1] The sums given in francs in this text are those actually paid at the time of sale. Approximate equivalent values in dollars in 1972 are given in parentheses. Differences in the rates of conversion reflect changing values of the currencies. [To convert 1972 dollars into 1977 dollars, multiply the 1972 dollar amounts by approximately 1.36, to take into account inflation since 1972.–ED.]

eye and he managed to sell a few. Fortune, which had barely smiled at him, then turned against him. In 1866 he destroyed a good number of his canvases, fearing that his creditors would seize them and sell them at auction. Happily Bazille bought his *Women in the Garden* for 2,500 francs ($1,600). But he could pay this sum only in 50-franc ($32) monthly payments.

In 1867 the Salon jury accepted only one of his paintings. For Monet, who now had others to look after—his mistress, Camille Doncieux, had just given birth to a boy—things went from bad to worse. Nevertheless there were a few to buy his works. In 1868 Arsène Houssaye paid 800 francs ($512) for his *Woman in a Green Dress* and a Monsieur Gaudibert of Le Havre ordered a portrait of his wife.

In 1869 things were really bad. His failure that year at the Salon proved scarcely encouraging to the few who could buy his work. Renoir brought him bread. In September Monet wrote, "Desperate state. I sold a still life and can work a bit. But as always I've stopped for lack of paint. . . ." After the French defeat at Sedan in the Franco-Prussian War, Monet fled to London, where thanks to Daubigny he met Paul Durand-Ruel, who bought a few of his canvases for 300 francs ($192) each. The dealer continued to help him during the following years, but in 1874, finding himself in serious financial difficulty, he had to leave Monet to his sad fate. The period of 1874–80 proved catastrophic. Sales at the Hôtel Drouot revealed that collectors were hardly interested in his work. During the auction held on March 24, 1875, prices for Monet's work varied between 180 francs ($115) and 325 francs ($208).

During the Hoschedé Auction on June 5, 1878, one could acquire the *Village*, 21.45 × 25.35 inches, for 60 francs ($38) and the *Young Girls in a Clump of Flowers*, 21.45 × 25.35 inches, for 62 francs ($40). The record price—505 francs ($323)—was paid for *St.-Germain-l'Auxerrois*, 31.2 × 39.4 inches. The painter increased his desperate appeals.

Did Monet have better luck in exhibitions? In 1876, during the second Impressionist exhibition at Durand-Ruel's, he managed to sell *Camille in a Japanese Robe* for 2,000 francs ($1,280). This was a short-lived success. Recalling these difficult times, Paul Durand-Ruel later related, "One day I bought five paintings by Monet which an intermediary offered me for 100 francs [$64]."

In 1881 Monet sold him twenty-two canvases at an average price of 300 francs ($192). During the following years the prices increased. In 1883 Durand-Ruel gave the artist 500 francs ($320) and even 600 francs ($384) for certain canvases. Difficult times, however, were far from over. The Monet exhibition organized in 1883 by Durand-Ruel was a "flop" as the artist described it, and in 1884, following a crisis on the art market, Monet's work sold for low prices.

In 1885, however, the artist achieved a definite success at the fourth international exhibition which was held at the Galerie Georges Petit, and in the following year, thanks to Petit, he sold several paintings, some for 1,200 francs ($768). In addition to Georges Petit, the dealers Knoedler, Boussod, and Valadon became interested in his work. Materially speaking, he was leading a far better life. This is revealed by the fact that in December, 1886, Monet was able to return to Durand-Ruel, with whom he had had a few words, the 1,000 francs ($640) which the dealer had sent him.

The period 1886–90 marked the artist's definite success. In 1889 Théo van Gogh, the manager of a branch of the Galerie Boussod et Valadon, succeeded in selling one of his paintings for 9,000 francs ($5,760). In 1890 Monet was able to buy a house at Giverny. From that date on, the prices of his work continued to increase. In 1891 the artist exhibited his Haystack series at Durand-Ruel's. Three days after the opening every painting was sold. The prices were from 3,000 francs ($1,920) to 4,000 francs ($2,560). The year 1904 saw the exhibition of his *Views of London*. News spread that the Comte Isaac de Camondo had bought them all. Actually he had acquired only one, but on the tenth day of the exhibition Durand-Ruel sold ten canvases for 20,000 francs ($12,800) each.

When Claude Monet died in 1926 he was a rich man. To gain some idea of the increase which occurred between the 1880's—the period during which Monet lived in poverty—and the present time, we merely have to glance at the development of the sales price of one of his canvases, *The Port of Honfleur*.

The Port of Honfleur, about 1866–67.

1881: 72 francs ($46)
1899: 2,550 francs ($1,632)
1921: 15,200 francs ($9,728)
1966: 13,000 pounds ($31,200 at that time)

Let us now follow the increase in prices of two paintings from the years prior to the First World War to [1972].

The Banks of the Seine at Argenteuil [ca. 1873–74], 21 x 28.9 inches.

1912: 27,000 francs ($17,600)
1970: 240,000 guineas ($604,800 at that time)

Terrace at Ste.-Adresse [see Fig. 9], ca. 1866–67, 38.2 x 50.7 inches.

1913: 27,000 francs ($17,200)
1926: $11,500
1967: $1,411,200

RENOIR

On March 18, 1872, Paul Durand-Ruel bought his first Renoir, *The Pont des Arts* [*The Pont des Arts, Paris,* 1868; see Fig. 14] for 200 francs ($128). On June 9, 1932, the painting was sold at auction for 133,000 francs ($16,500). On October 9, 1968, the painting was sold again at auction for $1,550,000. These three prices offer an idea of the increase in Renoir's works in less than a century. The last performance of *The Pont des Arts* has another merit, for thanks to this painting, Renoir takes a lead, with Cézanne, in the race of record prices during recent years of Impressionist works. He takes a slight lead over Monet—whose *Terrace at Ste.-Adresse* [see Fig. 9] was sold, in 1967, for $1,411,200—and is well ahead of other competitors, like Pissarro and Sisley.

During his lifetime, Renoir had already appeared to his Impressionist friends as a privileged person, though only relatively, in that, unlike Monet, Pissarro, and Sisley, he never knew poverty. Not that he had an income, but even during the worst years he managed to sell a few paintings. He specialized in the human figure. Now, rather than buy a landscape from an unknown painter, one would more easily order one's portrait. And for the joy of seeing their faces, collectors often proved rather generous. This does not mean that Renoir lived like a king. In 1870 he confessed to Théodore Duret that he had to leave a few canvases as security in a studio because he had been unable to pay his full rent. Duret hastened to this studio, stopped before *La Grande Lise* and bought the canvas for 1,200 francs ($768).

Obviously this was a friend's price, that is, far superior to the one which other collectors would have agreed to pay. The painter was convinced two years later when, together with Monet, Sisley, and Berthe Morisot, he decided to try his luck at the Hôtel Drouot. The auction took place on March 24, 1875, and proved a disaster. The Renoirs went for 50 to 300 francs ($32 to $192). A second attempt, in May, 1877, was equally a failure. The Renoirs were sold for between 47 and 285 francs ($28 and $182). And the Hoschedé Auction which took place in June, 1878, offered collectors and art lovers an opportunity to buy Renoirs at even lower prices. *Girl in a Garden* was auctioned for 31 francs ($20) and *The Chatou Bridge* for 42 francs ($27).

Renoir's future appeared as anything but bright. And yet, a year later, he had become almost a ranking painter. Renoir owed his growing fame to a portrait—or rather to its model, Madame Charpentier [see Fig. 7]. The wife of a much-talked-about publisher, she had agreed to pose with her children for her portrait, and Renoir sent the canvas to the Salon of 1879. (It is now in the Metropolitan Museum of Art, New

York.) Madame Charpentier was not one to have her painting placed in a position unworthy of her. Consequently she took the precaution of "strongly shaking" a few members of the jury, with the result that the portrait, placed in a favorable position, enjoyed great success. And certain important members of Parisian society, following Madame Charpentier's example, did not hesitate to order their portraits from Renoir. Durand-Ruel who, since 1874, had been forced to stop buying almost any of their work, now began anew to help his painters. In January, 1881, he bought Renoir's *Woman with a Cat* for 2,500 francs ($1,600) and his *Luncheon of the Boating Party* [see Fig. 13] for 6,000 francs ($3,840). Unusual prices for Renoirs, though it is true these were important works.

But the painter was not out of the woods completely. The following years had many an illusion in store for him. The mediocre success of his exhibition in 1883 at Durand-Ruel's, the art dealer's new financial difficulties, the serious crisis in 1884 of the art market, all contributed to making things difficult. And yet his fame grew. When in 1892 Durand-Ruel held a Renoir exhibition, the manifestation, according to Franz Jourdain, turned to apotheosis, for the unbelievable happened: The State ordered a painting.

The verdict at the Hôtel Drouot likewise proved encouraging. A few prices during auction from 1894 to 1900 offer an ideal of Renoir's increase in value. *La Toilette,* sold for 140 francs ($89) in 1875, fetched 4,900 francs ($3,136) in 1894; *Anna,* which Chabrier had bought from Renoir for 300 francs ($192) in 1883, was sold for 8,000 francs ($5,120) in 1896. In 1899, during the auction of the Count Armand Doria collection, *La Pensée* found a buyer for 22,000 francs ($14,080). It was said that Renoir had sold it to the collector less than thirty years before for 150 francs ($96).

In 1900 Renoir could be considered a successful painter.

Victory bulletins were to multiply during the following twenty years. Here are two of the most eloquent. *Madame Charpentier and Her Children* [see Fig. 7]—the painting which had "launched" Renoir—was sold for 84,000 francs ($63,000) in April, 1907. The artist had received 1,500 francs ($960) for the work in 1879: Its value had therefore been multiplied some sixty times in less than thirty years. *The Pont-Neuf,* which was sold for 300 francs ($192) in 1875, was sold for 93,000 francs ($22,888) on December 14, 1919.

The day before this auction Renoir died. The disappearance of the painter merely increased his prices. In 1923 Durand-Ruel succeeded in selling Duncan Phillips *The Luncheon of the Boating Party* [see Fig. 13] for $200,000. In 1925 the Hôtel Drouot was the scene of a memorable event, the auction of the collection of Maurice Gangnat, who had ac-

cumulated 160 Renoirs dating from his Cagnes period. The auction totaled more than 10,000,000 francs ($1,560,000).

The world crisis of 1929 interrupted this triumphal ascension. The results of the Gangnat Auction form valuable references for an idea of the repercussion which this crisis would have had on the prices of Renoir's work. In fact, some of the paintings which were outstanding reappeared later at public auction and seemed to have lost much of their magnificence.

YEAR IN WHICH THE PAINTING REAPPEARED IN PUBLIC AUCTION	TITLE	VARIATION OF VALUE IN RESPECT TO THE PRICE REACHED DURING THE GANGNAT AUCTION IN 1925
1933	*Head of a Young Girl,* 1913	-69%
1936	*Amour en bronze,* 1913	-78%
	The Path at Cagnes, 1907	-77%
1939	*Nude Drying Herself,* 1912	-45%
	Jeune Fille Accoudée, 1911	-31%
	Roses and Small Landscape, 1911	-61%
	Woman Wearing a Red Hat, 1908	- 7%
	Woman Reading, 1909	+ 2.5%

In other words, on the eve of the Second World War, the Renoirs had not yet recovered from the blow inflicted by the 1929 crisis. It is true that the paintings of the Gangnat Collection belonged to the artist's Cagnes period, the most controversial, and that for this reason they were vulnerable. The master's earlier works, it seems, had weathered the blow better. In any case, prices rose immediately after the war and led to the spectacular bids which are familiar to all. In the light of these prices, to appreciate the increase in Renoirs, the best is still to establish a reference date—for example, 1892, the date of the Durand-Ruel exhibition—then to choose among the paintings auctioned those whose bidded prices (or the prices paid by Durand-Ruel) are known on or about this reference year.

THE PRICE PAID FOR	IN	REPRESENTS	THAT OF
The Mosque at Algiers	1957	56 times	1892
The Hothouse	1957	117 times	1894
Woman in a White Hat	1959	89 times	1896
Young Soldier	1964	444 times	1894
Girl in Profile	1968	2,181 times	1890
The Pear Tree	1969	472 times	1892

Thus during the past fifteen years Renoirs have reached prices which on the whole represent 50 to 2,000 times those which they reached about 1892. But if we choose the year 1872, when Durand-Ruel bought his first Renoirs, instead of the period around 1892, we would have more spectacular results. An example seems conclusive. The price paid in 1968 for *The Pont des Arts* is some 12,000 times the one which the dealer paid the painter in 1872. It is true, however, that this canvas was of "museum quality" and that for this reason it was especially favored.

The Pont des Arts, Paris. About 1868, 23.8 x 39.4 inches.

1872: 200 francs ($128)
1932: 133,000 francs ($16,500)
1968: $1,550,000

Girl in Profile, 1888, 12.5 x 9.4 inches.

1890: 150 francs ($96)
1968: 1,070,000 francs ($239,600)

SISLEY AND PISSARRO

For anyone exclusively concerned with price development, a sole event in Sisley's life offers a certain interest. That event is his death. Indeed, the disappearance of the painter created a strong increase in the price of Impressionist works. As for Sisley's existence, it can be summarized in one sentence: He was the poorest and least known among the Impressionists. Whereas as early as 1892 Monet, Renoir, and Pissarro were famous and well-off, Sisley continued to have a hard time to make ends meet. Certainly his exhibition in 1897 at the Galerie Georges Petit enjoyed a real success, and that same year some of his canvases fetched good prices at auction, but unfortunately it was his old paintings which were received with favor. And he still led a hand-to-mouth existence. A few months before his death, Sisley, a cancer victim, wondered whether his doctor bills would be more than 200 francs ($128).

Pissarro was somewhat more fortunate, at least during the last fifteen years of his life, for his fate prior to the year 1890 was scarcely more enviable than that of Sisley. In 1884 he summarized his situation in the following manner in a letter to his friend Murer, "Tell Gauguin that after thirty years of painting . . . I am hard up." He had to wait until the years 1888–89 to see his paintings sell for a decent price. The exhibition organized at the Galerie Durand-Ruel in 1892 marked his general acceptance, and several paintings were sold for prices varying from 1,500 to 6,000 francs ($960 to $3,840). From then on until his death the prices of his paintings continued to increase.

Beginning in the 1900's the value of Sisleys and Pissarros followed, with a slight delay it is true, a curve parallel to that which reflected the triumph of Monets and Renoirs. Their works enjoyed the same gain until 1929, the same vicissitudes caused by the world crisis, the same hours of glory beginning in 1950.

These identical fluctuations, however, should not conceal the essential difference: Sisleys and Pissarros sold—and still sell—for less than Monets and Renoirs.

Sisley: *Inundation, Road from St.-Germain,* 1876, 17.2 x 23.4 inches.

1880: 300 francs ($192)
1936: $2,000
1969: 60,000 pounds ($144,000 at that time)

Pissarro: *Tuileries Garden, Spring Morning,* 1899, 28.5 x 36.3 inches.

1899: 3,000 francs ($1,920)
1968: $260,000

PART FIVE / Style, Technique, Influences,
Present Status

IMPRESSIONIST STYLE

Lionello Venturi (*1936*)

Much has been written about impressionism, and still more talked, among painters, sculptors, poets and musicians, with much contempt of nearly everybody before 1880, with great favour of the "open" minds between 1880 and 1905, and with much patience by the cubist revolutionaries and the neo-classic conservatives from 1905 until today. The phenomenon which was restricted to five or six scoundrels of painters before 1880 became European and world-wide in little more than a decade, literary and musical as well as pictorial, was adapted to all tastes, and transformed to the point of becoming unrecognizable. So, it is difficult to understand what impressionism really was without going back to origins, to the moment in which a relation existed between some few painters.

Any hasty formula or definition becomes inadequate, because it varies according to whether importance is given to the relation between the artists or to the personality of each one, to the ideals followed or to the technique used. Hence it happened that between 1874 and 1880 nobody doubted the participation in impressionism of Monet, Renoir, Cézanne, Pissarro, Sisley, Guillaumin and Berthe Morisot, while afterwards the impressionism of Cézanne was denied, on account of his constructive form, that of Renoir, because he painted figures rather than landscapes, that of Pissarro, because he was theoretical, and that of Sisley, because he was a sentimentalist. As if in impressionism, who knows why, sentiment could not be expressed, nor figures painted, nor a new form discovered. The personalities of the impressionists were very different among themselves, and their value was different, but their convergence can be perceived, rather than their divergences: not certainly

Impressionist Style [Editor's title]. From Lionello Venturi, "Impressionism," in *Art in America* (July 1936), excerpts from pp. 95–110. Reprinted by permission of the publisher.

in one master who regroups the others as pupils, but in a tendency of ideas and modes of feeling, in kindred and characteristic preferences, even in a new moral and social world, in short, in a *taste* which is common to them all, without defining the personality of each one. Since every taste belongs to a given historical moment, it is vain to proclaim it as an absolute value or non-value. It is not a subject of aesthetic judgment but of historical research, even if the personalities who formed impressionism, and were formed by it, and are to be judged as the most sublime in plastic art of the nineteenth century, reflect a little of their glory upon the taste and render it historically interesting.

The first public manifestation of impressionism was, as is known, an exhibition of 1874; and the taste of impressionism was already almost realized two years before, when the protagonists found themselves in Paris again, after the war and the revolution. In 1872, then, could be indicated the end of the preparatory phase, of the moment of meetings, a phase which was somewhat slow and complex.

In the studio of Gleyre there met in '63, Monet, Renoir, Sisley and Bazille. Pissarro, who had already known Monet in '57, meets Cézanne in '63. In '65 Monet, Bazille, Renoir, Sisley, Pissarro and Cézanne meet Manet, besides Baudelaire and Gambetta, in the rooms of the Lejosnes. In '66 Cézanne leads Zola to Manet in that café Guerbois where Manet is surrounded by the other painters of the vanguard, by Degas, and by some critics, Huysmans, Duranty and Duret. In '65 Pissarro was 35, Manet 33, Sisley 28, Cézanne 26, Monet 25, Renoir and Bazille 24. Of them, Manet is already famous by success of scandal, and Monet, in whom Courbet is interested, has already been noticed, and receives the eulogy of an official critic, Paul Mantz. Monet and Cézanne bring two provincial experiences: the first had started his marines under the influence of Boudin, encountered at Havre, and of the Dutchman, Jongkind; the second had studied at Aix in Provence in an ambience dominated by romantic taste, derived from Delacroix and Decamps, and impersonated in Emile Loubon. Pissarro, after having had some contact with the school of Düsseldorf, becomes an imitator of Corot. Sisley and Cézanne bring into the group a literary culture. All study the forest of Fontainebleau and its interpreters, Corot and Rousseau, all admire Courbet; and Renoir has a weakness for Diaz.

Of all the group the "strong" spirit is Monet. From 1830 onwards the "open air" was the fashion among the landscapists, that is to say they made sketches from nature and composed the picture in the studio. In 1865 Monet paints a picture outside the studio, in the garden, and repeats the attempt in 1867. The pretension shocks Courbet and Manet, but a few years later they conform. The picture of '67 is today in the

Louvre, *Women in the Garden,* and it is not a success. The colours are very light, but by that lightness Monet reduces the figures to cut-paper. This is one of the rare pictures of the group in which may be noted the so much lauded influence of Japanese prints.

Elsewhere, in the years before '70, Monet is able to find the way of impressionism, even to advance, by that way, more than any of the others, studying reflections in water. Rose, greens, browns, reflected in the blue of a stream, change and yet distinguish themselves; they are varied, and yet they are united by the blue; for clear profiles is substituted the trembling of gradations; for atomic colourism is substituted harmony. It is "open air," but not abstract—concrete. Besides Monet, Renoir, Pissarro and Sisley dedicated themselves to reflections, and are able to find a synthesis of light, rich with colour, movement, and gradation, though Manet had not as yet. It was necessary to elevate to style the chromatic harmony studied in reflections, and this is the work of the following decade.

The war broken out, Bazille finds in it death, Manet fights, Renoir is a soldier not in battle, Cézanne isolates himself in Estaque, near Marseilles, Monet and Pissarro take refuge in England, where they are introduced by Daubigny to Durand-Ruel, who as a dealer afterwards favours impressionism, and where they have occasion to see the works of Turner without being able to draw anything from them. From London Monet goes to Holland, where the study of canals procures him some further subtleties.

• • •

On April 15, 1874, there opens the exhibition of an "Anonymous Society of Artists," etc. Cézanne, Degas, Monet, Berthe Morisot, Pissarro, Renoir, Sisley exhibit there, together with many others more or less akin. Their common object is practical, independence of the official Salon. Manet, awaiting "official rewards," does not unite himself with the group, although with his exhibition of 1867 he had been the example. The anger of the public and the journals assumes incredible manifestations, which have been many times recounted and need not be repeated. Rather we should recall the conditions of the Parisian public in 1874: after the Commune, in full reaction, with the example of Courbet, realist painter and Communard, who had had his day of popularity towards the end of the Empire and had lost it; the public has the impression that the new independents menace the bases of society and becomes ferocious. Meanwhile the newspapers begin to call the exhibitors by the name of *impressionists,* suggested by a picture of Monet entitled: *Impression, Sunrise.*

The second exhibition is in 1876, the third in '77. This time the

artists themselves accept the name of impressionists and, asked the reason of the appellation, reply in their journal *The Impressionists,* of April 21, '77, that the painters have adopted such a name to distinguish themselves, to assure the public that in their exhibition there would not be historical pictures, Biblical or Greek or Roman, nor "great-painting," nor Oriental themes, nor genre subjects, and that, moreover, not even the terms of classic and romantic had been more clear when they were new in 1830. The reply is negative; the impressionists do not wish to make theories, limiting themselves to the negative and revolutionary attitude assumed ten years before. The group is complete as it was in 1874, and Georges Rivière already begins to distinguish the true impressionists from their companions in struggle, the simple "irreconcilables." The exhibition of '77 sees for the last time the group completely represented. Cézanne exhibits no longer with his friends, in '79 Renoir also is absent, in '80 and '81 Monet, Renoir and Sisley are wanting, so that the group is dissolved. It is partially recomposed in '82 and '83; and in '86 in the eighth and last exhibition, the dispersion is definite. The manifestation which represented the maximum collective force, the conquest of various artists, the influence on the painters of the official Salon, is therefore the exhibition of '77.

One of the principal motives of aversion from the impressionists, consisted in the subjects treated by them. In vain Rivière maintains that nobody has a right to ask the artist to give account of his subject; but only of the artistic result. In vain, because in '77 the social prejudice was even stronger than it is now. The impressionists came of the common folk or from a middle-class very close to the masses. But the amateurs of painting came from the nobility and the upper middle-class, and had almost always been backed by previous painters. (Daumier was an exception: and they ignored him.) It did not therefore escape them, that a new social content was inherent in the painting of the impressionists, more or less unknown to them. The graces of Renoir did not belong to the "boulevard" but to the "outskirts," the peasants of Pissarro were "vulgar," and people saw in them relations with the personages of *Les Miserables,* by Hugo; the revolutionary power of Monet puffed from his locomotives, and the mind of Cézanne, for one, was evidently anarchical, parallel to that of Zola. Impressionism had brought to painting something similar to that which was called in the political life of France *the end of the notables:* the end of elegance and splendour, the beginning of a new dignity for the humble masses. However, in the impressionist works the social content remained content, and did not oppress the form. "To treat a subject for the tones and not for the subject itself, that is what distinguishes the impressionists from other painters," as Rivière

said. Here is the catharsis, the liberation from the passionateness of romantic painting and from the polemical character of realistic painting, of the Courbet type; here is the serenity, which is a smile, of impressionistic paintings.

In the common taste of the impressionists the critics were able, moreover, to note the character of each one; the triumphal jocosity of Renoir, the vigour of Monet, the grandiosity of Cézanne, the "rural religiosity" of Pissarro, the subtlety and tranquility of Sisley. To the accusations of insincerity and artifice to astonish the public, the critics counterposed the faith of the impressionists in their ideal and their tenacity in spite of suffering.

Not less active than the social prejudices were the artistic prejudices. The public remained disconcerted by the lightness of the colours. But the connoisseurs, even if adverse, perceived, with Fromentin, that the impressionist's eye "generally had very just perceptions, and particularly delicate sensations."

In later times impressionism was interpreted as an application of the laws of Chevreul. As is evident, it is, instead, a discovery of artistic sensibility, promoted by love of nature and of the light of the sun, and by the desire of enriching the harmony of the colours themselves. As has been said already of the studies on reflection in water achieved by Monet and Renoir even before '70, the decomposed colours were then used in the water, but not in the sky, which remained completely blue. They needed, then, to free the decompositions of colours from their naturalist limits without extending them systematically throughout the canvas, but making of them an element of style, appropriate in their places, as if they were the accents of verse. The extension of the decomposed colours becomes, then, a need of stylistic coherence, a surpassing of photographic naturalism, a mode of impressing movement and life in everything created. But in order for this to happen, it was necessary that the decomposed colours should fill a need, a mode of feeling, without regularity, therefore, or pedantry, rather with the pauses imposed by ever-varying sensibility. Up to 1880 this artistic mode of decomposing colours was adopted, now more, now less, according to the talent of each one. Unfortunately until today the critics have not been able to justify the drawing and the composition of the impressionists, hence the legend, unfortunately very general, of their incompleteness.

It will be well, therefore, to deny every right of association in art criticism to the so-called "parts of painting." Painting is an indivisible whole of which coherency is the law. The impressionists starting from light, decomposed in colours, their form had to be other than that of the painters who founded themselves upon chiaroscuro. The perfection of

their form had to be reached in the limits of coherency with their colour-light. The same thing may be said of composition. Therefore, all the accusations of superficiality, incompleteness, fragmentariness, lack of details fall of themselves, without the necessity of demonstration. At most, it may serve, with the aim of burying it forever, the record of those who "completed" impressionism, by avoiding the "fragmentary," by opposing the proper "depth," by showing care in details.

The impressionists succeeded in liberating painting from that *academic form* which had remained in Courbet, against which Delacroix was enraged, and in a more conscious way than that used by Corot and Daumier; and they succeeded by sensibility to both light and colour, which they had more alive and subtle than all their predecessors, and above all because they loved so much and so deeply the light of the sun, by which they found everything beautiful, and had no need of recourse to mathematics or literature to find motives to paint. There is therefore in them full coherency of choice, in means and aim, full correspondence between vision and mode of feeling, full creative spontaneity, worthy in everything of the great primitive painters.

In '80 and '81, the group of impressionists is dissolved, for both material and artistic reasons. Material, because the public aversion is not disarmed, in spite of the adhesion of critics or men of letters like Zola, Daudet and d'Hervilly; and the aversion of the public signifies misery. It was necessary to meet the public in some way, to find a way of selling pictures, to make it forgotten that they had participated in impressionism, and possibly speak ill of it. Without reckoning that the impressionists could for a moment have doubted themselves, seeing their imitators in the Salons profiting by their discovery; they could add to it a little of "tradition," and by their compromise obtain success. It was natural that a centrifugal force should push them different ways.

Renoir, who was not a strong spirit, wished to acquire academic drawing, and after various alternations of success and non-success, arrived at a new synthesis, which in part exceeded the impressionistic taste. Cézanne isolated himself and with heroic tenacity sought the solution of all the problems which the impressionistic taste had set. Some, who have observed in the works of Renoir and Cézanne after '80 their departure from impressionism, have concluded a little hastily that they never were impressionists, and have limited the appellation of impressionistic to the works after '80 of Monet, Pissarro and Sisley. The mistake is precisely here. If by impressionism is understood that convergence of taste which had its consecration in the exhibition of '77, that common spiritual and technical point, which contemporaries were then able to see distinctly, and is a taste historically determined, in that case it is necessary to

establish clearly that neither Monet, nor Pissarro, nor Sisley, were com-
pletely impressionists after '80. No painter was an impressionist all his
life; impressionism is a *moment* of taste of some painters.

<p style="text-align:center">• • •</p>

I have chosen some characteristic works of Pissarro, Monet, and
Renoir to suggest to you that my "assertions" on impressionism are
founded on a knowledge of painting.

In 1868 Pissarro painted a view of *Pontoise* [similar to Fig. 5], which
is to be found in the Mannheim gallery. The light blue of the sky is
broken by white clouds, the houses, road and bridge are coloured light
brown-green with black shadows, the figures black, blue, violet and
white. All the colours appear as spots of light or dark, without grada-
tions. From this there is a certain romantic energy and a growling wild-
ness. This picture re-enters into the tradition of a manner of Corot's,
with greater polemical force and with less art.

Five years later, in 1873, Pissarro painted *The Haystack* [similar to
Fig. 16] of the Durand-Ruel collection, one of his masterpieces of very
small dimensions. On the green and yellow ground, on the heap of brown
gradations (the stack itself), the light penetrates and makes precious all
that it touches: the enchantment of the artist by the miracle of light is
felt almost as in Ver Meer. In the background the blues are illuminated
with yellow, and the greens with pink. The clouds in the sky shine white
and pink and are shaded with blue and violet. There is no longer the
"picturesque" interest of the view as in the pictures of 1868, no longer
the polemical contrasts of lights and darks, but a lightness, a new solidity,
a new sense of form as mass and volume, in short, a regeneration. Nothing
of the picturesque remains in the motive, everything is pictorial in form
and colour; if it were not for a lack of grandeur one would think of
Cézanne. When before a similar masterpiece one remembers to have
read that the impressionists do not construct, do not know perspective,
make an art of surfaces, are decandentists and "deprived of soul," one
has a right to be disdainful.

In '98 Pissarro painted various views of Rouen which are among the
best of his later period. Among them is one entitled *Saint-Sever* [*Port of
Rouen, Saint-Sever;* see Fig. 17]. The experience of divisionism was now
overcome, though there is no longer the synthesis of *The Haystack,* nor
the spontaneous adherence of the subject to the pictorial, nor the nature
created, nor the primitivity, nor the enchantment. Certainly there remains
the good effect of light, but a little heavy and mechanical, and viewism,
the picturesque, reappears. It is a well organized spectacle.

Monet was considered "the head of the impressionists," "the impres-

sionist par excellence," and those who said so, had their eyes above all upon the decomposition of colour. Something programmatic, systematic was felt in his painting before '70, and it reappeared now and then, but was attenuated in the happy moment between '72 and '80. The strong spirit of Monet, ready for struggle, responded naturally, with a systematic defiance, to the aversion of the public. After '80 he painted the decomposition of colours, with some conventional sentimentalism, with a musicalist tendency: his haystacks, his poplars, his cathedrals are simply pretexts for the overflowing of confused colours. It was no longer a case of surpassing the subject, naturalistically understood, by force of the elaborating imagination of an impression, but rather of a fantastic imagining with no longer a relation with reality, nor with form, nor sometimes with his own chromatic sensibility. The equilibrium between art and nature, which was the property of impressionism, was broken.

If we compare the pictures by Monet prior to '70 with the *Sailboat at Argenteuil* [similar to Fig. 18], which is of 1875, we see clearly that polemics have disappeared, that the opposition of lights and darks is superseded by the finest gradations, that every tint becomes colour and every colour becomes light and shade; hence there is a unity of style and a fusion of things in style which were lacking before. The profiles are lost, and should be lost, as Titian and Rembrandt have taught. The tints are fused in the atmospheric mass, the displeasing contrast between the flat figures and the perspective construction of the academic type is overcome by the meeting of blended colours and space, which is no longer empty space but full of atmosphere. It is an immersion in nature, under the guidance of light, a new form, no longer closed in schematic detachment, but participating in a universal vibration, which is the reason of both life and ecstacy. It is a spiritual mode, refined, because made of imperceptible gradations, and at the same time primitive, because the eye of the artist sees its spectacle, not through the rules of the school or the principles of a system, but through a spontaneous creative imagination. In sky and water the reflections of the sunset (orange, yellow, sky-blue, violet) are kindled in an orgiastic festival, but the green and blue calm and dominate them, with a contrast which is at the same time a fusion. Now we shall be able to see that the palette is lightened, that the decomposition of tones exists, salutary, where the effect requires, that the so-called colourism of the impressionists is colour, rich but sane, not exaggerated, but harmonious and delicate.

And now look at a work of Monet's of 1881 [see Fig. 19, *Lavacourt (?) Winter*] . . . If there were a difference of tone between the two hills in the picture it would be preserved in the photograph. There are certainly blues in the foreground, pinks in the background, and yellows in the sky,

without any regard for local colour, and they are exaggerated, seen for themselves, abstracted from the whole. Hence a confusion of planes, a summary rather than synthetic effect, something arbitrary and indifferent, a lack of realization. The abandonment of the aesthetic and technique of impressionism, clear in the *Sailboat at Argenteuil* [similar to Fig. 18], is therefore evident.

In 1869 Renoir exhibited at the Salon a figure of a woman entitled *In Summer* [*In the Summertime (The Bohemian)*; see Fig. 20], now in the National Gallery of Berlin, which is a good piece of naturalistic academy in the Courbet style, in which the drawing of the face and arms has no relation with the incipient impressionism of the background, and where, observe, the subject *In Summer*, which is already an impressionistic subject, is represented by the bare neck of the woman according to the custom of "painters of genre."

In 1876 Renoir painted a true genre motive, *Confidences* [see Fig. 21], now in the Oscar Reinhart collection at Winterthur. But now, already master of the impressionistic ideal, he has not represented the fact of a chronicle, but rather a smile which spreads from the eyes, the lips, the colours, from everything, and therefore becomes an eternal moment of grace.

But in 1885 *The Bather* [*After the Bath;* see Fig. 22], of the Oslo National Gallery, shows the new research of abstract form, of the plasticity of arm and breast, of the continuous line of the face, and it is a curious academic essay in a stereotyped style, like a scheme from which Renoir himself must have drawn later a new vigour of art. After 1895, however, he was able to create again masterpieces. . . .

IMPRESSIONIST TECHNIQUE: PISSARRO'S OPTICAL MIXTURE

Richard Brown (1950)

In spite of all that has been written on color and light in the theory and practice of impressionist and neo-impressionist painting, a great deal of confusion on the subject still exists. Many interpreters maintain that the so-called process of "optical mixture" is paramount in impressionist technique. In recent years, however, the tendency has been to minimize its importance; and, certain statements of the artists themselves to the contrary, some critics have denied that optical mixture had any place whatever in the technique actually used by impressionists. Thus J. Carson Webster, in an excellent discussion of this problem entitled "The Technique of Impressionism; a Reappraisal (*College Art Journal*, Vol. IV, November 1944), corrected many common errors about optical mixture but went too far in his principally negative conclusions, even denying that the artists themselves had a clear idea of what they were about.

Most of the contradictory points of view found in discussions on the subject have been reached by reading documents, such as letters or recorded statements of the painters, then deciding what is meant by optical mixture, and then looking at the paintings to see if they substantiate the conclusions. A better understanding of the problem may result if we try first to define what is on the canvas, then to compare this with what we see in nature, and finally to relate these findings to the historical documents.

This method entails a certain amount of atomistic analysis of paintings which unfortunately tends to do violence to the kind of unity essential to a work of art. It also requires reliance upon a color system

Richard F. Brown, "Impressionist Technique: Pissarro's Optical Mixture," from *Magazine of Art*, Jan. 1950, pp. 12–15. Reprinted by permission of the author.

and a color terminology derived from the scientific study of color. The use of such a system and of what may seem an overly technical vocabulary does not mean that the painters whose works we study knew or painted according to this system or thought in this terminology, but that these are merely means by which we may describe the facts existing on the canvas and determine the principles of color vision involved in perceiving these facts.

The works of a single artist, Camille Pissarro, may be chosen as illustrative. Although he never exemplifies the extreme ideal of impressionism, as does Claude Monet, Pissarro's total stylistic development presents, as much as that of any single painter can, all the technical methods and stylistic concepts adopted by the impressionist school in general. Pissarro, as the most constant and inveterate experimenter of the entire group, thus serves as the best barometer of impressionist trends in technique and style.

In order to discover one of the specific factors in Pissarro's technique that contributes strongly to the effect of bright sunlight, for example (only one of his principal aims), we may analyze the tonalities he employed in two paintings that achieve this effect.

The *Factory Near Pontoise* [see Fig. 16], painted in 1873, is typical of this period in Pissarro's development. The simplest way to indicate the tonality of the artist's palette at this period is by reference to the three-dimensional tone-solid system, which best expresses in an elementary way the world of light and color.

Most people are familiar with some such graphic representation of the various dimensions of color as that shown in Diagram 1. The central vertical axis represents what may be called either brightness, or value, or total amount of white light (at top) in relation to total absence of light, or black (at bottom). Various points around the solid, within the 360 degrees of the circle, represent differences in hue—that is, the specific spectral wave length of the light: its redness, greenness—or blueness and so forth. Distance away from the central, or neutral, black-to-white axis, towards the perimeter of the circle, indicates what might be called the saturation, chromaticity, or intensity of the particular hue. Thus, if blue falls at *A* on the color circle, and is at *B* level of brightness, we can specify its saturation or intensity by indicating a point on the horizontal measuring line *C*. For the purposes of this discussion, the customary terminology will be used as follows: *value* to mean the degree of darkness or lightness in respect to the total amount of white light present; *hue* to mean the redness, yellowness, blueness and so forth; and *intensity* to mean the amount of hue involved.

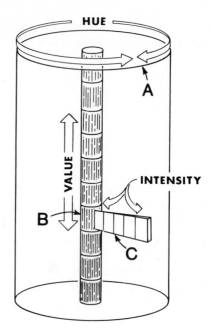

Diag. 1: Tone-solid showing
relations of value,
hue and intensity.

Attempts have been made to represent such a concept of color by matching up specified positions in all parts of the theoretical tone-solid with actual samples of color. The systems most widely known and used are those of Munsell and Ostwald. It is instructive to try to match the separate touches of pigment of some of Pissarro's paintings with individual small samples taken from the Ostwald manual. Perfect matches can seldom be found, of course, because of the unavoidably limited number of samples in the manual; nevertheless, a judgment made by means of a carefully specified and standardized color system is certainly more reliable than one made independently by an eye subject to all the deceptions of surroundings, colors, changing illumination, etc. The use of such a standard enables us to make a more accurate check upon the range of color used by the painter.

In examining Pissarro's painting of 1873 in this manner, we are impressed by two facts. First, Pissarro uses as complete a range of values as possible. His actual pigments go all the way up to pure white and as far down towards black as they can while still retaining any appreciable amount of hue content. He uses a number of devices, such as abrupt contrasts of value or hue to make the whites seem whiter and the darks as deep as possible. Secondly, in nearly all the colors he limits his range

of intensities to a surprising degree. In this painting, amazingly few of
the smaller colored areas extend farther away from complete neutral
than Ostwald's second step. This means that the intensity range is
restricted, for the most part, to less than thirty percent of the total range
that can be attained by ordinary oil pigments.

Ten or fifteen years later, the tonal scheme in the majority of Pis-
sarro's paintings is reversed. In *Spring Pasture,* for example [see Fig. 23]
hardly a touch of color goes more than halfway down towards black
from white, and most of the strokes of individual color are quite intense.

Presented diagramatically, the change in tonality can be indicated
as in Diagram 2. *A* is the range of color in the earlier painting, with the
greatest possible extension of values combined with a narrow restriction
of intensities. *B* indicates the color range of the later painting, with a
restriction of all values from about midway on the scale up to white,
combined with a greater saturation of most of the intensities.

What are the reasons for this variation in color scheme? They are,
of course, infinite. But how does each tonality contribute to the effect of
bright sunlight? Even in this lesser question there are a number of factors,
but we may choose one as an illustration, that of surface reflectance of
neutral light.

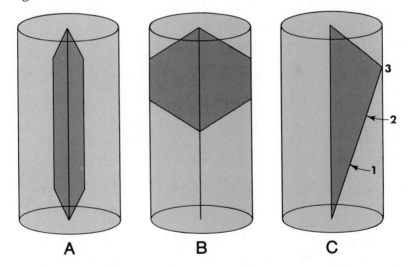

A B C

Diag. 2: *A:* Color range in *Factory Near Pontoise,* 1873 [see Fig. 16].
B: Color range in *Spring Pasture,* 1889 [see Fig. 23]. *C:* Effect
of increased illumination on relation of value and intensity.

Any colored object in light reacts, in relation to the eye, in ac-
cordance with its inherent potentialities of hue, intensity and value. In
total darkness, therefore, any object may be thought of as being at the

zero point of value, hue and intensity (Diagram 2 C 0); that is, invisible. If it is brought out into the light of a room, it will move up in value and out towards a fuller intensity according to its specific hue (Diagram 2 C 1). If taken to the window, its intensity and value will continue perhaps to the point indicated by Diagram 2 C 2. Outside in the bright sunlight, it will reach its maximum intensity (Diagram 2 C 3). When the illumination is increased, however, something else happens in addition to the selection of wave lengths or the partial absorption of white light. That is, the object not only acquires its color, but causes a certain amount of illuminating light to bounce off the surface of the object without being partially absorbed or selected. This neutral surface reflectance tends to increase in direct ratio to the amount of illumination and has the effect of neutralizing the color beneath it. Hovering over objects in strong illumination, this reflectance contributes very strongly to our realization of the presence of both the envelope of atmosphere around objects and the dominating light source itself. The critic Duranty recognized this phenomenon in his apology for *La nouvelle peinture*, written in 1874, when he said that the most important single contribution of impressionism to date was its recognition that "great light" neutralized all things. This explains at least partially the tonality of Pissarro's painting of 1873.

What about *Spring Pasture?*

By raising all the values and extending the intensities, Pissarro was trying to increase the total *volume* of light coming to the eye—in other words to approximate more closely the total amount, or impact, of light that the eye would receive from the scene in nature. Oil pigments cannot, of course, compete with the strength of sunlight, just as even an extended value scale in pigments cannot achieve the degrees of contrast that the eye experiences in looking at nature. In the more traditional handling of tones (Diagram 2 A) the shadows, half-shadows and lights maintain on an unavoidably reduced value scale the same relative positions as the corresponding tones in nature, and thus a sense of reality is conveyed. In the later handling of tones (Diagram 2 B) the adaptation level of the eye is raised in the absolute sense, and even though the level cannot possibly reach that of a sunlit landscape, the necessary adjustment of the eye to a higher total value level plus the greater range of intensities helps to convey the reality of open air sunlight. Pissarro often used white frames for his later works in order to augment this effect (as well as to attain tonal harmony).

What happens to the intensities of objects when illuminated to such high levels? As described before, the amount of neutral surface reflect-

ance increases; but so does the intensity. An increase in light enables any object to increase its selectivity of wave length of its specific color. Which does the eye perceive—the greater intensity of color, or the greater amount of neutral surface reflectance? Both: variations in angle between our eye and the objects, differences in angle between the light source and the objects, differing atmospheric conditions near the various objects, differences in our attention towards the scene before us, differences in our knowledge of the many objects before us and so forth, usually result in a fluctuation between the intense color of the objects and their neutral surface reflectance. Obviously, a palette using only the relatively neutral tones cannot represent this visual experience.

Although from the standpoint of pure physics the intensities could be pushed to extreme degrees by an increase in illumination, the limitations of the human eye make this *visually* unappreciable. The eye will remain sensitive to different hues and intensities up to a certain point; beyond this, any further amount of light fatigues the receptors which make distinctions of hue and intensity possible, and a whitish or neutral glare appears upon objects. The eye, however, constantly renews its efforts to identify the hue and intensity of the objects it perceives, and therefore in brightly illuminated scenes some degree of fluctuation between intensity and neutrality results from this limitation of the adaptation level of the eye. Here again, a painting in restricted intensities cannot reproduce this visual experience.

To achieve the scintillating, sunlit effect that fascinated Pissarro, the full intensity of objects, combined with the neutralizing effects of brilliant illumination, must somehow be expressed in paint.

In order to do this, Pissarro in at least one phase of his work kept his individual touches of pigment at fairly full intensity and modulated this intensity by juxtaposition of tones, thus maintaining a greater total volume of light coming from the painting to the eye of the observer. To be sure, he used in this type of work a great many touches of pure white pigment, which has the desired dual effect. The small spots of neutral white are interpreted as surface reflectance or glare, but beside them, in accordance with the laws of simultaneous contrast, the touches of color seem more intense than they would beside tones of a lower value. The intensity of the larger areas is enhanced by placing yellow-green trees against blue sky, or reddish earth against blue-green grass, or similar arrangements whereby simultaneous contrast between more or less complementary hues increases the intensity of each. Within these larger areas, however, depending upon their position in the scene, Pissarro restricts the hues to those that are very close to each other on the hue circle. The

principle behind this may be explained by a diagram such as Diagram 3. Each color induces its complementary. Each induced complementary is added to the adjacent hue so that in addition to a neutralizing tendency, a fluctuation or tendency to separation between the two adjacent hues results. Because of the high value level and full intensity of many of the colors, this effect of fluctuation and neutralization seems much more appreciable than it would at low value and intensity levels. This system of coloration was known at the time as the "small interval," and we can see Pissarro repeatedly using it and adjusting it beautifully to the representation of space and light. In *Spring Pasture,* for example, the separate touches of color in the grass of the foreground range all the way from yellow-green to violet. In the field just beyond the hedge, the violet and blue-violet touches disappear, and in the farthest field the range of hues is limited to a small segment in the yellow and green portion of the hue circle. This principle applies also, of course, to other objects in the picture, the play of red-orange touches in the blue shadows of the foreground, for instance, being minimized or omitted entirely in other shadow areas, depending upon their position in the scene. A much simplified scheme of Pissarro's use of the "small interval" and of complementaries is shown in Diagram 4.

This is only one instance of the manner in which color may be modified without changing the physical nature of the coloring material. It is so referred to by the principal sources of impressionist and neo-impressionist theory: Michel Chevreul in 1827, Hermann von Helmholtz in 1857 and again in 1870, Ogden Rood in 1879, David Sutter in 1880 and Delacroix in some of his notes on color.

In 1888 the American critic, William George Sheldon, asked Pissarro to define impressionism. Pissarro answered that there were two main principles: don't mix pigments; study the complementaries. He added that any student could comprehend the theory within a few minutes but that to achieve harmony and representation through its mastery took years of painting. He also said that what the impressionists sought above all was to study what they saw in nature.

The optical mixture practiced by the impressionists, therefore, does not necessarily mean the fusion of blue and yellow to achieve green (which is impossible), or even the fusion of red and blue to achieve violet (which is hard to illustrate by examples). Recent criticism has disposed of these fallacies quite effectively, but in doing so has gone too far in denying any place whatever to so-called optical mixture. An attempt to discover from their *paintings* what the impressionists meant by this term leads us to conclude that they understood what they were doing and had good reason for doing it.

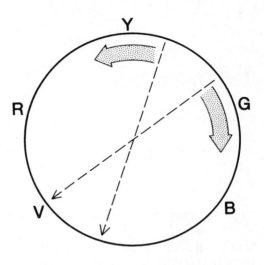

Diag. 3: Neutralization and fluctuation of complementaries induced by adjacent hues.

Diag. 4: . . . showing Pissarro's color system [detail of *Spring Pasture,* Fig. 23].

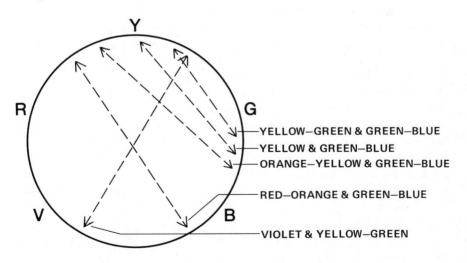

THE INFLUENCE OF PHOTOGRAPHY

Aaron Scharf (1968)

THE CLANDESTINE USE OF PHOTOGRAPHY

The young Impressionist painters appeared in Paris in the early 1860s in the thick of the battle between photography and art. It is hardly possible that they were not affected by it. They were on one hand the progeny of a long tradition of naturalism culminating in an absolutist conception of realism; on the other they were heirs to a legacy of cynicism towards all imitative art. Both attitudes were undoubtedly germinated and exacerbated by the existence of photography. The apparent dichotomy in Impressionism, the concern with both imitation and expression, the attempt to reconcile truth with poetry was by no means new in art. But in the context of the struggle between art and photography this dualism was likely to be exaggerated and, at some point, to undergo a qualitative change. Baudelaire's warning that photography and poetry were irreconcilable is pertinent here and, because of this conviction, he not only anticipated but helped nurture the essential concepts on which Post-Impressionist styles were formed.

The paucity of references to photography in the notes and letters of the Impressionists is no guarantee that they did not use it. Indeed, the silence may be entirely relevant considering the growth of photography as an art and the commensurate antipathy artists felt for it. Artists found it expedient to hide the fact of their use of photographic material or its influence upon them. Only one of Delacroix's status and literary propensities would be likely to express candidly and in detail his opinions on the subject, and to confirm his use of photographs. But, by implication

at least, critics in France and in England demonstrated that there was an obvious correlation between the use artists made of photographs and their reluctance to admit it. How many painters exhibiting in the 1861 Salon would dare to confirm Gautier's observations without the fear of losing face?

> I do not propose [declared Joseph Pennell when asked later to comment on the use artists made of photographs], to give away the tricks of the trade. By refraining I have no doubt I shall receive the silent blessings of the multitude of duffers among whom I find myself.

Artists did not publicize their use of photographs, it was said, because "they have a notion . . . that they would lose caste with their picture-purchasing public." Sickert's view on this question, in the words of a music-hall ditty, was that "some does it hopenly, and some on the sly."[1]

THE IMPRESSIONISTS' USE OF PHOTOGRAPHY

In these circumstances it is difficult to know the exact extent to which the Impressionists made straightforward use of the camera image, though certainly its oblique influence is detectable. Admittedly sparse, and not always of immaculate provenance, there are nevertheless certain examples which show that these artists sometimes utilized photographs directly. The uncompromising naturalism to which they aspired—Monet in particular, and particularly in the earlier years—their dedication to painting only before nature; the great emphasis on the objective eye; their desire to record the transitory character of natural light and shade, amounted to a kind of perceptual extremism which was germane to photography itself, and would not necessitate—indeed would obviate—

[1] . . . Pennell's statement was sent to *The Studio* and published in one of its first numbers in 1893, vol. I, p. 102. See also Hector Maclean, *Photography for Artists* (London 1896). Sickert's frivolous quip is from his letter to *The Times* (15 August 1929). It is worth noting that neither Courbet, Manet, Degas, Gauguin or Derain, all of whom frequently had recourse to photography, ever saw fit to mention the fact (as far as I can discover) in as candid a way as Delacroix did, if indeed they referred to it at all.

The word "impressionism" itself had earlier become inextricably associated with both the photographic process and its images. It would be redundant to cite the many examples in the literature on the subject which refer to the "impression of the entire view," "these impressionable plates," etc. In 1861 Burty described the "impressions" one receives in looking at certain landscape photographs because of the peculiar way in which they record light ("La photographie en 1861," *G.B.A.* (September) p. 244). When Monet's painting, *Impression: Sunrise,* was singled out for abuse in the exhibition of 1874, one may justifiably conclude that, in some part, it embodied a derogatory association with the images of the camera.

copying from photographic prints. But by the same token it is most likely that in their own interests they would scrutinize the work of contemporary photographers.[2]

[2] . . . According to François Daulte, Bazille's *Jeune Homme nu couché sur l'herbe* [*Young Nude Man Laying Down in the Grass*] (*c.* 1869) was begun out-of-doors and completed in the studio after a photograph. Though his sources are not made clear, he writes that "occasionally Bazille used the photograph simply as reference material. Thus it took the place of the absent model" (*Frédéric Bazille et son temps* (Geneva 1952) pp. 151, 184). Gaston Poulain noted that Monet's *Femmes au jardin* [*Women in the Garden*] (1867) had its origin in two photographs taken at Méric (near Montpellier) which were owned by the Bazille family (*L'Amour de l'Art* (Paris: March 1937) pp. 89–92, illustrated). The painting, he says, was executed at Bazille's request and since, like his own picture of his family that year, it was intended as a group portrait, Monet was probably supplied with the photographs to enhance its accuracy, the commission carried out in the artist's garden at Ville-d'Avray in the north of France. The similarities which exist between the painting and the photographs are confined to the individual figures and their costumes. George Heard Hamilton suggests that Monet employed as an *aide-mémoire* a photograph taken of Rouen Cathedral when reworking a painting at Giverny (see *Claude Monet's paintings of Rouen Cathedral*, Charlton Lecture, University of Durham (O.U.P. 1960): *Monet, Rouen Cathedral*). . . . [Also cf. Figs. 14 and 15 of 1868 and 1867.–ED.]

JAPONISME:
JAPANESE INFLUENCE ON FRENCH PAINTING

Gerald Needham (1975)

The enthusiasm among painters for Japanese art in the last forty years of the nineteenth century was intense and long-lasting . . . [There] is a detailed illustration of the impact on Claude Monet to show that every period of his career was intimately bound up with Japanese art. As Monet laid so much stress on his faithfulness to the motif and is usually seen as the purest Impressionist, it is hoped that this will demonstrate both the pervasiveness of the influence and the fact that it occurs where often today we do not suspect it.

A number of reasons accounted for the appeal of Japanese art to writers and artists. Nineteenth-century imperialism included a genuine interest in other peoples and parts of the globe, as is evident from the hero worship of explorers, and from the contents of the World Fairs. The opening up of Japan revealed an almost unknown and decidedly exotic civilization which was both quaint and refined. In addition it seemed to be permeated with artistic values in all aspects of life. This made it doubly attractive to French intellectuals revolted by the more depressing aspects of the new industrial society (one remembers their opposition to the Eiffel Tower), and by that society's failure to appreciate its best artists. Even more important, by the middle of the century the principles of Greco-Roman art which underlay European art had lost most of their vitality, as was widely recognized in spite of

From Gabriel P. Weisberg, Phillip Dennis Cate, Gerald Needham, Martin Eidelberg and William R. Johnston, *Japonisme: Japanese Influence on French Art 1854–1910* (Cleveland: The Cleveland Museum of Art, 1975), pp. 115–19 and pp. 130–31 by Gerald Needham; reprinted by permission of The Cleveland Museum of Art. [This book is a catalog of an exhibition of prints, decorative art objects, and paintings influenced by Japonisme.—ED.] [I would also like to thank Gerald Needham for granting his permission to reprint his work.—ED.]

the lip service still paid them. Japanese art was introduced to the West at just the right moment to offer the alternative of a varied and sophisticated artistic tradition. A European artist could find in the fans, screens, kimonos, and bric-a-brac a highly refined and delicate inspiration (as Whistler did), or, if he preferred, he could find in the flat colors, emphatic outlines, and frequent grotesqueries of the prints a primitive, refreshing spirit and style. . . .

Once Japanese art had become fashionable all types of art were, of course, imported. As a result the important Japanese works in the sixties were not necessarily those that we know best today. For instance, Hokusai's *One Hundred Views of Fuji,* which is a book, was even more influential than the famous *Thirty-Six Views of Fuji.* On the other hand, Hiroshige's single prints of the *One Hundred Views of Famous Places in Edo* [see Fig. 24] had more influence than the *Fifty-Three Stages of the Tokaido* because they were published in the late 1850's, after the opening of Japan, and were extremely accessible to French artists throughout the period of Japonisme. Needless to say, when a Japanese work is cited in this essay . . . it does not always mean that an artist must have seen a copy of this particular print. The Japanese artists endlessly copied each other and themselves, and any specific compositional or stylistic element can be found in a number of different works.

An important reason for the assimilation of Oriental ideas by French artists is that many of the Japanese elements they encountered corresponded with effects they had noticed and admired in their own environment. . . . Certain effects in photographs (a non-art medium) struck artists, and when similar elements were found in Japanese works it became apparent that these effects could also be achieved in art. In complementary fashion, the photograph corroborated that what might appear outlandish in a print was, in fact, "true"—a key word to the Impressionists with their respect for visual data. . . .

Among the open-air Impressionists Claude Monet was the leader in absorbing lessons from Japan. This fact has not been recognized, as Monet has always been regarded as the purest Impressionist. The Japanese influence has been seen in only a few Monet works of the sixties and seventies, those which did not have an atmospheric, perspective effect. As W. C. Seitz has written, Monet "followed Whistler and Manet in incorporating the flat, decorative qualities of Japanese prints into his art."[1] This cliché about the "flatness" of Japanese prints is ubiquitous and has prevented us from seeing how varied were the qualities of

[1] W. C. Seitz, *Claude Monet* (New York, 1960), p. 25.

Japanese art that so fascinated the Impressionists. (Monet's extensive personal collection of prints and fans demonstrates his personal enthusiasm for Japanese art.)

As a matter of fact, the Japanese artists who particularly interested Monet and the open-air Impressionists were the landscapists whose prints were not "flat." The great artists of the late eighteenth and early nineteenth century—Kiyonaga, Hokusai, and Hiroshige—were part of a new realism in the arts, and their popularity was in part caused by the vogue for travel books and novels like Ikku Jippensha's *Hizakurige* of 1802. These printmakers partially rejected the Japanese pictorial tradition and eagerly studied the Western landscape prints (chiefly Dutch) that trickled into Japan through Nagasaki. Not only were European perspective concepts adopted but Hokusai even signed some of his landscapes in horizontal Western fashion to indicate his sources. At the beginning of Monet's development it was these semi-Europeanized pictures that he was able to learn from; he found the more purely Japanese works alien to his search for a faithful rendering of visual experience.

Japanese artists began to copy European perspective in the middle of the eighteenth century. At first these pictures, known as *uki-e* (not to be confused with *ukiyo-e*), were curiosities or were used for architectural scenes where the lines of the buildings provided a natural linear perspective scheme. An emphatic, exaggerated one-point perspective scheme was used in these latter works, presumably because it could be more easily constructed and because the dramatic result suited Japanese taste.

This type of perspective, as mastered by Hiroshige, proved to be a decisive influence in Monet's development during 1866–67, and through him it affected all the other Impressionists. We illustrate a comparison between Monet's *Road Near Honfleur in the Snow,* probably January, 1867, and Hiroshige's *Asakusa Kinryuzan Temple,* 1856 . . . The reason Monet borrowed a perspective scheme from Japan which had come from Europe in the first place is that the Japanese exaggeration of perspective foreshortening contributed to the particular kind of painting Monet was trying to evolve. Monet wanted to paint a scene that not only was visually convincing in its freshness and immediacy but also included the atmosphere—what he referred to as the *enveloppe* of air. The traditional Japanese picture precluded this latter element, while the one-point perspective style in Western landscapes created a steady recession with a time element that eliminated immediacy. The dramatization of the perspective in the Honfleur snow pictures rapidly funnels the spectator's eye to the back of the scene, where the lack of any object to fix on forces his attention quickly over the remainder of the canvas. The picture is thus received

in a single glance (as an *impression*) without sacrificing the actual depth of the landscape or its atmospheric qualities.

This concept was so successful that it became a standard for Impressionistic composition; it was used especially frequently by Pissarro and Sisley in their views down roads.[2] Monet himself used it most often in his views of the Seine where the towpath and the river combine as one perspective unit. This assimilation of the Japanese style was undoubtedly encouraged by some of Jongkind's compositions of the mid-sixties which moved in this direction. Additionally, the foreshortening effect resembles that found in photographs and prints. To emphasize this important compositional type we [can compare certain paintings by Monet, such as] . . . *Rue de la Bavolle, Honfleur*, probably Fall 1866, and Hiroshige's *Evening Scene in Saruwakacho* [see Fig. 24], circa 1857.[3] The X-shape superimposed on the composition by the buildings creates a surface tension as well as depth.

The most widespread influence of the Japanese on the Impressionists was the freshness and brightness of their color. So different was the Japanese use of color from that of the open-air painters that it might seem an unlikely source of influence. Yet the earliest writers on Impressionism and the Japanese—Armand Silvestre and Théodore Duret—both singled out Japanese color as a major influence on these painters, who were well known to them as friends. Though the Impressionist brushstroke and optical realism created an effect very different from the arbitrary Japanese color, the connection was clearly expressed by Duret:

> Well it may seem strange to say it, but it is none the less true, that before the arrival among us of the Japanese picture books, there was no one in France who dared to seat himself on the banks of a river and to put side by side on his canvas, a roof frankly red, a white-washed wall, a green poplar, a yellow road, and blue water.[4]

The freshness of Japanese color thus inspired French painters to seek color boldly in their observation of the motif. This is particularly true of Monet, most of whose works in the sixties were not particularly bright, since he was seeking a harmony of light. In 1871 he bought a

[2] When Monet visited Pissarro in the winter of 1869–70, he painted a view of *The Road to Versailles at Louveciennes* with this perspective, which was repeated almost exactly by Pissarro. See illustrations in J. Rewald, *The History of Impressionism* (1961), pp. 212, 213. When Sisley in his turn visited Monet at Argenteuil in 1872, they painted identical views of a *Street in Argenteuil*, illustrated in Rewald, p. 288.

[3] [This, as well as other perspective] Hiroshige prints are from the *One Hundred Views of Famous Places in Edo*.

[4] T. Duret, preface to *Works in Oil and Pastel by the Impressionists of Paris* (New York, 1886), p. 5.

number of Japanese prints in Holland (earlier he was too poor to acquire them personally), and his color immediately became brighter. *Blue House at Zaandam,* 1871–72 (private collection), is an obvious example.[5] The Renoir painting *Still Life with Bouquet,* 1871 [see Fig. 25], shows how the color of a Japanese fan can set the tone for a whole painting. It also illustrates the importance of fans and prints in studios and homes of French artists, for Monet was not the only painter to come under this influence. In 1873 Silvestre wrote in the preface to the volume of etchings of paintings belonging to the Durand-Ruel Gallery:

> What seems to have hastened the success of these newcomers, Monet, Pissarro and Sisley, is that their pictures are painted in a singularly joy-ful range of color. A blond light inundates them and everything in them is gaiety, sparkle, springtime fete, evenings of gold or apple trees in flower—again an inspiration from Japan.[6]

Silvestre's comment suggests another aspect of the Impressionist-Japanese relationship—subject matter. Just as the Impressionists painted scenes of recreation in Paris and the surrounding resorts (the cafes, dance halls, race courses, theaters, boulevards, and bridges, and the promenad-ing and boating at Argenteuil, Bougival, Chatou, or at the seashore), so the *ukiyo-e* prints depicted the pleasures of Edo (the theaters, street scenes, and wrestlers, the cafe life of the brothels,[7] and the many excur-sionist scenes of surrounding beauty spots). This correlation must have encouraged the assimilation of Japanese qualities and shows why the Impressionists were much less influenced by Japanese paintings and screens.

Pissarro, the most rural of the Impressionists in this period, reveals still another aspect of the influence of Japanese prints in the weather effects of mist, fog, and snow that occur in his canvases. Eventually he was to write to his son Lucien after seeing a show of Japanese prints at the Durand-Ruel Gallery:

> Damn it all, if this show doesn't justify us! There are grey sunsets that are the most striking instances of impressionism.... Hiroshige is a mar-vellous impressionist. Monet, Rodin, and I are enthusiastic about the show.[8]

[5] Reproduced in color in Rewald, *History of Impressionism,* p. 270.
[6] Galerie Durand-Ruel, *Receuil d'estampes gravées á l'eau-forte* (Paris, 1873), p. 23.
[7] Apart from specifically erotic prints, the brothels are represented as centers of social life, conversation, and music-making, thus portraying a subject matter analogous to that of the Impressionists. E. Scheyer, "Far Eastern Art and French Impressionism," *Art Quarterly,* VI (1943), pp. 118 and 119, stresses the correspondence between Impressionist and *ukiyo-e* subjects but fails to see the stylistic debts.
[8] C. Pissarro, *Letters to his Son Lucien* (New York, 1943), p. 206.

The support of Durand-Ruel in the early 1870's after the Franco-Prussian War enabled the Impressionists to buy prints, and their influence on the artists was further strengthened. In addition to the pervasive interest in color, numerous Japanese–inspired motifs can be found in Monet, for example, in his pictures with bridges filling the upper part of the painting, or with a screen of branches obscuring the motif (a technique also favored by Pissarro), in pictures of snow actually falling, and in individual compositions like his painting of men unloading coal from barges.

The famous *La Japonaise*, 1876 (Boston Museum of Fine Arts), Monet's painting of his wife wrapped in a spectacular Japanese-appliqued cloth with fans on the wall behind her, is the one fashionable and obvious picture that he painted in this period. Renoir, Monet's friend, was sensitive to Japanese color but his compositions are less innovative than Monet's; where we see traces of Japonisme they may have come from the works of his friends rather than directly from the Japanese. An admiration for Japanese art is seen most clearly in the use Renoir made of fans, screens, and silks in his portraits, particularly those of Monet's wife.

Pissarro, like Degas, was challenged by the fan shape, and this is especially interesting in his case. He usually had little time for delicate or feminine art, but again the fascination of Japan was irresistible. In the *Girl in a Field with Turkeys* [see Fig. 26], however, the handling of the peasant subject and panoramic landscape almost refutes the Japanese examples. The composition, with a close-up subject on one side and a vista on the other, is derived more from painting than from prints and is equally as much Chinese as Japanese; it may possibly be one of the rare instances at this time of a Chinese inspiration. . . .

Claude Monet's work changed steadily in the 1880s as he, too, entered the new phase of Japonisme. He became concerned with dramatic compositional elements and turned to obvious Japanese sources. . . .

In 1884 Monet painted some decorative panels of flowers and fruit for Durand-Ruel. The tall, thin shape of some of the panels betrays their Japanese inspiration, as does Monet's signature, written vertically up the panel—a reversal of Hokusai's habit of writing his signature in horizontal Western style! Unlike the Japanese influence on Monet in the sixties and seventies, this new stage has been widely recognized because it is so apparent.

Monet's love of things Japanese was carried over from the decoration of his dining room with prints into his garden at Giverny, where he built a Japanese bridge that naturally figured in some of his paintings. The last, and climactic, phase of Monet's career in the first quarter of the twentieth

century—the phase which saw his large paintings of water lilies and wisteria—is also infused with Japanese feeling. The confusions of perspective in the water lilies and the lack of ground or skyline closely resemble elements in Redon's pictures. The lilies themselves float in a sea of reflections, so that there is an ambiguous play of surface and depth. Monet's development has brought him from his early "snapshots" of contemporary life to an art of evocation and contemplation—the last, but one of the most profound, gifts of Japan to French painting.

THE SALON AND THE IMPRESSIONISTS

Carol M. Osborne (1974)

The Official Exposition of Living Artists, the Paris Salon, was a yearly event of enormous popularity throughout most of the nineteenth century. By the mid-1870s the Parisian habit of taking in the show on the Champs-Elysees had become as much a part of the spring season as the races at Longchamps or the *revues* on the Grand Boulevard. Zola, reviewing the Salon of 1875 for *Le Messager de l'Europe,* speculated that on Sundays when entrance to the vast display at the Palais de l'Industrie was free, more than 30,000 visitors streamed through its doors—on opening day the turnstiles whirred like windmills.

Part of the attraction was the chance for the crowds to see themselves as others saw them, to know what comments artists had to make about the way they lived their lives, wore their clothes, and carried on their love affairs. Zola couldn't decide if the public's taste for trivia—the stock-in-trade of the year's Salon as he saw it—was inculcated by the painters, or demanded of them by the crowd; he waited for "the genius of the future" to emerge to re-educate the people. Meanwhile, he watched them make their way through the thirty large, hot, dimly-lit rooms: while the ladies paused before portraits of the fashionably dressed, the men headed for the glassed-in sculpture garden where, with a beer in one hand and a cigar in the other, they could take in the statues of the nude goddesses.

The Salon and The Impressionists [Editor's title]. From C.M.O. (Carol M. Osborne), "The Impressionists and the Salon I," in *The Impressionists and the Salon (1874–1886),* honoring the centennial of the first Impressionist exhibition California Collections, an exhibition organized by the students in the department of the History of Art, University of California, Riverside, appearing in the Los Angeles County Museum of Art and in the Gallery, University of California, Riverside, April–June, 1974. © The Regents of the University of California, 1974, n.p. Reprinted by permission of the Regents of the University of California. [I would also like to thank Carol Osborne for granting her permission to reprint her work.—ED.]

century—the phase which saw his large paintings of water lilies and wisteria—is also infused with Japanese feeling. The confusions of perspective in the water lilies and the lack of ground or skyline closely resemble elements in Redon's pictures. The lilies themselves float in a sea of reflections, so that there is an ambiguous play of surface and depth. Monet's development has brought him from his early "snapshots" of contemporary life to an art of evocation and contemplation—the last, but one of the most profound, gifts of Japan to French painting.

THE SALON AND THE IMPRESSIONISTS

Carol M. Osborne (1974)

The Official Exposition of Living Artists, the Paris Salon, was a yearly event of enormous popularity throughout most of the nineteenth century. By the mid-1870s the Parisian habit of taking in the show on the Champs-Elysees had become as much a part of the spring season as the races at Longchamps or the *revues* on the Grand Boulevard. Zola, reviewing the Salon of 1875 for *Le Messager de l'Europe,* speculated that on Sundays when entrance to the vast display at the Palais de l'Industrie was free, more than 30,000 visitors streamed through its doors—on opening day the turnstiles whirred like windmills.

Part of the attraction was the chance for the crowds to see themselves as others saw them, to know what comments artists had to make about the way they lived their lives, wore their clothes, and carried on their love affairs. Zola couldn't decide if the public's taste for trivia—the stock-in-trade of the year's Salon as he saw it—was inculcated by the painters, or demanded of them by the crowd; he waited for "the genius of the future" to emerge to re-educate the people. Meanwhile, he watched them make their way through the thirty large, hot, dimly-lit rooms: while the ladies paused before portraits of the fashionably dressed, the men headed for the glassed-in sculpture garden where, with a beer in one hand and a cigar in the other, they could take in the statues of the nude goddesses.

The Salon and The Impressionists [Editor's title]. From C.M.O. (Carol M. Osborne), "The Impressionists and the Salon I," in *The Impressionists and the Salon (1874–1886),* honoring the centennial of the first Impressionist exhibition California Collections, an exhibition organized by the students in the department of the History of Art, University of California, Riverside, appearing in the Los Angeles County Museum of Art and in the Gallery, University of California, Riverside, April–June, 1974. © The Regents of the University of California, 1974, n.p. Reprinted by permission of the Regents of the University of California. [I would also like to thank Carol Osborne for granting her permission to reprint her work.—ED.]

Until the inauguration of independent shows by the Impressionists in 1874, this was the showplace—"department store," Zola called it—to which the more than 4,000 (after 1863) French artists brought their works for recognition and for sales. In spite of the periodic intransigence of its jury, the Salon had presented the rich variety of French art to the public for three-quarters of the nineteenth century, as it had for years. Its walls reflected not only the preference of the bourgeoise for genre and the taste of the Academy for *le beau ideal,* but also the importance of landscape painting; on occasion its halls echoed with the laughter provoked by the canvases of such great painters as Courbet and Manet. It must be noted, however, that although works by nearly all of the finest French artists had been exhibited at the Salon during the course of the century, some Salon years were more democratic than others: tolerance fluctuated with changes in the French government.

Even when an artist got his work past the jury, he still had to worry about where it was placed. Only too often, painters like Monet and Renoir saw their canvases hung so high—"skied"—or so inconveniently— behind doors or in poor light—that they despaired of being noticed. The artists who attracted the attention of the public were the ones who were hung "on the line" or who got the prizes, for middle class buyers knew what they liked when jurors pinned medals on the winners. Like Henry James's naive American at the Louvre who knew which pictures to look at from the asterisks in his Baedeker, these buyers depended on professional guides to tell them which works were first class. Artists complained bitterly and constantly about the injustices of the jury, and though they tried for years to get the government to enforce a selection process that was fair to all, they never succeeded in finding a formula that pleased everybody.

How could they? Artists in Paris were turning out, at a conservative estimate, 200,000 paintings a decade. In the Salon of 1875 there were 3,862 works; by 1880 the number had increased to 7,235, the record for the century. Never before had there been a time when France had had so many professional painters—men, that is, who earned their living solely by painting. In Zola's words, Paris had become purveyor to the world not only of soap, gloves, and fine attire, but of fine art as well. As a critic he welcomed the chance to see all of the epoch's extraordinary variety in one place, but nonetheless he characterized the Salon as a regular Babel of art, an "absolute cacophony." No wonder it was hard to tell the players without a program of medals and prizes.

In 1874 when the avant-garde painters broke away from the Salon to exhibit for the first time as an independent group in the studio which the photographer Nadar had lent them for the occasion, they accomplished what was no easy task: they established an artistic identity for

themselves. And although the derisive term "Impressionist," which was given to them by an antagonistic critic, neither pleased every one of them nor aptly described all the styles of their group, it brought their work into focus as innovative and modern. In a practical sense, the exhibition on the second floor of the well-lighted building on the boulevard des Capucines gave the public a chance to see their paintings in congenial surroundings. It also precluded the unpleasantness of having to submit their works to jury members who were, on the whole, antipathetic to what they were doing. . . .

To the defenders of the Academic tradition these avant-garde painters were indeed an insult to the profession: artists were supposed to be learned men with an obligation to select subjects of a suitably elevated nature, and moreover, to treat them in accordance with the rules of painting. Conservative critics saw the Impressionists not so much as rebellious, but rather as "bad" painters—men who could not draw and would not use the conventions of light and shade which went with firm contours. To viewers accustomed to the careful finish of Salon paintings it is no wonder that the paintings exhibited in Nadar's studio seemed both shocking and incomplete.

The champions of tradition much preferred artists like Bouguereau who were faithful to styles which had originated in the Italian High Renaissance [see Fig. 27] and were perpetuated well into the nineteenth century by the French Academy. (Bouguereau was duly rewarded with the Grand Medal of Honor at the Salon of 1885.) The Academy, which is not a school as its name might suggest, was the Fine Arts Section of the National Institute of France—an august group of men, distinguished in the arts, sciences, and letters, which was formed in 1795 to replace the Royal Academy "for the general utility and glory of the Republic."

Though membership was honorary, the forty academicians (fourteen were painters) had a formidable hold on the course of French art during the first half of the nineteenth century for several reasons: they were frequently called upon by the government to serve on Salon juries; they controlled the curriculum at the Ecole des Beaux-Arts; and they governed the complicated system of prizes and awards by which young artists might make their way to success. . . .

The curriculum at the Ecole des Beaux-Arts, which was staffed by members of the Academy, was designed in large measure to produce Prix de Rome winners. Artists who stepped out of line knew their chances of winning this plum were jeopardized, and they diligently followed the painstaking and laborious discipline of the Ecole. Drawing was the basis of its carefully-structured regimen—painting and sculpture were taught elsewhere. . . .

Painting, which until 1863 was not part of the curriculum at the Ecole, was learned from copying at the Louvre as well as in private classes. (To accommodate museum visits in daylight hours, classes at the Ecole did not begin until four in the afternoon.) Not only traditionalists but innovators as well copied Old Masters both in order to learn the techniques of painting and to earn a living. Fantin-Latour began copying there as a young student—Rembrandt, Titan, Giorgione, Watteau, and Chardin were his teachers—and he continued to do so all his life. . . .

Couture, whose painting *Romans of the Decadence* had been a Salon sensation in 1847, was another non-Academician who was attracting pupils in the 1850s. Manet studied with him for six years, and Puvis de Chavannes worked with him briefly. In Couture's studio, pupils were not trained for the Prix de Rome; they were taught to master the technique of painting.

Others studied with Lecoq de Boisbaudran in whose studio at the Ecole de Dessin they were encouraged to paint from memory. Lecoq had them render objects as they observed them, and then repeat the mental image of what they had recorded. . . .

In addition, nearly all the young painters painted at one time or another in "free" schools like the Académie Suisse and the Académie Julien where, for the price of the model's fee, they could paint without any supervision at all.

The entire Impressionist group, with the exception of Cezanne, attended either the Ecole or a private atelier (Renoir and Sisley attended both) around mid-century. By that time, however, the Academy's highly competitive system could no longer accommodate the enormous number of young men who had come to Paris to study art, and its control over the form and content of the pictures they painted grew less and less secure.

As the Academy's hold over art slipped away, that of the *bourgeois* increased. Already in his Salon review of 1845 and again in 1846, Baudelaire recognized the power of the middle class: "You are the majority—in number and intelligence; therefore you are the force—which is justice." This was the group that found its voice in the July Monarchy of Louis Philippe, and continued to flourish in the expanding industrial economy that Napoleon III (and the Credit Mobilier) introduced to conservative France during the Second Empire.

With the same practical instincts of seventeenth century Dutch burghers, the *nouveaux riches* invested their money in works of art which not only suited their living rooms, but also confirmed their new style of life. Rather than enormous canvases of classical mythology with the gods in a "complication of embraces," they preferred paintings that were

small enough for Parisian apartments, and they wanted them to be up-to-date and modish. They liked paintings with subjects that told a story, or better, portraits for the mantel—Monsieur in his evening clothes or Madame in a Worth gown. These were the paintings that told them who they were: personages of circumstance and means.

Artistically uneducated, these new patrons appraised painting with the same sensibility they brought to test the quality of gloves and fine attire. The trompe-l'oeil effect of objects so real you could touch them, the surface so finished you could not detect the strokes of the brush that formed it, the illusion of reality—these were the qualities that impressed them. For this audience, the exquisite craft of Meissonier was a miracle; from the very first the public adored his work, and paid enormous prices for his paintings. His fastidious attention to detail, his skill as a miniaturist, his concern for historical veracity—he repainted the regimental dragoons in a painting which had taken him fourteen years to complete when he discovered, shortly before the Salon of 1880, that he had got the number wrong—in a word, his prodigious skill as artificer so impressed this audience both at home and in America that nobody could rival him. When Meissonier entered the Academy in 1861, genre—"the small change of art," as Zola called it—went in with him.

Art which was contrived to give the viewer a "you-are-there" sensation was what appealed to the majority of amateurs. Not only was praise lavishly bestowed on the miniatures of Meissonier, but also on the paintings of artists like Gerome, whose re-creations of scenes from the ancient past—the *Death of Caesar,* for example—and the present-day Near East, put together with archeological and documented exactitude, marked him as an historical realist. . . .

The innate taste of the bourgeoisie for subjects that looked "real" and told a story began to be felt with the coming of the July monarchy in 1830. Louis Philippe himself liked historical anecdotes. He liked artists, too, and it was his acquiescence to their pleas for an annual Salon which, in 1833, gave the public the opportunity to register its choices. The Academy, always elitist, was opposed to the yearly exhibition, and the fact that the Institute was allowed to run the Salon in the first place was an act of appeasement. . . .

By nature and by design, Louis Philippe's taste was a compromise between the "delirium" of the Romantics and the "closed thought" of the Classicists. Artists like Delaroche, Vernet, and Scheffer were especially favored for their Romantic themes taken from history and treated in the Academic style. . . .

These artists of the *juste milieu* were preferred by the bourgeoisie, and they were acceptable to those Academicians who found Delacroix

intolerable. The control of the Salon by this latter group, however, was temporarily suspended when the provisional government of the Second Republic came to power from 1848 to 1851. The Realist Courbet and the landscapist Rousseau emerged from the Salons of those years—the most liberal of the century. Any artist who wanted to could submit entries to the "free" Salon of 1848; and a committee chosen by the artists themselves appraised these 5,000 works for prizes and awards. (The following year they put together a jury to screen out the amateurs.) The 2,586 works in the Salon of 1849 make it one of the most outstanding exhibitions of the century. Courbet received a second class medal for the seven paintings he exhibited, and the long-neglected Rousseau won a first, while Fromentin, Troyon, and Jules Dupre were also given citations. Daumier exhibited for the first time, and paintings by Corot, Daubigny, and Courbet were purchased by the State.

The Second Empire put an end to the democratic spirit of those years. Political conservatism enforced censorship and construction in art. During the year that Napoleon declared himself Emperor (1852), Delacroix was rejected from membership in the Academy; with Alfred Emile O'Hara, Count of Nieuwerkerke, as Director General of National Museums, the make-up of the jury was shifted to the Institute. For the next decade its policy was restrictive.

In 1852 the jury was split between those elected by the artists and those appointed by Nieuwerkerke, himself a sculptor and a member of the Academy (as well as the lover of the Emperor's cousin, the Princess Mathilde.) Furthermore, it was now the rule that no artist could submit more than three works, and the Salons themselves were henceforth to be held only in alternate years. The total number of entries accepted for the Salon of 1852 dropped to 1,700. In 1853, the jury was even more severe in limiting the selections and the *hors concours* rule, which had previously accorded automatic admission to the Salon to all previous winners of first and second class medals, was applicable only to members of the Institute and the Legion of Honor.

Nonetheless, despite the restrictive nature of these years, Courbet, who is often referred to as the *enfant terrible* of the fifties, was accepted in enough Salons to make his mark. (This included the Salon of 1855, the year Courbet held his one-man show.) But there were other painters who did not have the chance to be seen, and in 1863 when the jury refused more than 4,000 works, they complained so vociferously that the Emperor himself ordered the famous Salon des Refuses to be held in galleries next to the official one. His Majesty, "in wishing to let the public judge the legitimacy of these complaints," opened the door to scandal, but though the public jeered, it came in droves to see the 687 rejected

works. The majority of painters had withdrawn their entries because they found it humiliating to be exhibited in such a way. Indeed, many of the refused works *were* embarrassingly poor, but interspersed among them were three distinguished canvases by Manet—the most famous being the *Dejeuner sur l'herbe*—as well as Whistler's *Woman in White* and others by Fantin-Latour, Pissarro, Jongkind, Legros, Harpignies, and Chintreuil. . . .

Nearly twenty years later the experts and arbiters of the Establishment saw the management of the Salon taken out of their hands and given to the artists themselves. In the years that intervened from 1863 to the time of the Franco-Prussian War in 1870, less severe juries began to accept works by Manet and the Impressionists. Their standards, however, were arbitrary and unpredictable. . . .

Immediately after the War, the enlightened dealer Paul Durand-Ruel started buying works by the Impressionists and by Manet to add to his collection of Barbizon painters. With his support and that of a small number of private collectors, the Impressionists felt less inclined to risk the ignominy of refusal by the Salon jury. On April 15, 1874, with Monet as their principal organizer, the Impressionists presented the first of the eight expositions which mark the break with the Salon system. Their emergence at that time was a manifestation of new attitudes which valued the immediacy and spontaneity of the artist over the finish and illusionistic perfection of the work. They carried with them a cluster of dealers and critics which, by the end of the century, had supplanted the Salon as the evaluative and interpretive filter for art. . . .

THE STATUS OF IMPRESSIONISM IN 1974

Kirk Varnedoe (1974)

In the myth-history of modern painting, the case of the Impressionist painters is the classic success story. Rebels against convention, they spent much of their lives struggling against critical bias and public ignorance, only to find their reward in posterity. Even before World War I, their rival contemporaries, the academic *pompiers,* fell off into the purgatory of museum storerooms, market devaluation, and general neglect. By contrast, the Impressionists' popularity, and their prices, have shown a consistent rise since the beginning of the century, with a sharp escalation since World War II. In the 1960s, the auction of Impressionist paintings at record prices became a commonplace.

As the 100th anniversary of the first Impressionist group exhibition, 1974 might thus have been awaited as a moment of apotheosis, when exhibitions and publications would crown a triumph already certified on the market. The [1974] Impressionist show at the Metropolitan Museum of Art (derived in part from a similar centennial affair in Paris) would seem to bear out these expectations. However, it is interesting to note just how few such shows there [were in 1974], and to remark, further-more, how much of the Met's display [was] given to "supporting material" in the form of documentation, contemporary works by other artists, demonstrations of roots in earlier painting etc. (there [were] only forty Impressionist works). . . .

In fact, one could review 1974 by saying that, far from apotheosis, it has offered counter-Impressionism, or anti-Impressionism. In this re-

The Status of Impressionism in 1974 [Editor's title]. From Kirk Varnedoe, "Revision, Re-Vision, Re: Vision: The Status of Impressionism," in *Arts Magazine,* XLIX (Nov. 1974), pp. 68–71. Reprinted by permission of the publisher. [I would also like to thank Kirk Varnedoe for granting his permission to reprint his work.—ED.]

gard, it has crystallized trends at work since the early 1960s. The most obvious of these tendencies, . . . has been occurring right under the noses, so to speak, of the Impressionists: it is the revival of their arch-foes, the academics, the painters of the juried Salons.

One hardly has to argue that the Salon revival is upon us. [The] . . . "Musée de Luxembourg en 1874" in Paris (a reconstitution of the French government collection that so effectively excluded the Impressionists for so long) was only the latest in a noteworthy series of such exhibitions. It was immediately preceded, for example, by the "Nineteenth Century Paintings From the Museo del Ponce" in New York, "The Elegant Academics" in Hartford, and "The Impressionists and the Salon" in Los Angeles. [1974's] focus on non-Impressionist and/or counter-Impressionist art of the period has further precedents, to mention only a few, in the "Equivoques" of 1972 (Paris), the Gérôme and Tissot resurrections (Dayton, 1973, and Providence, 1968, respectively), and the "Salon Imaginaire" of 1968 (Berlin); serious shows all, and there will be more to come—for example, Christopher Forbes' collection of British painting from the Royal Academy [followed] the Impressionists at the Met.

Nor does one have to dispute the fact that the phenomenon of the reevaluation is a market reality as well. Sotheby's Belgravia is the prominent head of a long line of auctioneers and galleries in the U.S. and Europe that have, in growing numbers since the early 1960s, specialized in Victoriana, academic painting, nineteenth-century sculpture, and other fields of work formerly lost in grandmother's attic. Though the record prices for Renoir and Monet may have made bigger splashes, the surge in "non-mainstream" nineteenth-century painting has been at least as impressive over the past decade.

It might warrant stressing, though, since it is less in the public eye, that nineteenth-century art scholarship has moved in a parallel path. Important work by Robert Rosenblum, Albert Boime, Gerald Ackerman, and others has brought new attention to conservative (as opposed to proto-modern) work. Reviewing recent art history of the nineteenth century, it is clear that the prime characteristic exercises have been reconsiderations of "neglected" (i.e., previously thought second-rate or worse) artists, and thematic studies linking "mainstream" and "inconsequential" artists. Particularly in the latter (if not by implication in the former as well), a levelling effect has been at work. That is, the *connections* between the Impressionists and more conservative artists, in contrast to the traditionally accepted uniqueness (and consequent pre-eminence) of the Impressionist group, have been emphasized.

What has not been sufficiently explored, it seems to me, are the ways in which manifestations such as these—in the museum, in the market,

and among scholars—may interrelate, and further, the ways in which the Salon revival may be symptomatic of a larger shift of sights, not only with regard to the past, but also the present.

Can it be merely coincidental, for example, that, concurrent with the Salon revival, the 1960s also saw the derailment of the progress of twentieth-century abstraction? Certainly it was abstract painting, in Mondrian to some extent, but especially in the New York School, that did much to confirm the "relevance" of Impressionism to modern art.[1] The Impressionist painters' break with finished representation, and their unification of the canvas in a single texture of loose strokes, were prophetic of the vein of abstract art that gained overwhelming ascendancy in the 1950s. The subsequent rise of tight, high-status realism as a vanguard style has, however, been unsettling in this regard. Developments in art since 1960 (Pop and Photo Realism most obviously) force us to reconsider the degree to which our estimation of the Impressionists has depended on our acceptance of the importance of their heritage, in abstraction. It is unavoidable that, in the process of such a reconsideration (already in progress), the opprobrium heaped on the nineteenth-century academics for their retrograde technique will come to seem less valid. Meissonier, by virtue of his magnifying-glass realism, may even, unexpectedly, carry the crown of relevance.

This kind of connection between contemporary developments and historical judgments is not a simple cause-and-effect situation. Nor is it merely coincidental. The phenomena are related, in less direct but no less important fashion. There is one ready, albeit cynical, explanation by which one could unite all aspects of the Salon revival, and link into modern art as well: this hinges on economics, and especially on an economics of scarcity prevalent in several sectors of the art world since the 1960s.

In the market sector, first of all, skyrocketing prices have put the works of the original Impressionist group out of reach of all but a highly select group of dealers and collectors. Furthermore, the escalation has included, in a coat-tails effect, virtually every peripheral artist of the late nineteenth and early twentieth centuries who bears some stylistic similarity to Impressionism. The result has been a gross overvaluation, prodded by an eccentrically narrow-focus demand (Japanese buyers being especially influential) in this limited area. With the concurrent

[1] In this regard, see William Rubin, "Jackson Pollock and the Modern Tradition," *Artforum,* February and March, 1967; and especially William Seitz, "The Relevance of Impressionism," *ART News,* January, 1969. Prof. Seitz's essay, which discussed coincidences between various sectors of the art world, encouraged me in the present speculation.

general increase in participation in the art market, and the specific popularity of things nineteenth-century, large numbers of dealers and collectors have seen in non-Impressionist and/or anti-Impressionist painting a better field of value, more accessible and more profitable. The resultant boosting of the academics, particularly by interested dealers, constitutes a kind of revival in itself.

A similar set of conditions affects the museum world. Curators have been less and less able to afford desirable work by the nineteenth-century "masters"; as a result, they have become more alert to the less glamorous "representative" painters of the time. This means more traditionalists, fewer "mainstream" artists—and virtually no Impressionists. Beyond the matter of acquisition, prohibitive insurance costs, restricting major loan shows, have forced the curator of nineteenth-century art to develop a new acquaintance with his own storeroom; and a flair for interesting exhibitions based on less treasured works has become a virtual prerequisite for his job. Again, this means we have been seeing, and will be seeing, more Bouguereau [see Fig. 27] and Meissonier, less Renoir and Monet.

One could extend this analysis of scarcity economics another step, to include a parallel situation obtaining in art history. Art scholarship on the nineteenth century finds itself now in a third or even fourth generation; the students of Friedlander and others have produced scholars who are themselves now well established and guiding theses. This means, among other things, that a limited field of study is getting increasingly crowded; since that field is steadily more and more popular, the crowding can only get worse. In such a situation, the neglected Salon "greats" such as Bouguereau provide the historian (particularly the young one) a more fruitful field for original discovery and significant personal contribution than accepted "major" figures, whose terrain is well gleaned or at the least well guarded. Impressionism is overworked, and the moss of neglect makes the Salon all the more attractive.

In all of these areas, then, we see that a common dilemma has recently arisen: a pressure to expand or innovate has been concurrent with a field of operation heavily oversubscribed in key areas. It does not take too large a leap to see an analogy with the kind of dilemma that characterized the contemporary art scene around 1960. Pressure to expand or innovate came from the accelerating pace of investment and from the fascination for the idea of the avant-garde; it was concurrent with an apparently depleted field of possibilities, in the wake of the extreme, seemingly ultimate extensions of 1950s abstract painting (in the work of Pollock, Reinhardt, and others).

If the dilemma of painting in 1960 had elements similar to those

present in other sectors of the art world, so, too, the manner of resolving that dilemma has parallels in all these cases. The dealers, the curators, and the scholars have succeeded, by reviving Salon art, in transposing the hopelessly *passé* into the novel. New Realism, as well as certain kinds of modified Dada and Surrealism of the past decade, have, in a similar manner, revivified art forms thought to have been left derelict by progress; the new art is radically *retardataire*.

This last stretch of the economic explanation, however, defies common sense; as, indeed, do all of the other steps when looked at more closely. It is hardly credible that any of the phenomena mentioned, and especially not all of them together, could flourish in an aesthetic vacuum. Experience as well as common sense tells us that no change in style or taste can be successfully force-fed to an audience to whom that style has absolutely nothing to say. The success of Sotheby's Belgravia, Boime's writing, and post-abstract contemporary art all indicate not simply that alternatives were necessary and inevitable, but that these specific alternatives were appreciated. A significant number of people in producing, marketing, and receiving roles in the art system are now actively interested in things which, until quite recently, were thought to be without interest. This is a question not just of economics, but of taste. It demands a probing, not only of common external conditions, but related internalized attitudes as well.

In regard to the question of historical revisionism, for example, we should look to the particular conditions affecting art history. Here, revision is perforce re-vision, seeing the same things in ways significantly different from before. Some conditions that affect such vision are the subject of a [1975] publication by Lorenz Eitner, and his analysis is especially germane to the question at hand.[2] As Eitner sees it, art history since World War II, especially in the large universities, has become increasingly entrenched as an academic discipline, peopled (in contrast to its aristocratic past) by working scholars and teachers. The new art historian, according to Eitner, moves increasingly, and not without pressure, towards the emulation of his peers in the humanities, most notably by the frequent publication of scholarly articles. As Eitner points out, these teachers and scholars depend absolutely on photographs and slides, without which, indeed, contemporary art history, both in teaching and in

[2] Dr. Eitner's remarks on "Art History and the Sense of Quality" were delivered as a lecture at Cooper Union last spring . . . [subsequently published in *Art International*, May, 1975, pp. 75–80]. I am grateful to him for many hours of pleasant and challenging discussion, on this and other topics.

I would like to take this opportunity to acknowledge as well my debt to my brother, Sam Varnedoe, Jr., for his valuable criticism, unending patience, and supportive good will in helping me give form to these ideas.

scholarship, could not have developed as it has, nor exist as it does. There is no doubt that the growth of academic art history has occasioned an impressive expansion of knowledge, particularly in analytic/comparative capacities. But this is at the expense, Eitner argues persuasively, of a large part of art itself. The sensual/physical/kinesthetic experience of the work, which is only marginally articulable and almost totally elusive of reproduction, escapes the method of the scholar-analyst. As academic art history continues to grow, then, the immediate sensory aspects of art will suffer systematic neglect. At the extreme, the sense experience, problematic because unadaptable to the framework of study, would come to be actively denigrated as frivolously subjective. The recent dominance of thematic histories, mentioned above, seems symptomatic of this kind of cerebralization.

This scenario for art history bears directly on the question at hand, as it surely holds a poor fate for the Impressionists. As the study of nineteenth-century art tends toward illustrated intellectual history, much of the Impressionists' production will inevitably be found wanting. Unprepossessing as theoreticians or articulate intellects, most of these painters (Degas aside, as always) were purveyors of a rococo sensibility, a sensibility dissociated from the idea of significant narrative content, but strongly dependent for its delectation on the direct experience of the canvas, in proper scale. The higher-definition, low-surface-quality rhetoric of the typical Salon picture, by contrast, loses less of its significant features in slide or print. Furthermore, there is the matter of historical relevance, which may be in for a change of definition. For William Rubin (comparing Monet to Pollock in 1967), Monet opened up the future in the intuitive response of his brush to the accelerated pace of Paris in his time. But, through the lenses of the contemporary scholar, Monet, Renoir, and the others may seem distressingly detached from their society; while Gérôme, Cabanel, and others like them may yield more fruitful studies in iconography, biography, and ideology.

What the changes in art history produce is, then, among other things, a vastly increased stress on subject (the academics) as opposed to technique (the Impressionists). It would be facile to go on from there to say that this new attention to the subject, and concurrent disregard for surface sensuousness, provide parallels with contemporary painting. The resurgence of the subject, and a simultaneous depletion of complex painterly surfaces, have, after all, been among the most notable developments of post-1960 art. However, the common factors of sharp-focus representation and tight technique provide only superficial elements of comparison, and limit the linkage to New Realism alone. In fact, the Salon revival, as a reaction against certain aspects of Impressionism,

relates to a broader spectrum of contemporary art, not on the level of appearance, but on the level of underlying ethic.

Since 1960, a contemporary artistic bias has been antagonistic to the (apparently) loose discipline and willful, isolated individualism of the 1950s. Its most obvious expressions lie in Pop, with its homage to machine printing, and in Photo Realism, with its icy airbrushing. Chris Burden's conceptual stunts are perhaps, however, only an extreme manifestation of the same assertion: that the artist should subject himself, or appear to subject himself, to a binding concern with a reality outside himself. The Salon artists of the nineteenth century would have recognized the ethic, perhaps; for they understood, in a different but parallel way, that individuality was to be strongly delimited—in their case, not only by expectations of verisimilitude, but also by known hierarchies of themes, formats, color, etc.

The evocation of the shutter's eye; the canonical banality or gruesomeness of a limited strata of modern subject matter; the insisted-upon detachment of the artist in his method and in his evidenced willingness to bow the personal before the external: do these not provide for post-1960 art a *cachet* of seriousness, . . . and *sang-froid* echoing that which Bouguereau and his fellows found in academic *dicta?* In each case, a supra-individual ethic asserts non-subjectivity in creation, as an antidote to the irresponsibility of excess.

Another element of the contemporary ethic, in conscious opposition to the confessional involvement of the action canvas, is the insistence on irony; and again, to the degree to which this attitude is broadly shared, it operates against appreciation of Impressionism and in favor of the academics. Most visible in Pop, but characteristic of a broad spectrum of work including Funk and its offshoots, post-1960 irony frequently finds expression in the glorification of the banal, and the calculated debunking of the concept of the masterwork and the master painter. Glorified banality of course abounds in the later nineteenth-century Salon, and there is little question that some of the appeal of its revival lies in the semi-camp attraction of dated trivia. Camp, however, was a 1960s sensibility, and its mocking tone, with every revival exhibition, seems to be giving way to a more serious, anti-progressive appreciation of the comfortably *passé*. In regard to the second tactic, the proscription of the artist-hero, Impressionism is again on the defensive. Lichtenstein's dot-screened Monets point out that the once-underdog Impressionists have themselves become sanctified shibboleths. Paradoxically, by contrast, the Salon successes, by virtue of long neglect and denigration, come forward now free from the onus of heavy critical pretension; in this, too, the times are in their favor.

One might say, in fact, that in contemporary art, as in art history, a new academicism has set in. A jaundiced view would unite the two fields in a common lack of imagination, just as the current market successes of both nineteenth-century academics and 1970s Photo Realists could be seen as the common grasping of confused collectors at the last-refuge criteria of simple craft (evidenced in trompe-l'oeil brushwork) as a standard of quality. However, such a negative view only seems to reflect the death agonies of a stylistic/historical bias.

We have come to a period of anomaly in contemporary art, a period of redefinition and reevaluation. No single paradigm of operation is yet able to establish itself as dominant, in the way that a Monet-vs.-Cézanne dialect of abstraction had seemed to establish itself as dominant before. Instead of answers, we are now involved with establishing the terms for a new set of questions. Current indications suggest that we are at least getting free from the tyranny of an exaggerated religion of the avant-garde; and thus that the new questions may well be revivified, redefined old questions. In this, apparent or self-styled "objective" Realism seems slated for an important role. If further evidence for the latter point is needed, one need only look to the current status of photography.

The last several years have not only seen an amazingly accelerated interest in the history of photography *per se;* they have also produced the first comprehensive studies of the tremendous debt of painting to photography, from the *camera obscura* to the present, with especially revealing attention to the nineteenth century. Painters of the past previously set aside as independent geniuses (Delacroix, for example) are recognized as having depended in part on photography; while the photographers of the past, previously dealt with only by specialists in that field, are coming into their own, commercially and critically, as artists. In contemporary photography, meanwhile, we have seen a marked rise of interest in semidocumentary images of unglamorized and/or grotesque realities (Owens' *Suburbia,* Krims' *Chicken Soup,* Davidson's *East 100th Street,* Arbus): the artist as mute selector. All of this betokens the disdain for individual artistic heroics, the devaluation of uniqueness, the disregard for complexity in abstract formal values or surfaces, and the new appreciation of the humble probity of objectivity, all discussed before in regard to painting.

This set of attitudes, extending across visual experience in the last ten or twelve years, has disrupted the contemporary art scene. Historical judgments are due for a similar shake-up. Impressionism is sure to remain popular, in a motel-wall-and-children's-bedroom sense, but it is overdue for searching critical review. Monet and Renoir's weaker works will soon

begin, I believe, to look very bad indeed; peripheral artists characterized by the awful term "Impressionistic" will fall sharply.

If this kind of critical surgery occurs, one might well ask, what will be gained in the process? We will not shift our values in a wholesale way, to delight in Bouguereau and send Monet to the cellar. More likely, like most revivals, the Salon revival will be seen to have dredged up, along with a lot of eminently forgettable things, a few interesting, appealing artists. For the moment, the most likely candidates for this more significant consideration would seem to be those painters who combined aspects of modernism and tradition in styles that have as yet no generic name (I think principally of Caillebotte and Tissot, whose particular uses of photography make some of their work seem very fresh today). Within Impressionism itself, along with a qualitative weeding, there should be a shift of interest (it has already begun) toward the tighter, more planar work of the 1860s, as more than mere prelude to the 1870s.

The Impressionists' classic success story, then, is having its ending modified. In all sectors of the art world, economic realities demand, and contemporary attitudes encourage, the end of the critical hegemony the Impressionists had obtained. What should follow that hegemony is not simply another dominant stylistic bias in opposition, but a more balanced, discerning critical view of the epoch—a view that sees that quality is not necessarily limited to one form of expression in any period. Innovation and relevance to the present seem to be revealed now as only partially satisfactory criteria of selection, and we must rearrange not only our judgments, but also our principles of judgment, concerning the art of the nineteenth century.

Appendix A: Map of France Showing
Where the Impressionists Worked

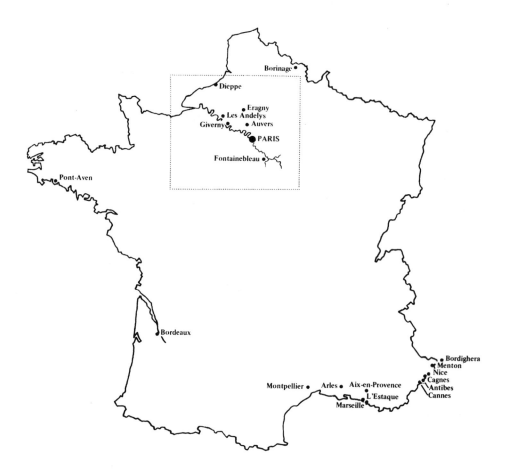

Map taken from John Rewald, *The History of Impressionism*, 4th ed. rev., 1973 (end-leaf). 1st edition © 1946, renewed 1974. All rights reserved by The Museum of Modern Art, New York. Reproduced by permission of the author and publisher.

*Appendix B: Map of Area Around Paris
Where the Impressionists Worked*

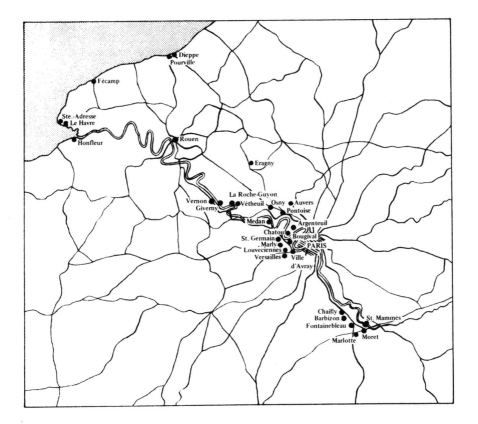

149

Chronological Survey (1830-1927)

Jean Leymarie (1959)

1830 Birth of Camille Pissarro at Saint-Thomas in the West Indies.

1832 Birth of Edouard Manet in Paris.

1834 Birth of Edgar Degas in Paris.

1839 Birth of Paul Cézanne at Aix-en-Provence and Alfred Sisley in Paris, the latter of English parents.

1840 Birth of Claude Monet in Paris; his childhood and youth are spent at Le Havre.

1841 Birth of Auguste Renoir at Limoges, Frédéric Bazille at Montpellier, Berthe Morisot at Bourges, Armand Guillaumin in Paris. Renoir's family moves to Paris in 1845.

1848 Birth of Gauguin.

1853 Birth of Van Gogh.

1855 Pissarro and Whistler arrive in Paris.

Degas and Manet are students at the École des Beaux-Arts.

Renoir enters on his apprenticeship as a porcelain painter in a Parisian china factory.

1855 Paris World's Fair, with large-scale exhibitions of works by Ingres, Delacroix, Théodore Rousseau and Courbet.

1856 Degas travels in Italy, staying at Rome, Naples and Florence. Manet leaves Couture's studio after traveling in Holland, Austria, Germany and Italy, where he studies the masterpieces.

1856 Duranty runs a magazine: *Le Réalisme.*
Courbet paints *Girls on the Banks of the Seine.*

1857 Baudelaire publishes *Les Fleurs du Mal.*

Chronological Survey (1830–1927) [Editor's title]. From Jean Leymarie, *Impressionism,* trans. by James Emmons (Geneva: Editions d'Art Albert Skira, 1959), I, pp. 9–13; II, pp. 7–11. Reprinted by permission of the publisher. [Also, see the excellent chronological chart in John Rewald, *History of Impressionism,* 4th ed. rev. (New York: The Museum of Modern Art, 1973), pp. 592–607.–ED.]

1858 Monet meets Boudin at Le Havre. The latter takes him along on painting excursions in the open country, where they work directly from nature. "A veil was torn from my eyes," Monet later wrote, "and in a flash I saw what painting meant."

1859 Monet comes to Paris, frequents the Brasserie des Martyrs, meets Pissarro at the Académie Suisse.

1859 Manet is rejected at the Salon, despite Delacroix's backing.

> 1859 Boudin, Baudelaire and Courbet stay at the Ferme Saint-Siméon, near Honfleur. Baudelaire praises Boudin's elliptical jottings from nature in his review of the Salon. Birth of Georges Seurat. Publication of Darwin's *Origin of Species*.

1860 Courbet opens a studio of his own at the request of the Beaux-Arts students, among them Fantin-Latour, and chooses an ox as the first model.

Monet sent to Algeria on military service.

> 1860 Large-scale Exhibition of Modern Painting in Paris (Delacroix, Corot, Courbet, Millet).

1861 Manet's first appearance at the Salon, where he attracts attention. He becomes friendly with Baudelaire and Duranty, and exhibits at the Galerie Martinet.

Pissarro meets Cézanne and Guillaumin at the Académie Suisse.

Berthe Morisot studies under Corot at Ville-d'Avray.

1862 Meeting of Manet and Degas. The latter does his first pictures of jockeys and the races, while Manet paints his *Concert at the Tuileries*.

Discharged from the army, Monet returns to Le Havre and paints with Boudin and Jongkind during the summer. Goes to Paris in November and enrolls in Gleyre's studio, formerly that of Paul Delaroche. There, amongst the newcomers, he meets Sisley, Renoir and Bazille.

1863 Manet, Pissarro, Jongkind, Guillaumin, Whistler and Cézanne exhibit at the so-called "Salon des Refusés," organized for painters whose work is rejected at the official Salon. Uproar over the *Déjeuner sur l'herbe;* from now on Manet is looked upon as the "ringleader" of the independent painters in their struggle for recognition.

Monet shares a flat with Bazille in the Place de Furstenberg, overlooking the studio of Delacroix, whom they often watch at work. They spend their Easter holidays working at Chailly, near Barbizon, on the edge of the Forest of Fontainebleau. Painting at Pontoise, Berthe Morisot meets Daubigny and Daumier.

Jongkind spends much of the year painting at Honfleur.

Tentative reforms made at the École des Beaux-Arts.

> 1863 Essay by Baudelaire on Constantin Guys and "modernity" in painting. Death of Delacroix.

1864 Gleyre's studio having shut down, Monet takes his friends to the Forest of Fontainebleau, where they paint directly from nature.

There Renoir meets Diaz, who gives him friendly tips and even helps him to sell his pictures. In the autumn Monet rejoins Boudin and Jongkind at Honfleur. "There's much to be learnt in such company," he writes to Bazille.

Manet paints the sea-fight between two American men-of-war, the Kearsarge and the Alabama, off the Cherbourg coast, paints *The Races at Longchamp* and takes a studio at 34, Boulevard des Batignolles.

Pissarro exhibits at the Salon as "Corot's pupil."

1864 Birth of Toulouse-Lautrec.

1865 Monet successfully shows his Honfleur seascapes at the Salon. He paints a large *Déjeuner sur l'herbe* in Fontainebleau Forest and seascapes at Trouville with Courbet, Whistler, Daubigny and Boudin.

Manet exhibits *Olympia* and travels to Spain in August, where he meets the critic Théodore Duret.

Renoir and Sisley paint together in Fontainebleau Forest.

Degas meets Zola and Duranty and paints his last historical picture, *The Evils befalling the City of Orléans*. Turning towards the portrait and scenes of contemporary life, he undergoes the influence of photography and Japanese prints.

1865 Death of Proudhon, whose *Du Principe de l'art et de sa destination sociale* is posthumously published. Zola visits Courbet.

1866 Monet exhibits *Camille* at the Salon, paints views of Paris and works at Sainte-Adresse and Le Havre. Meets Manet, whose influence affects him conjointly with that of Courbet. Renoir paints his *Inn of Mother Anthony* at Marlotte, in the Forest of Fontainebleau.

Courbet stays at Deauville with the Comte de Choiseul.

Corot and Daubigny are jury members at the Salon.

Pissarro's work is noticed at the Salon. He breaks away from Corot and paints on his own at Pontoise.

Rejected at the Salon, despite Daubigny's efforts in his behalf, Cézanne sends a letter of protest to the Director of Fine Arts but nothing comes of it.

1866 The Goncourt brothers publish *Manette Salomon*. Zola writes enthusiastic articles on Manet and reviews the Salon in the newspaper *L'Evénement*.

1867 Paris World's Fair. Manet and Courbet set up their own booths and show 50 and 110 canvases respectively.

Extreme severity of the Salon jury, all the Impressionists being rejected, except Degas and Berthe Morisot, with her *View of Paris from the Trocadéro*.

Large figure compositions painted entirely in the open air: Monet's *Women in the Garden* and Bazille's *Family Reunion*.

Renoir paints at Chantilly and Fontainebleau, Monet at Sainte-Adresse, Sisley at Honfleur, where Bazille does his portrait.

Cézanne moves back and forth between Paris and Provence, paints large, lowering, erotic compositions.

1867 Death of Baudelaire and Ingres. Birth of Bonnard. Karl Marx publishes *Das Kapital*. Opening of the Suez Canal.

1868 Manet exhibits his *Portrait of Zola* at the Salon, then stays at Boulogne, whence he makes a brief trip to England. Fantin-Latour introduces him to Berthe Morisot, who poses for *The Balcony*.

Monet works in Paris with Renoir and Bazille, then at Etretat and Fécamp, where he attempts to commit suicide.

Renoir successfully shows his *Lise* at the Salon.

Degas begins his methodical studies of dancers and stage scenes: *Mademoiselle Fiocre in the Ballet "La Source."*

1868 Birth of Vuillard. Corot paints his *Woman with a Pearl*. Zola praises Manet and Picasso in his review of the Salon.

1869 Renoir and Monet work together at Bougival. With their versions of *La Grenouillère*, the impressionist technique takes form.

Working on the Channel coast are Manet at Boulogne, Courbet at Etretat, Degas at Saint-Valéry-en-Caux.

Pissarro settles at Louveciennes, and first tries his hand at painting the gleam of light on water.

Gatherings of painters and writers at the Café Guerbois.

1869 Birth of Matisse. Death of Berlioz.

1870 Franco-Prussian War. Proclamation of the Third Republic. Bazille killed in action at Beaune-la-Rolande, November 28.

Manet serves in the National Guard, Degas in an artillery unit, Renoir in a light cavalry regiment.

Cézanne retires to L'Estaque, finishes *The Black Clock*.

Monet and Pissarro escape to England.

1870 Théodore Duret reviews the Salon.

1871 Having served as chairman of the Art Commission under the short-lived Commune, Courbet is accused of having dismantled the Colonne Vendôme and imprisoned at Sainte-Pélagie, where he paints some fine still lifes.

In London Monet runs into Daubigny, who introduces him to the dealer Durand-Ruel, to whom Pissarro is soon introduced in turn. Monet and Pissarro paint snow effects and views of the Thames and Hyde Park. Visiting the museums, they discover Turner and Constable.

Manet visits his family in the Pyrenees, then returns to Paris along the coast, painting seascapes all the way: *Bordeaux Harbor*.

Renoir divides his time between Paris and Louveciennes, paints his *Portrait of the Henriot Family* and yields to Delacroix's influence.

Monet's first trip to Holland: *Views of Zaandam*.

Pissarro returns to Louveciennes in June only to find his studio ransacked.

Degas stays with his friends the Valpinçons at Mesnil-Hubert.

1871 Duret sets out on a round-the-world trip by way of the United States and Japan. Birth of Rouault.

1872 Back in France, Monet visits Courbet in prison, accompanied by Houdin and Armand Gautier. After a second trip to Holland, he settles at Argenteuil.

Again in Paris, Durand-Ruel sounds out Degas and Sisley, then visits Manet's atelier and buys 30 pictures outright, for which he pays 51,000 francs. After this Manet takes a new studio at 4, Rue de Saint-Petersbourg, and in August travels to Holland to make a firsthand study of Frans Hals.

Pissarro leaves Louveciennes in April and moves back to Pontoise, where Vignon and Guillaumin join him. At the same time Cézanne settles down nearby, at Saint-Ouen-l'Aumône. Under Pissarro's influence his palette brightens up and he drops his luridly romantic themes for an objective study of landscape.

Degas takes to visiting the rehearsal rooms of the opera dancers. In October he sails for New Orleans with his brother René, only returning to Paris in April 1873.

Renoir paints views of Paris: *Le Quai Malaquais, Le Pont-Neuf.*

After a holiday at Saint-Jean-de-Luz, Berthe Morisot travels briefly in Spain, to Toledo and Madrid, where she admires Velazquez.

1873 Back from New Orleans in April, Degas begins painting dancers and contemporary themes in bright colors. Monet paints at Argenteuil. At Auvers Pissarro converts Cézanne to the impressionist technique. Taken up by Durand-Ruel, Renoir rents a big studio in Montmartre. Manet summers at Berck-sur-Mer.

1874 First Group Exhibition at Nadar's, 35, boulevard des Capucines (April 15–May 15); 30 participants, 165 works. Manet, Renoir, Sisley and Caillebotte join Monet at Argenteuil. Mature phase of the impressionist style of open-air painting. Sisley makes a trip to England. Pissarro stays at Montfoucault. Berthe Morisot marries Manet's brother.

1875 Disastrous auction-sale of works by Monet, Sisley, Renoir and Berthe Morisot at the Hotel Drouot, March 24. Cézanne lives in Paris on the quai d'Anjou: meets Victor Chocquet and the dealer Tanguy. Manet makes a trip to Venice.

1875 Death of Corot.

1876 Second Group Exhibition at 11, rue Le Peletier (April).

1876 Duranty publishes *La Nouvelle Peinture.*

1877 Third Group Exhibition at 6, rue Le Peletier (April). Gatherings at the Café de la Nouvelle Athènes, Place Pigalle. Second auction-sale at the Hotel Drouot (May 28); average price 169 francs.

1877 Death of Courbet. Georges Rivière publishes a periodical called *L'Impressionniste.*

1878 Monet moves to Vétheuil.

1878 Paris World's Fair. Duret publishes *Les Impressionnistes.*

1879 Fourth Group Exhibition at 28, avenue de l'Opéra (April 10–May 15). Renoir, Cézanne, Sisley and Berthe Morisot abstain. Renoir successfully shows at the Salon.

 1879 Charpentier launches "La Vie Moderne." Death of Daumier.

1880 Fifth Group Exhibition at 10, rue des Pyramides (April). Gauguin shows for the first time with the group. Monet abstains. Dissensions and disruption. One-man shows by Manet (April) and Monet (June) at "La Vie Moderne."

1881 Sixth Group Exhibition at 35, boulevard des Capucines. Cézanne works at Pontoise (May–October) with Gauguin and Pissarro. Renoir travels to Algeria in the spring, to Italy in the autumn. Monet lives at Poissy.

 1881 Birth of Picasso.

1882 Seventh Group Exhibition organized by Durand-Ruel. At the Salon Manet shows his *Bar aux Folies-Bergère*. Sisley settles down at Moret on the edge of Fontainebleau Forest. On his way back from Italy Renoir pays a visit to Cézanne at L'Estaque: enters on his "harsh manner."

 1882 Courbet Retrospective Exhibition at the Ecole Nationale des Beaux-Arts.

1883 Series of one-man shows at Durand-Ruel's from February to June: Boudin, Monet, Renoir, Pissarro, Sisley. Pissarro and Gauguin go to Rouen together. Sisley works at Saint-Mammès. Traveling in the South of France, Renoir and Monet pay a visit to Cézanne. Seurat's first appearance at the Salon. Monet settles at Giverny, near Vernon, in the Eure department. Death of Manet.

 1883 Huysmans publishes *L'Art Moderne*. Exhibition of Japanese prints at the Galerie Petit.

1884 Founding of the "Société des Indépendants." Seurat exhibits *Bathing at Asnières*. Monet takes trips to Bordighera, Menton, Étretat. Pissarro settles at Eragny, near Gisors, in the Eure department. Manet Retrospective Exhibition at the Ecole Nationale des Beaux-Arts.

1885 Pissarro meets Signac and Seurat and adopts Divisionism. Renoir stays at Wargemont, Essoyes, La Roche-Guyon; does preliminary sketches for his *Bathers*.

1886 Eighth and Last Group Exhibition (May 15–June 15). Degas shows a set of 10 pastel nudes. Monet visits Holland, then goes to Belle-Isle, where he meets Geffroy. Durand-Ruel organizes a large Impressionist Exhibition in New York.

 1886 Fénéon publishes *Les impressionnistes en 1886*. Gauguin's first stay at Pont-Aven in Brittany. Van Gogh comes to Paris (March).

1887 Lautrec and Van Gogh practise Pointillism.

 1887 Birth of Juan Gris and Marc Chagall. Death of Jules Laforgue.

1888 Cézanne receives Renoir at the Jas de Bouffan, then makes a long stay in Paris and the Ile-de-France. Monet stays at Antibes (January–April). Seurat stays at Port-en-Bessin; exhibits his *Poseuses* and *Parade*.

 1888 Van Gogh goes to Arles. The Nabis come together at the Académie Julian.

1889 Exhibition of the Impressionist and Synthetist Group at the Café Volpini. Monet and Rodin exhibit together at the Galerie Petit. Monet stays with Maurice Rollinat in the Creuse department. Renoir works in the neighborhood of Aix, near Cézanne. Degas travels in Spain and Morocco.

 1889 Bergson publishes *Les données immédiates de la conscience*.

1890 Seurat works at Gravelines, near Dunkerque; paints *Le Chahut*. Pissarro breaks with Pointillism, Renoir with his "harsh manner." Monet undertakes "sets" of pictures on the same theme.

 1890 Van Gogh commits suicide at Auvers-sur-Oise.

1891 Cézanne makes a brief trip to Switzerland and the Jura country. Renoir travels in the South of France and Spain. Monet paints a series of *Haystacks*. Death of Seurat and Jongkind.

 1891 Symbolist banquet presided over by Mallarmé. Van Gogh Retrospective at the Indépendants. Gauguin leaves for Tahiti.

1892 Renoir and Pissarro show at the Durand-Ruel Gallery. Seurat Retrospective at the "Revue Blanche." Cézanne works at Fontainebleau; paints his *Card Players*. Monet: *Poplars* and *Cathedrals*. Renoir works in Brittany.

1894 Pissarro at Knockke in Belgium. Cézanne visits Monet at Giverny (autumn), where he meets Rodin, Clemenceau and Gustave Geffroy. Death of Caillebotte; Renoir named executor of his will.

1895 First Cézanne Exhibition at the Vollard Gallery. Renoir visits London and Holland. Death of Berthe Morisot.

1896 Pissarro paints at Rouen in the spring and autumn.

 1896 First Bonnard Exhibition at Durand-Ruel's. Death of Verlaine and Edmond de Goncourt.

1897 Impressionist exhibitions in London and Stockholm. Pissarro stays in London (May–July). Uproar over the Caillebotte Bequest, in part refused by the State. Degas goes to Montauban to see the works in the Musée Ingres.

1898 Pissarro paints a view of the Place du Théâtre Français in Paris and, in July, several views of the docks and cathedral at Rouen. Renoir buys a house at Essoyes (Aube), where he henceforth spends the summer; in December he suffers his first bad attack of arthritis. Degas makes a stay at Saint-Valéry-sur-Somme; now nearly blind, he lives in seclusion and devotes himself more and more to sculpture. Death of Boudin.

 1898 Death of Mallarmé.

1899 Cézanne sells Le Jas de Bouffan and moves into Aix. Renoir takes a great liking to Cagnes; presents a canvas to Limoges, his home

town. Pissarro does more views of Paris (Tuileries, Carrousel) and works in the autumn at Varengeville. Death of Sisley.

1899 Group Exhibition of the Nabis at Durand-Ruel's. Signac publishes *D'Eugène Delacroix au Néo-Impressionnisme.*

1900 After a stay at Bonneval, near Dieppe, Pissarro does a series of views of the Louvre and the Pont-Neuf in Paris. Monet in London, Renoir at Magagnosc, Louveciennes, Essoyes. Seurat Retrospective at the "Revue Blanche." Maurice Denis paints his *Homage to Cézanne.*

1900 Paris World's Fair. Centennial Exhibition of French Art.

1901 Pissarro works at Moret (April–May) and Dieppe (August–September).

1901 Van Gogh Retrospective at Bernheim-Jeune's. Death of Toulouse-Lautrec.

1902 Renoir at Le Cannet (Riviera) with Albert André. Pissarro makes another stay at Dieppe. Cézanne has a studio built on the Chemin des Lauves, outside Aix.

1902 Lautrec Retrospectives at the Indépendants and at Durand-Ruel's. Death of Zola.

1903 Renoir settles at Cagnes, on the Riviera. After summering at Le Havre (July–September), Pissarro dies in Paris on November 13.

1903 Founding of the Salon d'Automne. Death of Gauguin and Whistler. Impressionist and Neo-Impressionist Exhibition at the Vienna Secession.

1904 Matisse at Saint-Tropez (Riviera) with Cross and Signac. Renoir and Cézanne rooms at the Salon d'Automne. Cézanne revisits Paris and Fontainebleau for the last time. Monet exhibits a set of *Views of London.*

1905 Manet Retrospective at the Salon d'Automne. Seurat and Van Gogh Retrospectives at the Salon des Indépendants.

1905 The Fauves at the Salon d'Automne.

1906 Death of Cézanne at Aix.

1908 Monet makes a trip to Venice.

1909 Monet exhibits a series of *Waterlilies* at Durand-Ruel's.

1910 Renoir makes a trip to Munich and writes a preface to a new edition of Cennino Cennini's *Treatise on Painting.* Death of Cross.

1910 Derain works at Cagnes.

1913 Renoir Exhibition at Bernheim-Jeune's.

1917 Death of Degas in Paris. Matisse settles at Nice, where he becomes friendly with Renoir and Bonnard.

1919 Death of Renoir at Cagnes, after a last visit to the Louvre and a last look at Veronese's *Marriage at Cana.*

1923 Monet presents a set of decorative panels on *Waterlilies* to the State. After his death, in accordance with his last wishes, these were installed in two oval-shaped rooms in the Musée de l'Orangerie, Paris.

1926 Death of Mary Cassatt and Monet.

1927 Death of Guillaumin.

Notes on the Editor and Contributors

Barbara Ehrlich White (1936–). Art historian. She has published on Renoir, on Impressionism, and on Women's Studies in Art History. She has taught art history at Tufts University since 1965.

Pierre Bonnard (1867–1947). Painter. During the late 1890s, Bonnard, along with Vuillard and Denis founded the Nabis association. Bonnard liked to say that he was an Impressionist at heart.

Richard F. Brown (1916–). Museum director, scholar, and teacher. Currently Director of the Kimbell Art Museum, Fot Worth, Texas.

Paul Cézanne (1839–1906). Painter. One of the four great Post-Impressionists. Cézanne had an Impressionist phase from about 1872–1897, when he was influenced by Pissarro.

Giorgio de Chirico (1888–). Painter. Founder with Carrà of the quasi-surrealist Italian movement.

François Duret-Robert (1932–). Writer. Background studies were, in general, in mathematics. Recently, he has collaborated on books on Renoir, Impressionism, and Van Gogh and is living in France.

Paul Gauguin (1848–1903). Painter and sculptor. One of the four great Post-Impressionists. Gauguin was influenced and aided by Pissarro in the late 1870s and early 1880s. In the late 1880s, he began to write manuscripts, some of which were published in the later years of his life.

Vincent Van Gogh (1853–1890). Painter. Born in Holland, but spent his most productive years in France. One of the four great Post-Impressionists. Van Gogh had a brief period in Paris (1886–1888), where he was influenced by the Impressionists.

Arnold Hauser (1892–). Writer. His brilliant *Social History of Art* is a profound analysis of the arts and of social history throughout the ages.

George Inness (1825–1894). Painter. American landscapist of the poetic realist tradition.

Henry James (1843–1916). Novelist. Considered one of the greatest American novelists, his work is noted for its realistic psychological penetration. The *Painter's Eye* is a collection of published and unpublished critiques on art.

Wassily Kandinsky (1866–1944). Painter. Born in Moscow, trained in Munich; was a founder of the Blaue Reither movement and an innovator of pure abstract painting.

Jules Laforgue (1860–1887). Poet and art critic. Laforgue became an art critic for the *Gazette des Beaux Arts* early in the 1880s. At that time, he met most of the Impressionists, whom he ardently supported.

Jean Leymarie (1919–). Curator-in-Chief of the Museum of Modern Art in Paris and author of many books on modern art.

André Masson (1896–). Painter. Joined the surrealists in 1924.

Henri Matisse (1896–1954). Painter. A principal figure of the Fauve (ca. 1903–1907) movement and a major figure of twentieth century art.

Guy de Maupassant (1850–1893). Writer. He was influenced by Flaubert and by the school of Naturalism. He is best known for his short stories.

Claude Monet (1840–1926). Painter. One of the greatest Impressionist painters.

Robert Motherwell (1915–). Painter. American artist who has been associated with the Surrealists and with the Abstract Expressionists.

Gerald Needham (1934–). Art historian. His areas of interest are Monet, Japonisme, photography, Russian constructivists, and contemporary art. He currently teaches at Douglass College, New Jersey.

Carol Osborne (1929–). Art historian and writer. Ms. Osborne is currently a graduate student in art history at Stanford University.

Pablo Picasso (1881–1973). Painter, sculptor, designer. Picasso was a major figure of twentieth century art.

Camille Pissarro (1831–1903). Painter. A central figure of the Impressionist movement and one of the greatest Impressionist painters.

Auguste Renoir (Pierre-Auguste Renoir) (1841–1919). Painter. One of the greatest Impressionist painters. While his landscapes were consistently Impressionist, his large-scale figures became increasingly classical after 1880.

John Rewald (1912–). Art historian. One of the foremost Impressionist scholars. See further comments in the Acknowledgments in this volume.

Oscar Reutersvärd (1915–). Art historian, sculptor, painter, writer. Author of books on Monet and on Impressionism. Presently at the Institute of Art History at Lund, Sweden.

Georges Rivière (1855–1943). Writer and art critic. Rivière was a staunch supporter of the Impressionists at the time of their greatest difficulties in the late 1870s.

Aaron Scharf (1922–). Art historian. Recent publications on photographs and art. Currently a professor of art at the Open University.

Paul Signac (1863–1935). Painter. Theoretician of Neo-Impressionism.

Kirk Varnedoe (1946–). Art historian. Currently teaching at Columbia University. Varnedoe has written on Rodin and on Caillebotte.

Lionello Venturi (1885–1961). Art historian. Venturi has published numerous studies of nineteenth and twentieth century art. His *Archives of Impressionism* is one of the basic sources in the field of Impressionism.

Harrison White (1930–). Sociologist. *Cynthia White* (1933–). Art-illustrator. Harrison White, Chairman of the Department of Sociology at Harvard University, is especially interested in the dynamic structure of organizations, whether historical or contemporary. Cynthia White was trained as an art historian at Harvard University; she is specifically interested in early nineteenth century French painting.

Oscar Wilde (1856–1900). Writer. Irish aesthete and wit who wrote on art and other topics. He wrote in the "soufflé style" that was light and suggestive.

Émile Zola (1840–1902). Novelist. Leader of the Naturalist movement. In the mid-1860s, he defended Manet and the Impressionists. By 1880 he had turned against Impressionism.

Selected Bibliography

BLUNDEN, MARIA and GODFREY, and DAVAL, J.-L. *Impressionists and Impressionism*. Geneva, 1970.

BOIME, ALBERT. *The Academy and French Painting in the 19th Century*. New York, 1970.

CHAMPA, KERMIT. *Studies in Early Impressionism*. New Haven, 1973.

CHIPP, HERSCHEL B. *Theories of Modern Art: A Source Book by Artists and Critics*. Berkeley and Los Angeles, 1969.

CLAY, JEAN, and the EDITORS OF RÉALITIÉS. *Impressionism* (pref. by René Huyghe.) Paris, 1973.

COURTHION, PIERRE. *Impressionism*. New York, 1971.

DAULTE, FRANÇOIS. *Auguste Renoir–Catalogue raisonné de l'oeuvre peint*. Vol. I, *Les Figures* (1860–1890). Lausanne, 1971.

DELTEIL, L. *Pissarro, Sisley, Renoir* (Vol. XVII of *Le Peintre-Graveur Illustré*). Paris, 1923.

FRIEDENTHAL, RICHARD, ED. *Letters of the Great Artists: From Blake to Pollock* (trans. by Daphne Woodward). New York, 1963.

GAUSS, CHARLES E. *The Aesthetic Theories of the French Artists, 1855 to the Present*. Baltimore, 1949.

GEFFROY, GUSTAVE. *Claude Monet, sa vie, son temps, son oeuvre*. Paris, 1922.

GOLDWATER, ROBERT and MARCO TREVES, EDS. *Artists on Art from the XIV to the XX Century*. New York, 1945 and 1973.

HAESAERTS, PAUL. *Renoir: Sculptor*. New York, 1947.

HAMILTON, GEORGE H. *Painting and Sculpture in Europe, 1880–1940*. Baltimore, 1967.

HAUSER, ARNOLD. *The Social History of Art* (trans. by Stanley Godman). 2 vols. New York, 1951.

NOTE: For a more complete bibliography, with over one thousand titles, covering the century until 1973, see John Rewald, *The History of Impressionism* (New York, The Museum of Modern Art, 4th ed. rev. 1973, pp. 608–52).

HOLT, ELIZABETH GILMORE, ED. *From the Classicists to the Impressionists: A Documentary History of Art and Architecture in the Nineteenth Century.* New York, 1966.

IMPRESSIONISM: A CENTENARY EXHIBITION. Pref. by Jean Chatelain and Thomas Hoving, intro. by René Huyghe, forward by Hélène Adhemar and Anthony Clark, catalogue by Anne Dayez, Michel Hoog, Charles S. Moffett, eds. New York, The Metropolitan Museum of Art, Dec. 12, 1974–Feb. 10, 1975.

ISAACSON, JOEL. *Monet–Le Déjeuner Sur L'herbe.* New York, 1972.

KELDER, DIANE. *The French Impressionists and Their Century.* New York, 1970.

LASSAIGNE, JACQUES. *Impressionism* (trans. by Paul Eve). Geneva, 1969.

LETHEVE, JACQUES. *Impressionnistes et Symbolistes devant la presse.* Paris, 1959.

LEVINE, STEVEN. *Monet and his critics.* New York, 1976.

LEYMARIE, JEAN. *Graphic Work of the Impressionists.* New York, 1972.

———. *Impressionism* (trans. by James Emmons), 2 vols. Paris and Geneva, 1966.

———. *Impressionist Drawings from Manet to Renoir.* Geneva, 1969.

MATHEY, FRANÇOIS. *Impressionists.* New York, 1967.

MUEHSAM, GERD. *French Painters and Paintings from the Fourteenth Century to Post-Impressionism: A Library of Art Criticism.* New York, 1970.

NEWHALL, BEAUMONT. *History of Photography from 1839 to the Present.* New York, 1971.

NOCHLIN, LINDA. *Impressionism and Post-Impressionism, 1874–1904: Sources and Documents.* Englewood Cliffs, N. J., 1966.

NOVOTNY, FRITZ. *Painting and Sculpture in Europe, 1879–1880.* London, 1960, 1971.

PACH, WALTER. *Renoir.* New York, 1950.

PISSARRO, L. R. and VENTURI, L. *Camille Pissarro, son art, son oeuvre.* 2 vols. Paris, 1939.

POOL, PHOEBE. *Impressionism.* New York, 1967.

RAYNAL, MAURICE, LEYMARIE, JEAN, and READ, HERBERT. *History of Modern Painting from Baudelaire to Bonnard.* Geneva, 1949.

REFF, THEODORE. "Copyists in the Louvre, 1850–1870. From *Art Bulletin,* vol. 46, no. 4, Dec. 1964, pp. 552–59.

REWALD, JOHN. *The History of Impressionism,* 4th ed. rev. New York, 1973.

———. *Pissarro.* New York, 1963.

———. ED. *Camille Pissarro: Letters to His Son Lucien* (trans. Lionel Abel). New York, 1943, and Mamaroneck, 1972.

ROUART, DENIS. *Renoir.* Geneva, 1954.

SCHAPIRO, MEYER. "Matisse and Impressionism." From *Androcles,* vol. 1, no. 1, Feb. 1932, pp. 21–36.

———. "The Nature of Abstract Art." From *Marxist Quarterly,* vol. 1, no. 1, Jan.–March, 1937, pp. 77–98.

SCHARF, AARON. *Art and Photography.* London, 1974.

SCHEYER, ERNEST. "Far Eastern Art and French Impressionism." From *The Art Quarterly*, vol. VI, no. 2, Spring, 1943, pp. 117–32.

SEITZ, WILLIAM. *Claude Monet*. New York, 1960.

SLOANE, JOSEPH. *French Painting Between the Past and the Present: Artist, Critics and Traditions from 1848 to 1870*. Princeton, 1951, 1973.

VENTURI, LIONELLO. *Les Archives de l'Impressionnisme*, 2 vols. Paris, 1939 (reissued in 1969).

WEBER, EUGEN. *Paths to the Present: Aspects of European Thought from Romanticism to Existentialism*. New York and Toronto, 1964.

WEBSTER, J. C. "The Technique of Impressionism—a Reappraisal." From *College Art Journal*, vol. IV, no. 1, Nov. 1944, pp. 3–22.

WHITE, HARRISON C. and CYNTHIA A. WHITE. *Canvases and Careers: Institutional Change in the French Painting World*. New York, 1965.

List of Illustrations